The Catalog Book

DESIGNS FOR CATALOGS & DIRECT MAIL

The Catalog Book

DESIGNS FOR CATALOGS & DIRECT MAIL

Judy Shepard

VISUAL REFERENCE PUBLICATIONS, INC., New York, NY

Visual Reference Publications, Inc.
302 Fifth Avenue
New York, NY 10001

Distributors to the trade in the United States and Canada
Watson-Guptill
770 Broadway
New York, NY 10003

Distributors outside the United States and Canada
HarperCollins International
10 E. 53rd Street
New York, NY 10022

Library of Congress Cataloging in Publication Data:
The Catalog Book: Designs for Catalogs & Direct Mail

Printed in China
ISBN 1-58471-097-4

Book Design: Judy Shepard

CONTENTS

Design makes the difference

Great design can be confronting, it can be amazing, it can intrigue, it can motivate, it can inspire.

Great design always gets noticed.

And, in the three seconds that the decision is made to open or dump your catalog, the difference comes down to getting noticed.

Great design isn't about looking pretty, though that may, in fact, be the outcome. It pays heed to the rules—sometimes nodding to them, sometimes applying them exactly, but always acknowledging their existence.

Eye-flow theory, hotspots, font readability and floorplanning all help in layering the information, staging the flow for the reader to ensure that interesting products and stimulating copy combine with brand essentials to produce a cohesive and irresistible read.

This isn't just about graphic design, though. Photographic styles are chosen to build anything from value propositions to perceptions of sumptuous luxury. Models and locations are utilized to add product-in-use or demographic relevance; silhouettes and bare sets can imply either a simple elegance or basic budget positioning.

Whether you are driving orders or traffic to store or web, the menu of options is extensive.

How they come together determines whether the reader becomes a customer, opening the catalogue then their wallet.

Stuart Cumming

Marshall Field's

Department Store

MEDIA: catalog
DIMENSIONS: 6 1/2" x 9 1/2"
PAGES: 72
WEBSITE: www.fields.com

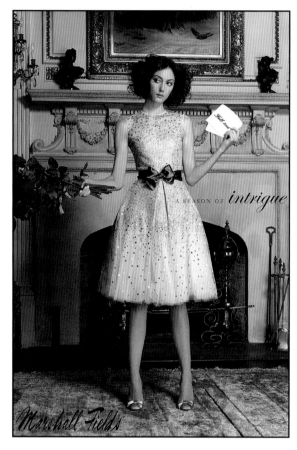

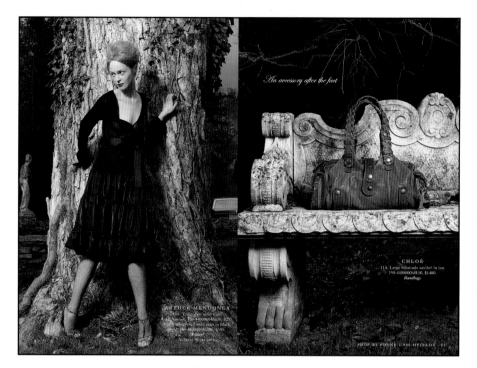

An old-fashioned who-done-it plays out in and around a grand mansion in Marshall Field's fall catalog. Entitled "A season of intrigue," the mystery takes its models throughout the house, the gardens and even the coal cellar (right). Headlines, set in an elegant script font, often hint at the merchandise—"An accessory after the fact," set above a handbag, for instance.

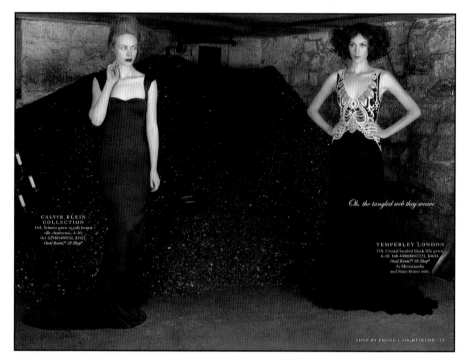

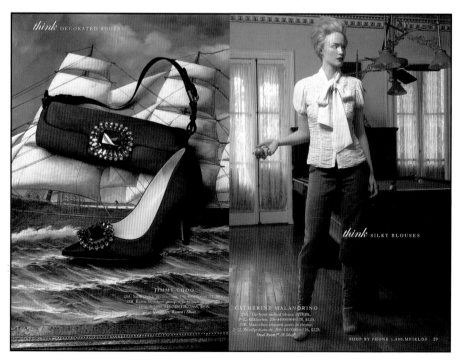

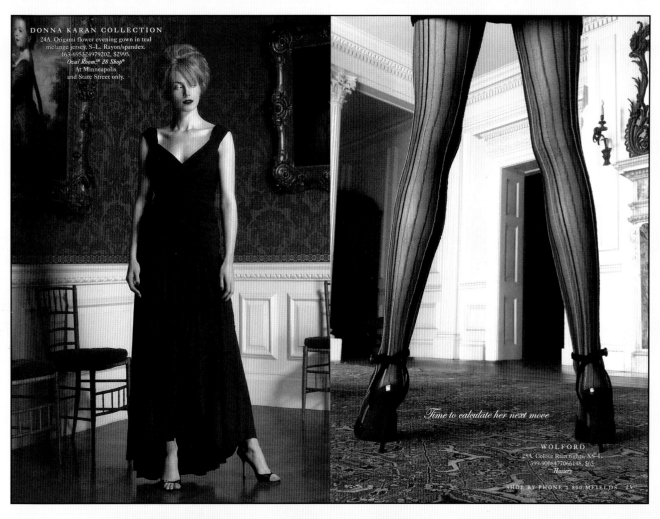

DONNA KARAN COLLECTION
24A. Origami flower evening gown in teal
mélange jersey. S–L. Rayon/spandex.
163-695324979202, $2995.
Oval Room,™ 28 Shop®
At Minneapolis
and State Street only.

Time to calculate her next move

WOLFORD
25A. Colour Rain tights. XS–L.
399-9008477066148, $65
Hosiery

SHOP BY PHONE 1.800.MFIELDS 25

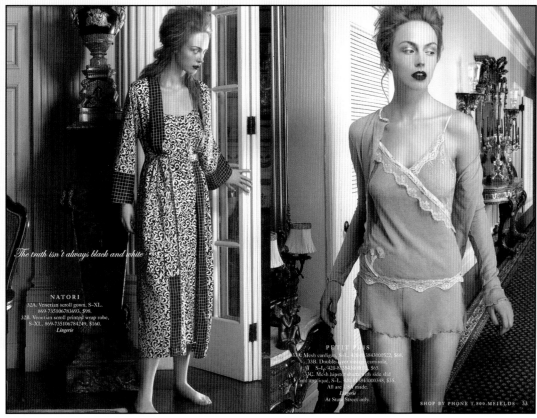

The truth isn't always black and white

NATORI
32A. Venetian scroll gown. S–XL.
869-735106783693, $98.
32B. Venetian scroll printed wrap robe.
S–XL. 869-735106784249, $160.
Lingerie

PETIT PLIS
33A. Mesh cardigan. S–L. 420-813843000522, $68.
33B. Double-layer cotton camisole.
S–L. 420-813843000199, $65.
33C. Mesh hipster short with side slit
and appliqué. S–L. 420-813843000348, $35.
All are USA made.
Lingerie
At State Street only.

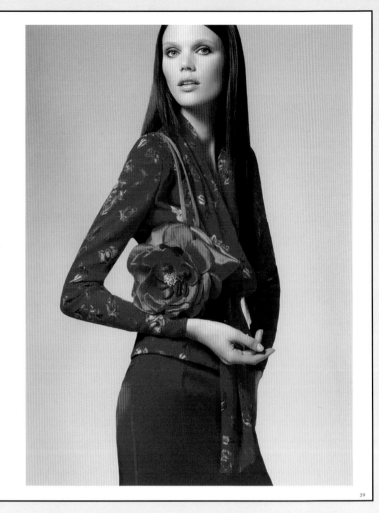

Escada

Detail shots, shown large and occupying entire pages, are interspersed throughout the four catalogs from Escada shown here and on the following three pages. At times the photos form abstract designs, while others clearly show identifiable product details such as stitching or buttons.

Women's apparel and accessories

MEDIA: catalogs
DIMENSIONS: 8¼" x 10⅞"
WEBSITE: www.escada.com

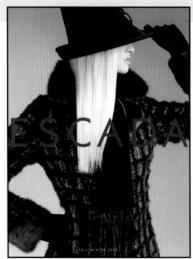

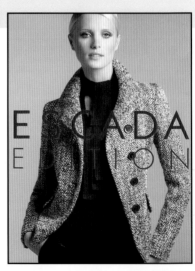

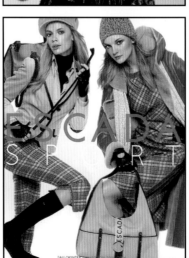

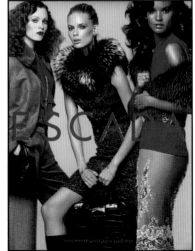

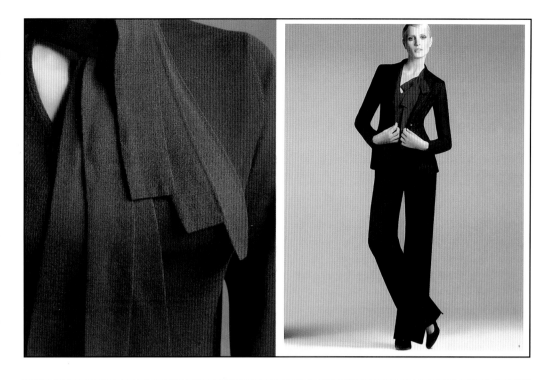

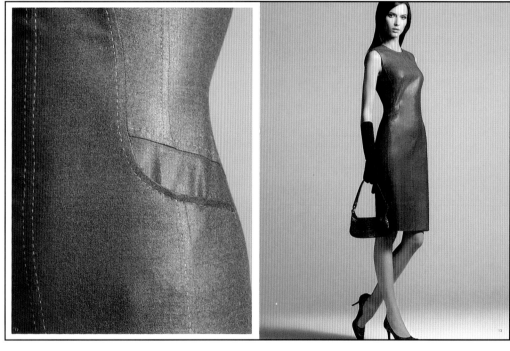

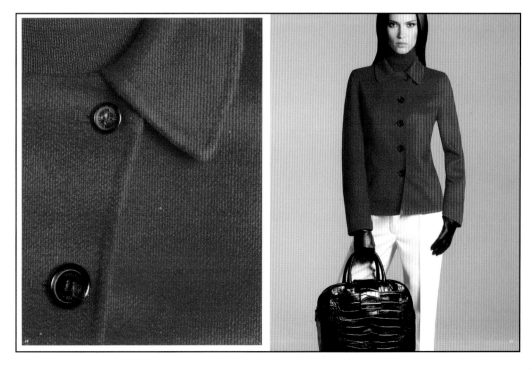

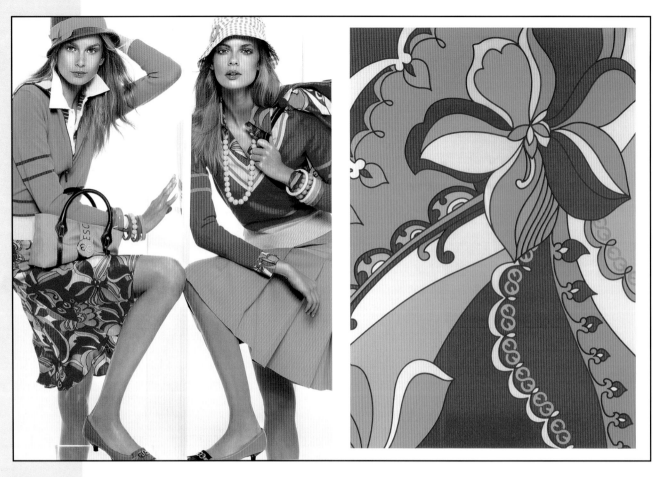

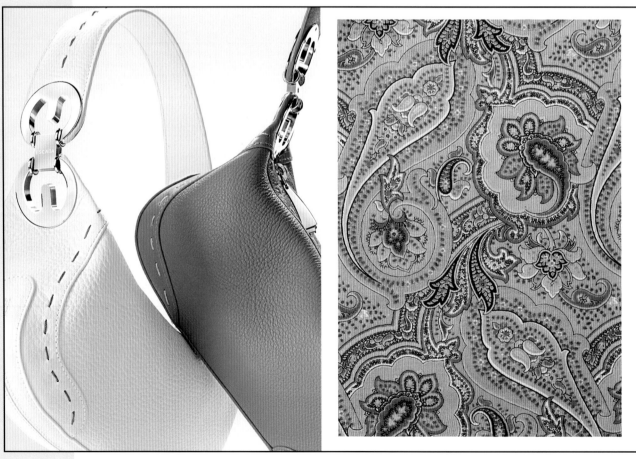

Vibrant fabric patterns jump from the pages of the
Escada Sport catalog (opposite page). Details shown
In the fall/winter catalog range from applique designs
to a page filled with colorful belts (below).

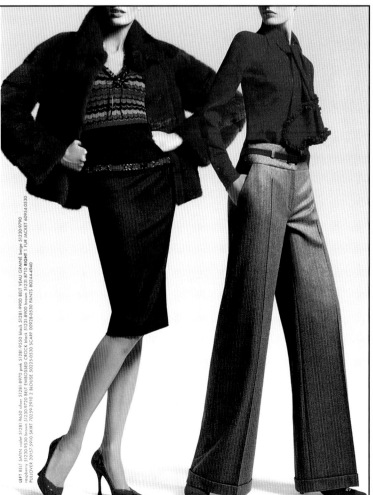

LEFT BELT SATIN violet 51281-9650 silver 51281-8970 pink 51281-9550 black 51281-8990 BELT VEAU GRAINE beige 51230-9790 raspberry 51230-9530 brown 51230-9720 BELT EMBOSSED CROCK black 51231-8900 brown 51231-8710 RIGHT I FUR JACKET 60954-0530 PULLOVER 20157-5910 SKIRT 70239-2910 2 BLOUSE 50225-0530 SCARF 00928-0530 PANTS 80244-4940

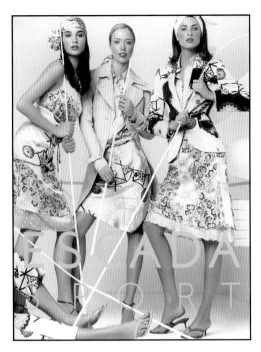

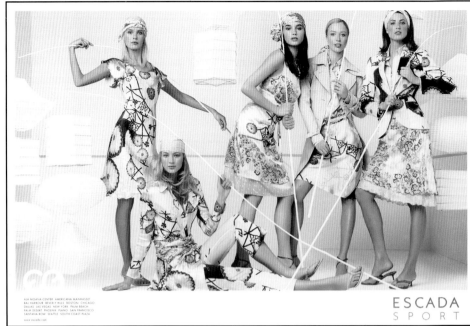

A related magazine ad shows the catalog cover imagery in its entirely.

Escada Sport

Women's apparel and accessories

MEDIA: catalog, magazine ad
DIMENSIONS: 8 1/8" x 10 7/8"
PAGES: 26
WEBSITE: www.escada.com

The merchandise in this catalog from Escada Sport is irresistible. Bursts of light cause the bags and sneakers to glow and the effect is heightened by the shiny surface on which the items are placed. Spreads throughout are, of course, carefully color coordinated.

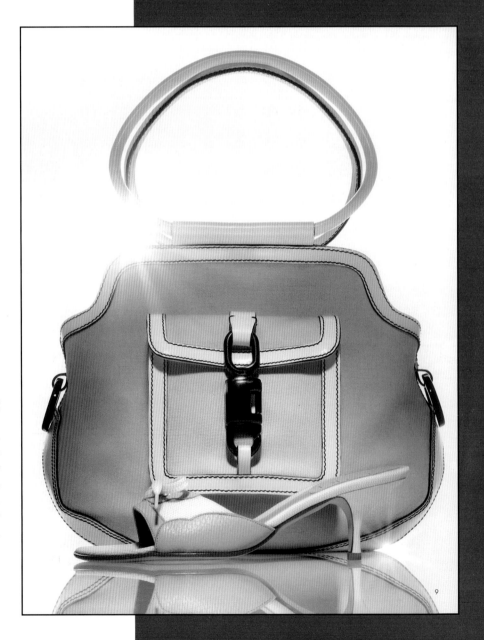

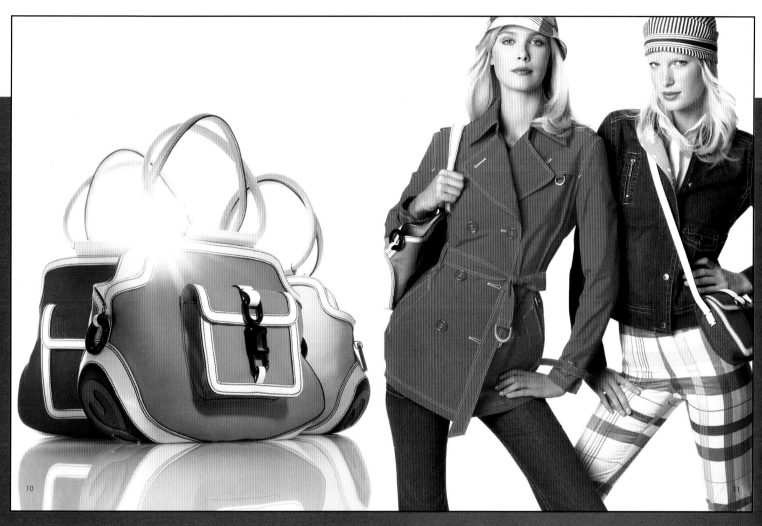

10

11

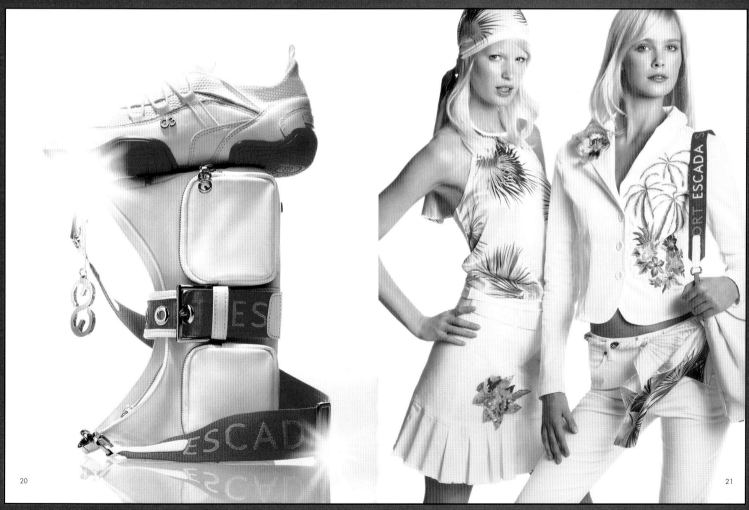

20

21

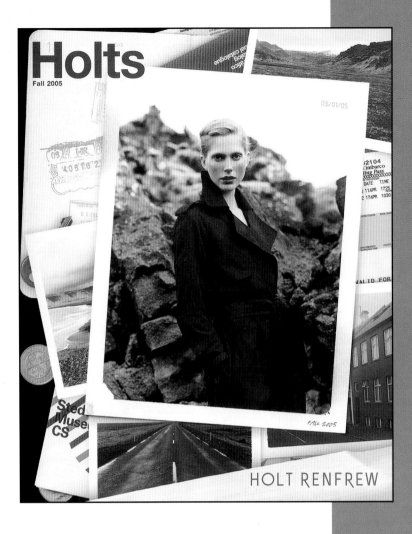

Holt Renfrew

Holt Renfrew evokes a sense of place in its fall catalog. As is explained on a page near the front, the catalog is meant as a homage to the themes of travel and culture.

Specialty Store

MEDIA: catalog
DIMENSIONS: 9" x 11"
PAGES: 210
WEBSITE: www.holtrenfrew.com

Travel and culture have forever been a mainstay in influencing every aspect of fashion, be it design, photography or beauty. As editor of this book, I've found that the themes of travel and culture are resonating this season more than ever. In homage to them, our Fall 2005 book references everything from remote locations that evoke the folkloric trends of the season to vintage films that set the tone for fall's classically tailored silhouettes. Whether it's a journey into an exciting new territory or the allure of old-world romance, Fall 2005 is yours to explore.

JOHN GERHARDT
Director, Creative Services

13

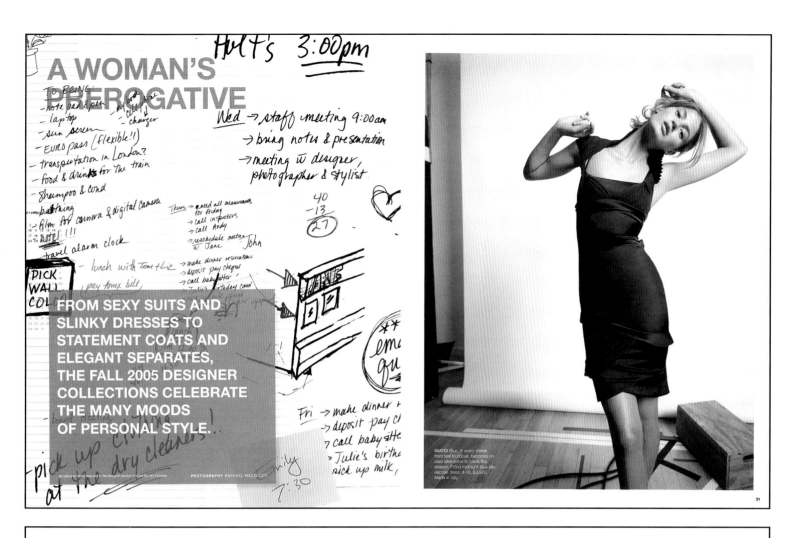

A WOMAN'S PREROGATIVE

FROM SEXY SUITS AND SLINKY DRESSES TO STATEMENT COATS AND ELEGANT SEPARATES, THE FALL 2005 DESIGNER COLLECTIONS CELEBRATE THE MANY MOODS OF PERSONAL STYLE...

PHOTOGRAPHY RAPHAEL MAZZUCCO

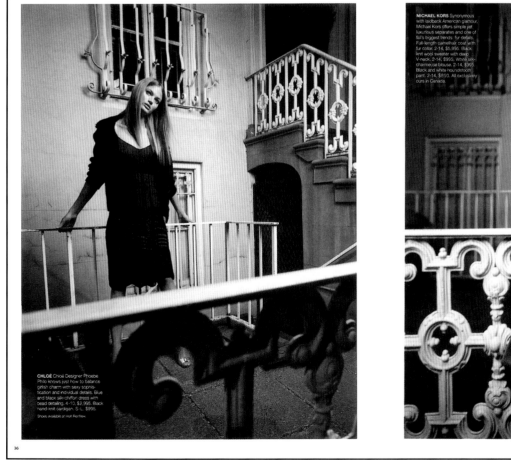

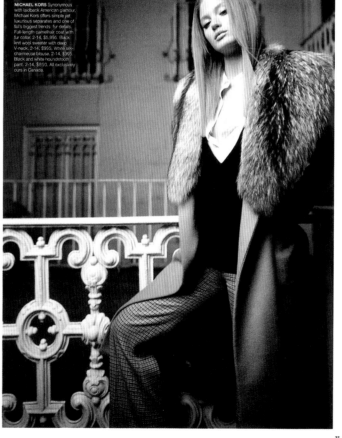

The pages of the catalog featuring the designer collections pages hint at a mysterious locale—perhaps these are the byways and dark corners of a romantic city.

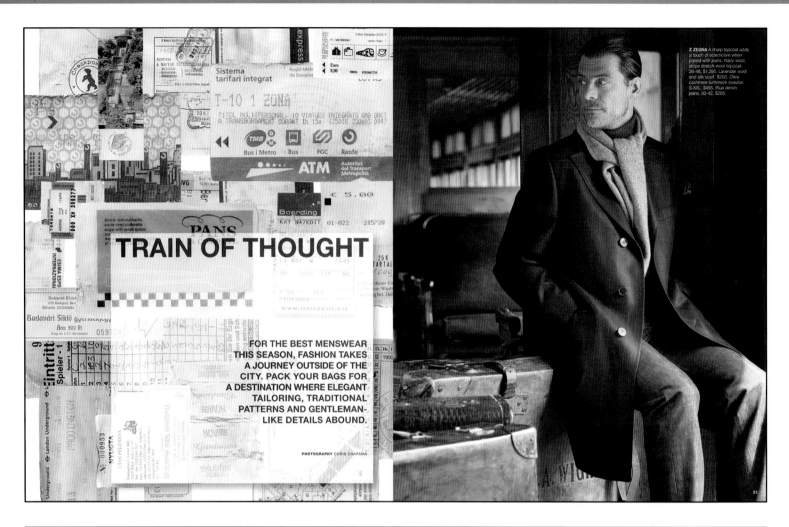

TRAIN OF THOUGHT

FOR THE BEST MENSWEAR THIS SEASON, FASHION TAKES A JOURNEY OUTSIDE OF THE CITY. PACK YOUR BAGS FOR A DESTINATION WHERE ELEGANT TAILORING, TRADITIONAL PATTERNS AND GENTLEMAN-LIKE DETAILS ABOUND.

PHOTOGRAPHY CHRIS CHAPMAN

Z ZEGNA A sharp topcoat adds a touch of eclecticism when paired with jeans. Navy wool, stripe stretch-wool topcoat, 36-48, $1,395. Lavender wool and silk scarf, $250. Olive cashmere turtleneck sweater, S-XXL, $495. Blue denim jeans, 30-42, $285.

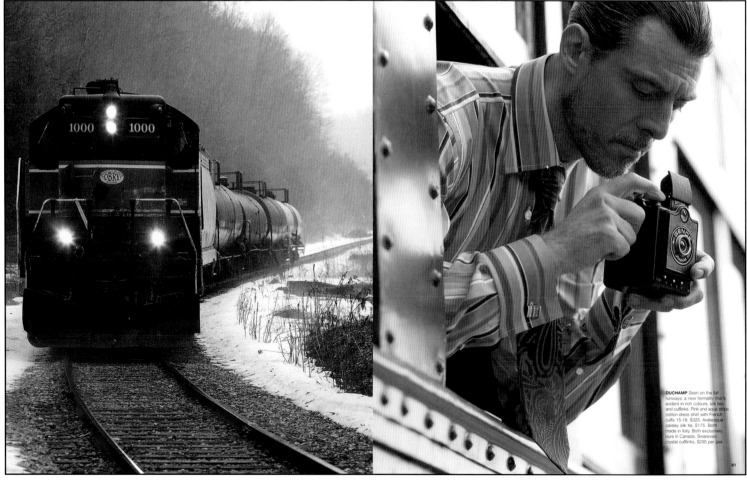

DUCHAMP Seen on the fall runways, a new formality that's evident in rich colours, silk ties and cufflinks. Pink and aqua stripe cotton dress shirt with French cuffs, 15-18, $325. Arabesque paisley silk tie, $175. Both made in Italy. Both exclusively ours in Canada. Swarovski crystal cufflinks, $295 per pair.

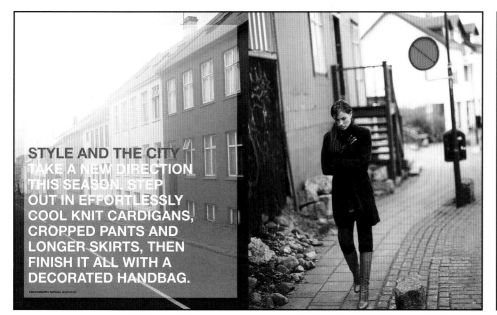

STYLE AND THE CITY
TAKE A NEW DIRECTION
THIS SEASON. STEP
OUT IN EFFORTLESSLY
COOL KNIT CARDIGANS,
CROPPED PANTS AND
LONGER SKIRTS, THEN
FINISH IT ALL WITH A
DECORATED HANDBAG.

The men's section of the Holt catalog (opposite), takes an old-fashioned journey to a world where "elegant tailoring, traditional patterns and gentleman-like details abound." Meanwhile, a mist-filled village from what seems to be another place and time sets the stage for women's sportswear (above). Yet another women's section is all about the elegance of a silhouette (below).

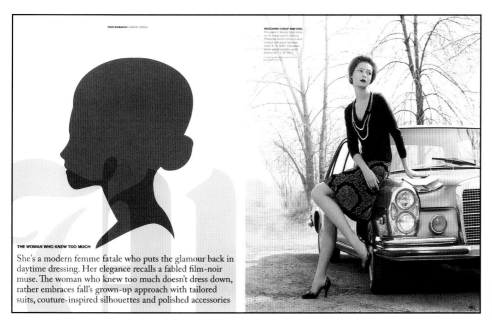

THE WOMAN WHO KNEW TOO MUCH

She's a modern femme fatale who puts the glamour back in daytime dressing. Her elegance recalls a fabled film-noir muse. The woman who knew too much doesn't dress down, rather embraces fall's grown-up approach with tailored suits, couture-inspired silhouettes and polished accessories

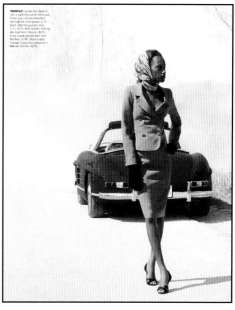

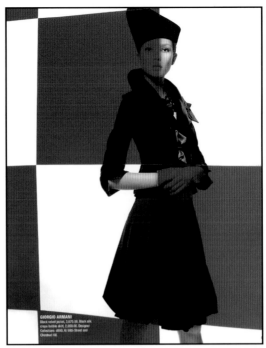

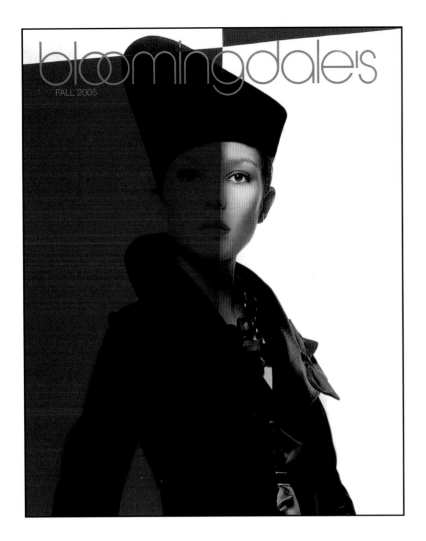

The cover shot is repeated, in a zoomed-out format, on an inside page.

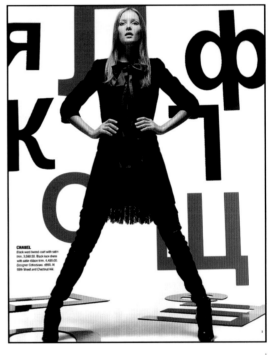

Bloomingdale's

Although Bloomingdale's allows Russia—the location for the catalog—to grab much of the attention, the merchandise is nevertheless kept front and center. The engaged viewer is left with two options: get a visa to visit Russia or...go to Bloomingdale's for a little shopping.

Department Store

MEDIA: catalog
DIMENSIONS: 8³/₄" x 7⁷/₈"
PAGES: 142
WEBSITE: www.bloomingdales.com

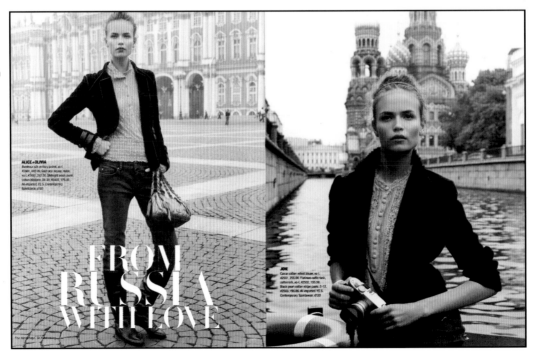

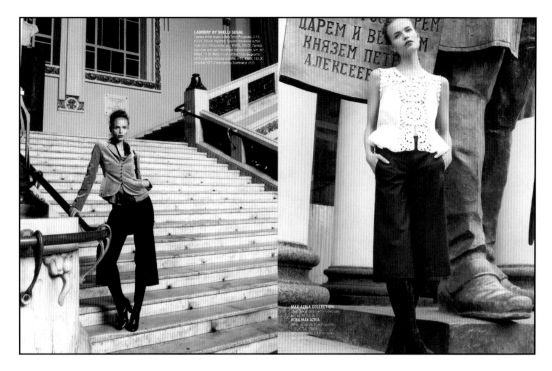

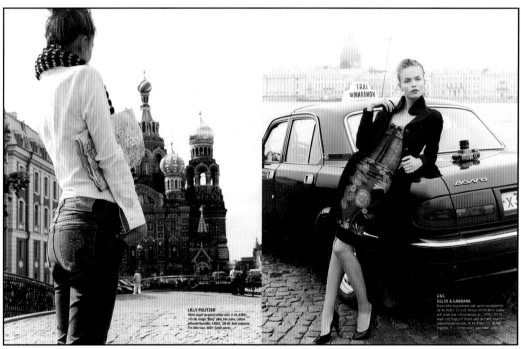

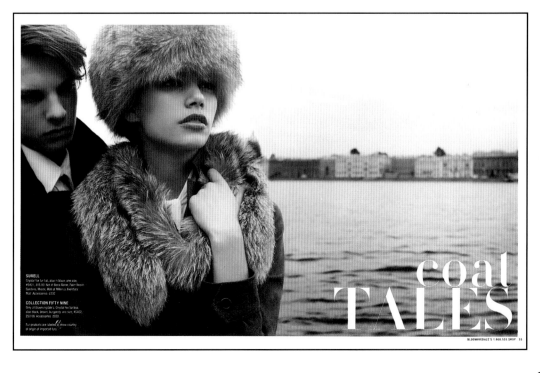

coat
TALES

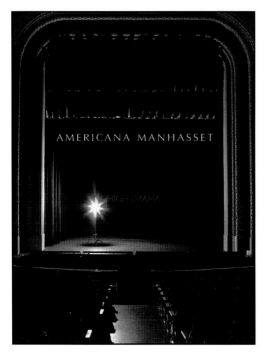

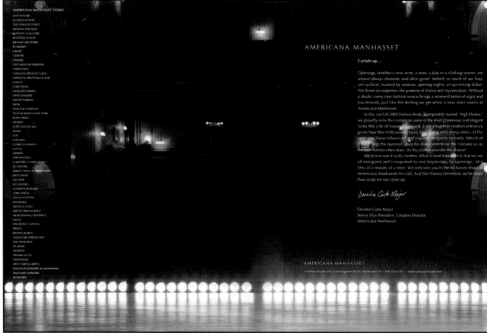

Americana Manhasset

Shopping Center

MEDIA: catalog
DIMENSIONS: 10" x 13"
PAGES: 56
WEBSITE: www.americanamanhasset.com

Americana Manhasset builds its catalog, entitled "High Drama," entirely around the stage and film. The footlights on the first spread (above) underscore a letter from a senior vice president while the "reel to runway" pages illustrate the transition of a fashion look from film to designer collection.

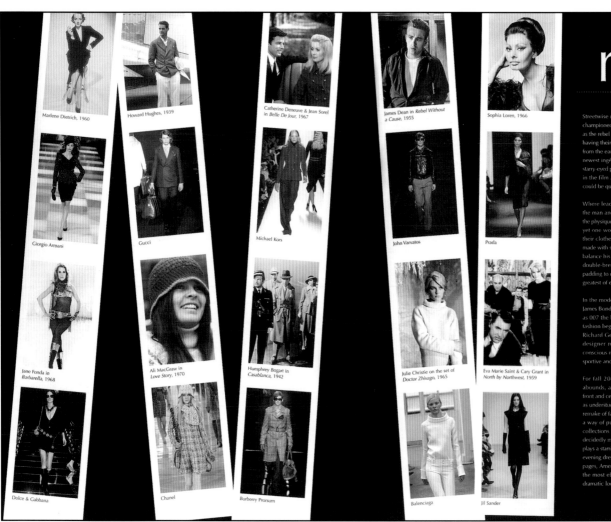

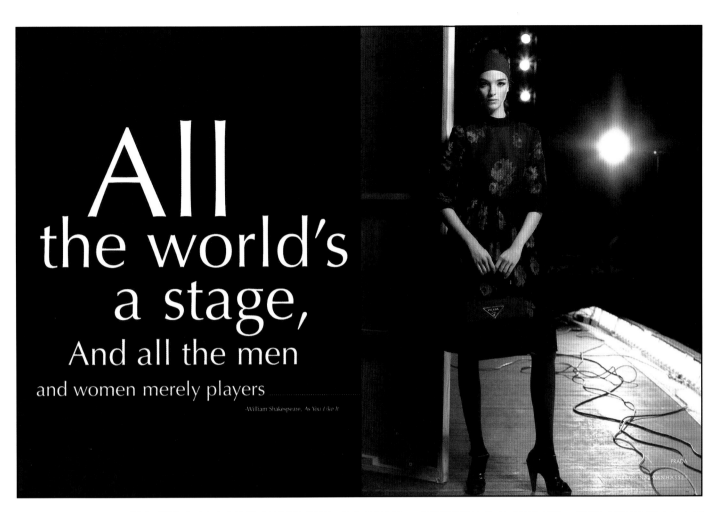

All
the world's
a stage,
And all the men
and women merely players

-William Shakespeare, *As You Like It*

PRADA
AMERICANA MANHASSET

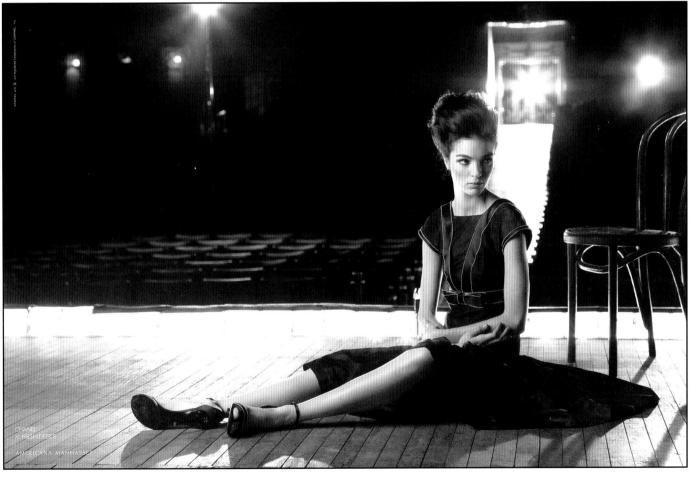

CHANEL
AT HIRSHLEIFER'S
AMERICANA MANHASSET

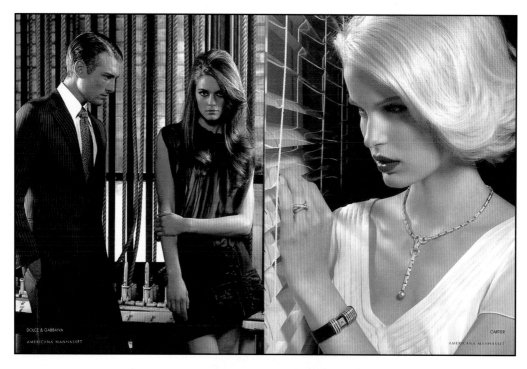

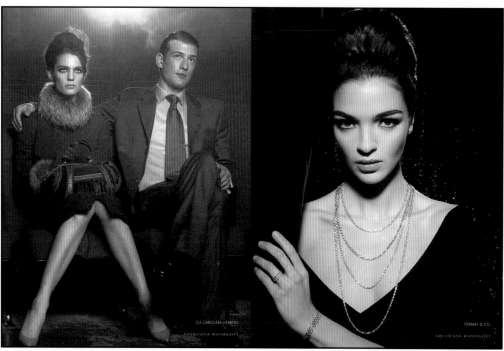

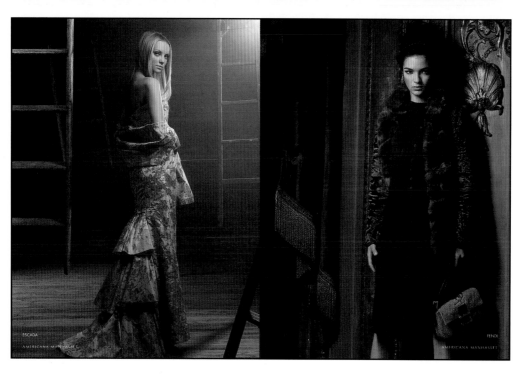

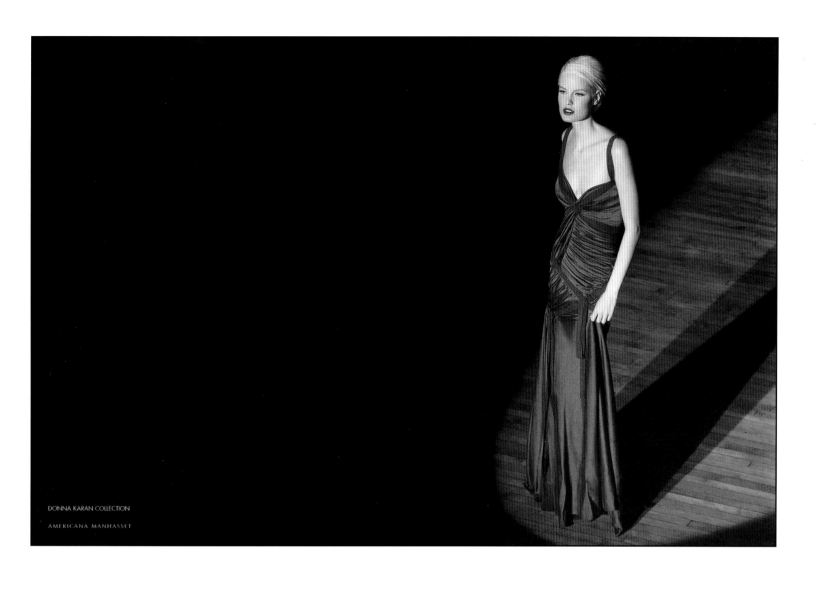

DONNA KARAN COLLECTION
AMERICANA MANHASSET

The contrast between the grittiness of the backstage world and the glamorous beings that exist there, provides creative fuel for many of the striking and moody photographs found in the Americana Manhasset catalog. This is a world of dim, smoky light, dark shadows, and, of course, fabulous clothing.

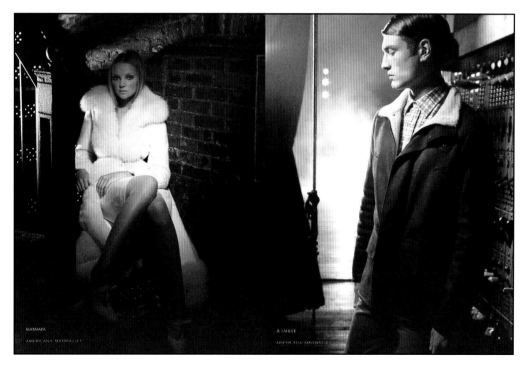

MAXMARA
AMERICANA MANHASSET

JIL SANDER
AMERICANA MANHASSET

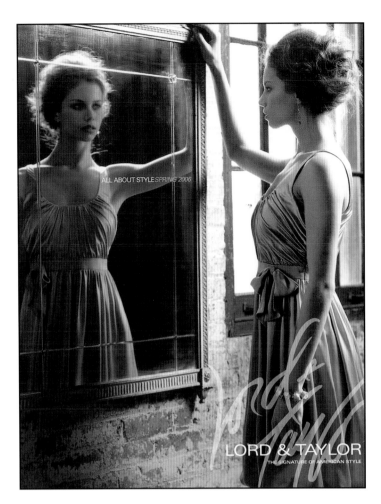

Lord & Taylor

Specialty Store

MEDIA: catalog
DIMENSIONS: 8¼" x 10⅞"
PAGES: 62
WEBSITE: www.lordandtaylor.com

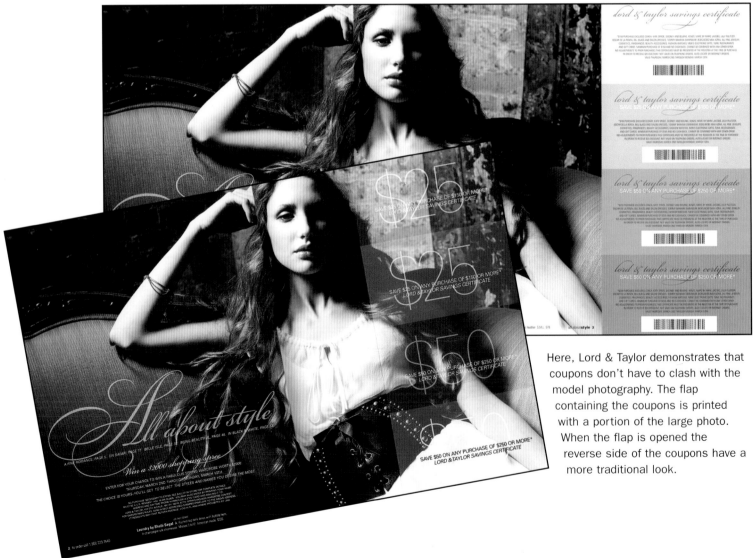

Here, Lord & Taylor demonstrates that coupons don't have to clash with the model photography. The flap containing the coupons is printed with a portion of the large photo. When the flap is opened the reverse side of the coupons have a more traditional look.

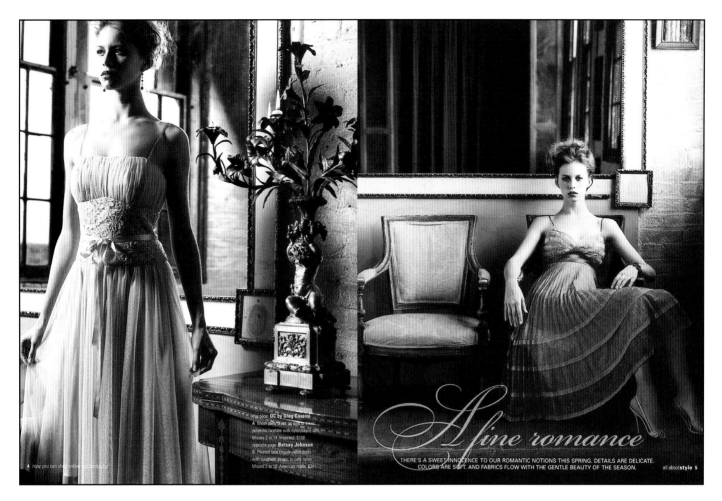

A fine romance

THERE'S A SWEET INNOCENCE TO OUR ROMANTIC NOTIONS THIS SPRING. DETAILS ARE DELICATE. COLORS ARE SOFT. AND FABRICS FLOW WITH THE GENTLE BEAUTY OF THE SEASON.

Completely charming this page, left to right: **Robert Rose** A. Multi-beaded necklace on cord. 36". $36.
Robert Rose B. Shell and carved floral charm necklace on cord. 32". $36 **Sequin** C. Beaded faux pearl necklace with charm accents. 36". $54
Robert Rose D. Charm necklace on cord with shells, beads and carved flowers. 32". $30 **Robert Rose** E. Beaded necklace with tassel charms and filigree accents. 32". $48
opposite page: **Ruth** F. Crinkled chiffon faux wrap dress with ruffled trim. In light blue silk. Misses 0 to 12. American made. $218

The feel of the catalog is romantic and sumptuous, in keeping with the season's merchandise.

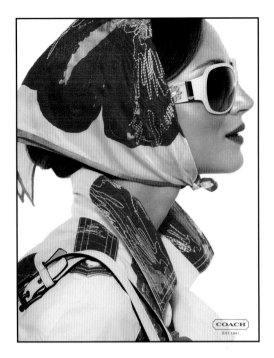

Coach

Leather goods and accessories

MEDIA: catalog
DIMENSIONS: 7³/₄" x 10"
PAGES: 56
WEBSITE: www.coach.com

A crisp, clean poppy motif graces the cover and several inside pages of this Coach catalog—keeping the company's classic look intact while providing a huge hit of spring color. The company's trademark still lifes are interspersed with some very Audrey Hepburn model shots (opposite).

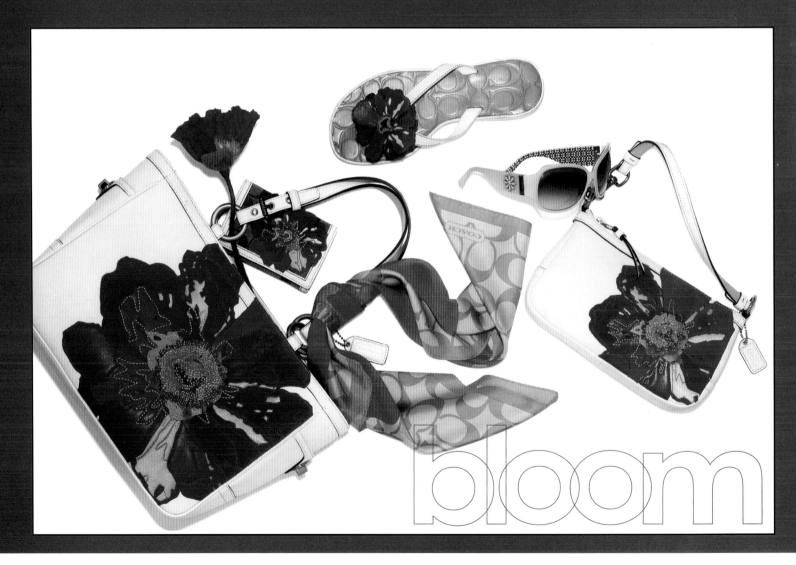

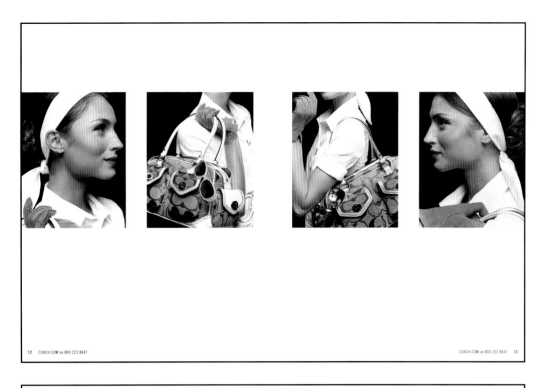

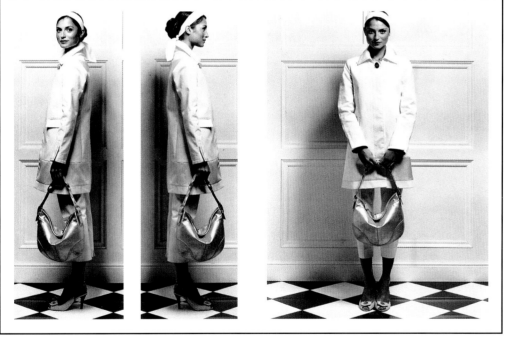

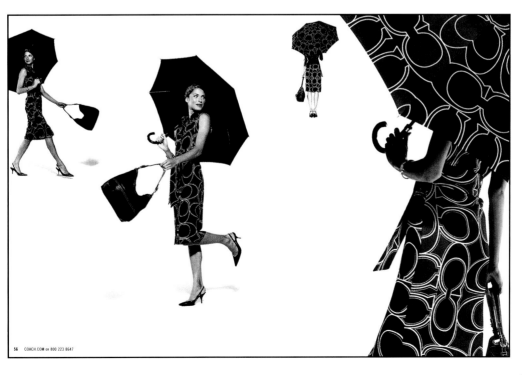

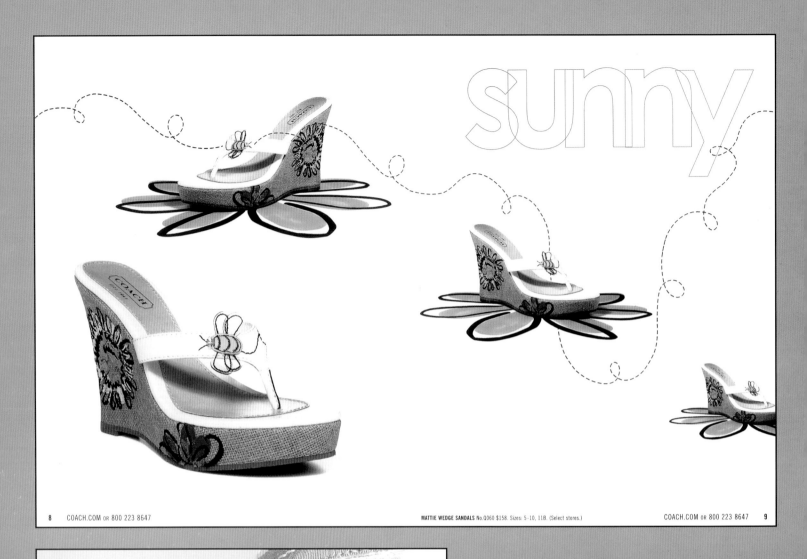

MATTIE WEDGE SANDALS No.Q060 $158. Sizes: 5-10, 11B. (Select stores.)

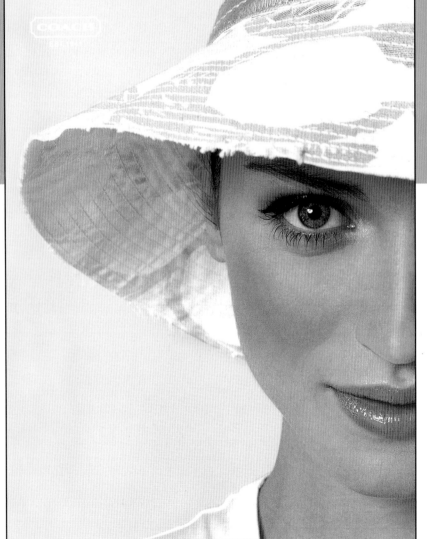

Coach

Illustrations and product shots playfully interact throughout this Coach catalog. On one spread (above) an applique bumble bee flirts from sandal to sandal while on another spread (opposite, top) a "drawn in" handbag holds an assortment of wallets and keychains.

Leather goods and accessories

MEDIA: catalog
DIMENSIONS: 6½" x 8⅝"
PAGES: 66
WEBSITE: www.coach.com

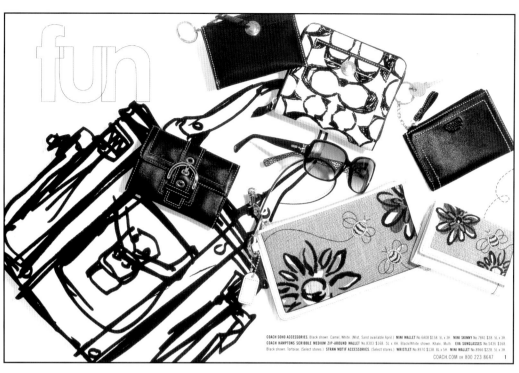

COACH SOHO ACCESSORIES. Black shown. Camel, White. (Mist, Sand available April.) MINI WALLET No.6408 $158. 5L x 3H. MINI SKINNY No.7841 $38. 5L x 3H.
COACH HAMPTONS SCRIBBLE MEDIUM ZIP-AROUND WALLET No.8303 $168. 5L x 4H. Black/White shown. Khaki, Multi. EVA SUNGLASSES No.5436 $168.
Black shown. Tortoise. (Select stores.) STRAW MOTIF ACCESSORIES. (Select stores.) WRISTLET No.8970 $138. 9L x 5H. MINI WALLET No.8966 $228. 5L x 3H.

COACH.COM OR 800 223 8647 1

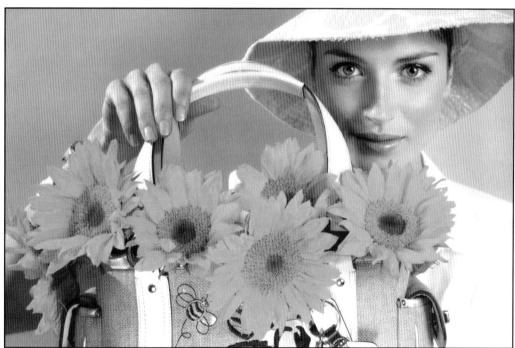

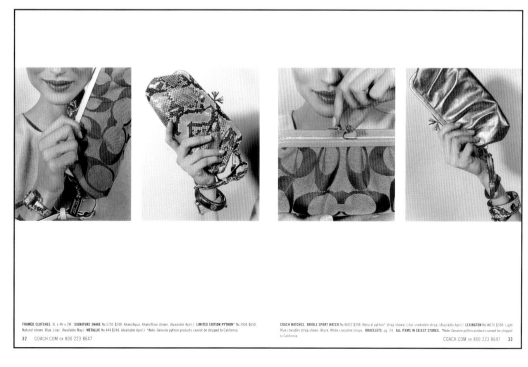

FRAMED CLUTCHES. 9L x 4H x 2W. SIGNATURE SNAKE No.5701 $248. Khaki/Aqua, Khaki/Rose shown. (Available April.) LIMITED EDITION PYTHON* No.3904 $650. COACH WATCHES. BRIDLE SPORT WATCH No.W422 $195. Natural python* strap shown. Lilac snakeskin strap (Available April.) LEXINGTON No.W676 $198. Light
Natural shown. Blue, Lilac (Available May.) METALLIC No.444 $248. (Available April.) *Note: Genuine python products cannot be shipped to California. Blue crocodile strap shown. Black, White crocodile straps. BRACELETS, pg. 74. ALL ITEMS IN SELECT STORES. *Note: Genuine python products cannot be shipped
to California.

Gucci

Accessories

MEDIA: catalog
DIMENSIONS: 5⅝" x 6⅝"
PAGES: 28
WEBSITE: www.gucco.com

15

16

9

10

All Gucci needs to make this small catalog memorable is its wonderful products, wonderfully photographed and interestingly positioned. Throw in a light cream background and the look is complete.

Gucci

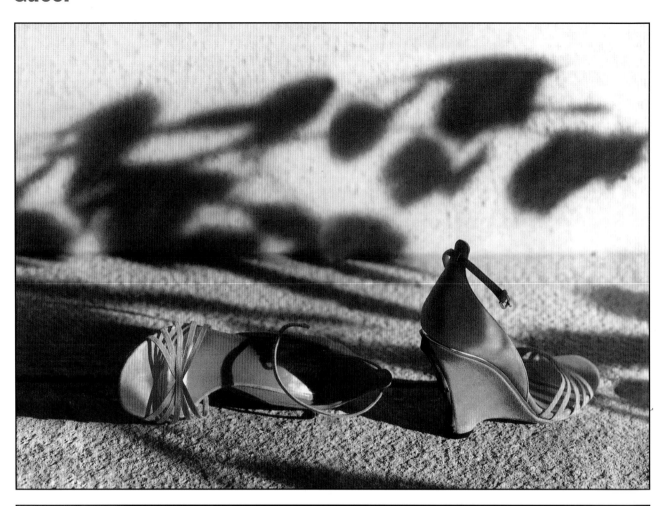

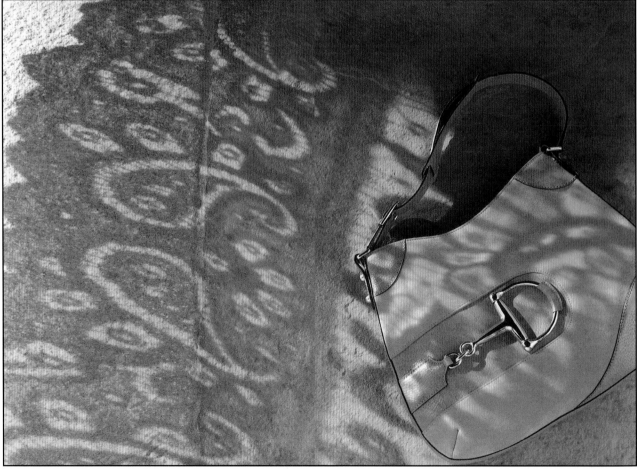

Shadows take on a life of their own in this Gucci catalog as they glide and dance over the pages, throwing intricate patterns on sand, walls, models and merchandise. The cover (not shown), was simply a heavy, white, textured stock with the Gucci name embossed in gold.

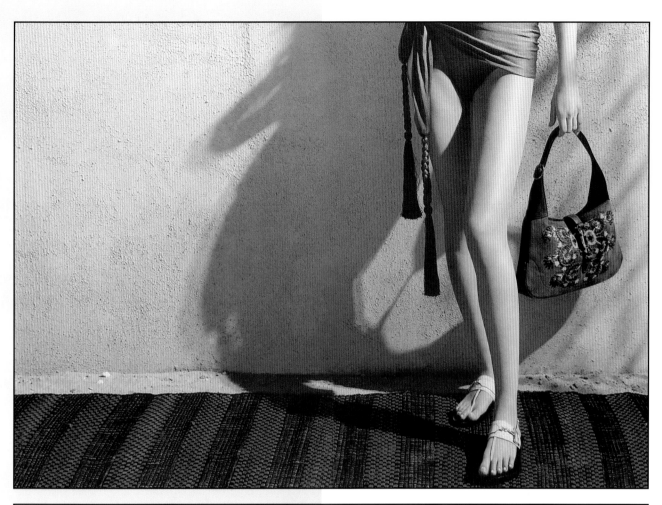

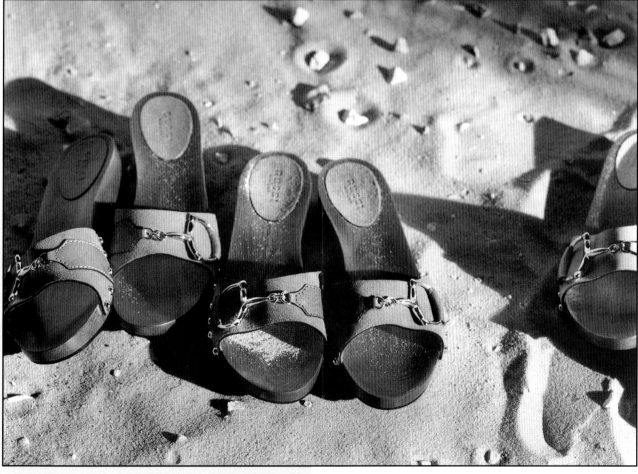

Accessories

MEDIA: catalog
DIMENSIONS: 6⁷/₈" x 9⁷/₈"
PAGES: 36
WEBSITE: www.gucci.com

FEMME FATALE

Bergdorf Goodman

Bergdorf Goodman mixes and matches styles of photography in a catalog selling only shoes. One section is soft-focused and feminine (including the cover) while another is hard-edged and…a different sort of feminine altogether.

Specialty Store

MEDIA: catalog
DIMENSIONS: 8" x 9¹/₂"
PAGES: 56
WEBSITE: www.bergdorfgoodman.com

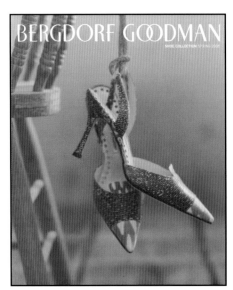

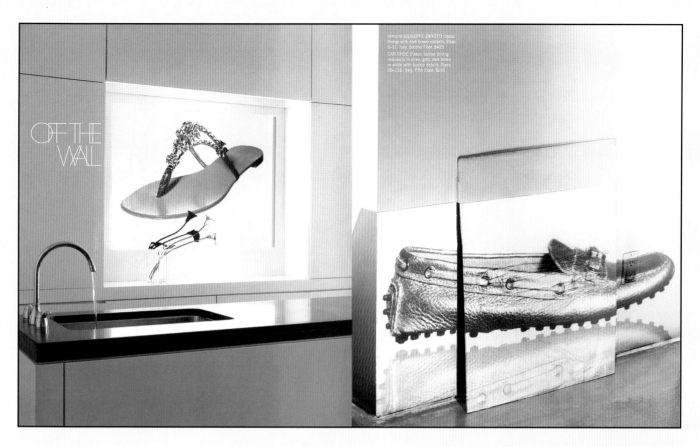

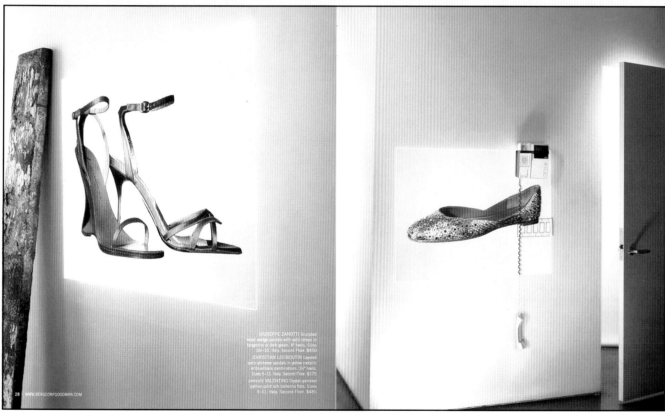

Yet another section, "Off the Wall," features shoe shots projected onto various walls—museum, kitchen—complete with faucets and phone cords.

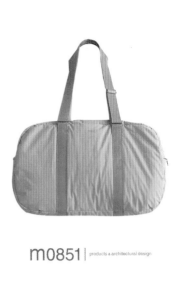

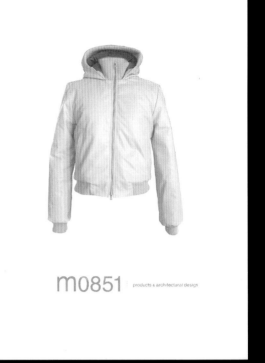

m0851

Retailer – apparel, accessories, home furnishings

MEDIA: catalog
AGENCY: In-house
CREATIVE DIRECTOR/PHOTOGRAPHER: Faye Mamarbachi
DIMENSIONS: 5" x 7"
PAGES: 40
WEBSITE: www.m0851.com

m0851...purposely neutral (the numbers are an amalgam of the owner's birthday), the name of the brand is, itself, eye-catching and unique. Founded in 1987, the first m0851 concept store opened in the hip Montreal district of Boulevard St. Laurent, offering a range of high-end products, from apparel to accessories and home furnishings. Today there are stores in Toronto, New York City, Tokyo and Taipei. M0851's products are designed to appeal to a broad spectrum of urbanites— those for whom function and fashion are equally important. The catalogs are conceptualized in-house four times a year, two for each season. Modern in their simplicity and minimalist in their approach, the brand's cool spirit is very effectively conveyed. Cream-colored paper stock adds to the sophistication. Catalogs are placed throughout the boutiques and—in a savvy marketing move—tucked inside the bag with every purchase.

flat pouch

12x8cm

14x11cm

23x14cm

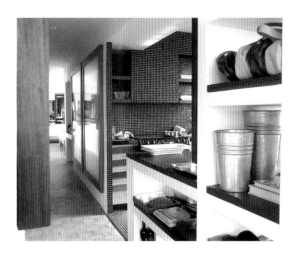

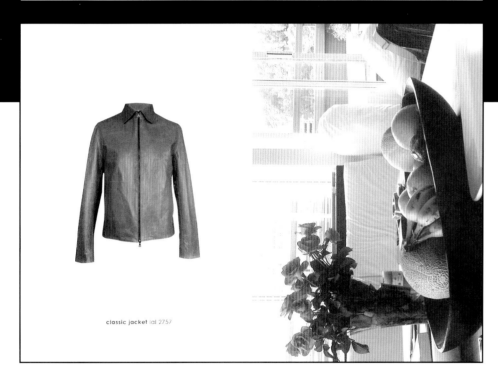

classic jacket ial 2757

bal fl 01 13x17cm

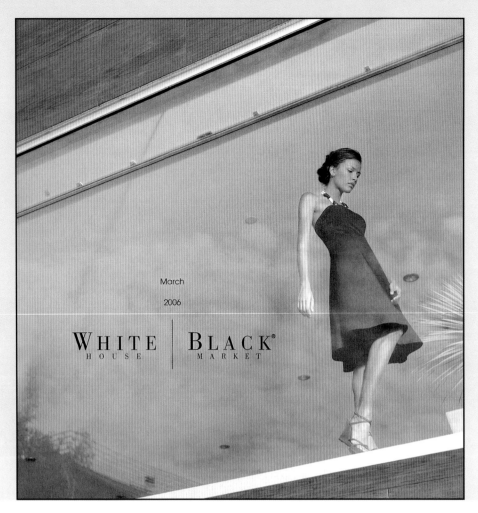

White House | Black Market

Apparel and accessories

MEDIA: catalog
DIMENSIONS: 9¹⁄₈" x 9¹⁄₂"
PAGES: 28
WEBSITE: www.whitehouseblackmarket.com

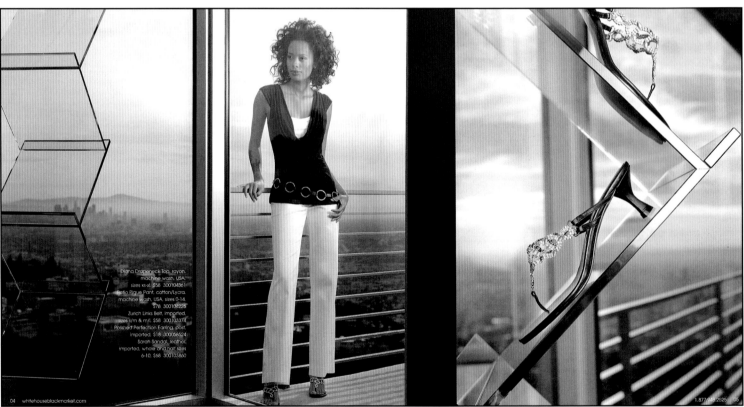

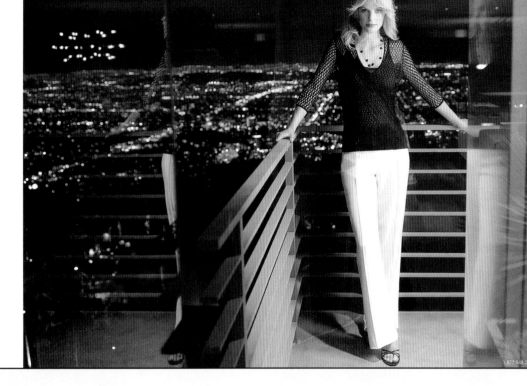

Left: Charming Medallion Clutch, imported, $58 300104395

Right: Serenade Top, viscose, dry clean, imported,
sizes xs-xl, $78 300104078
Ultra Soft Bra Cami, nylon/Lycra, available in black and white,
machine wash, USA, sizes xs-xl, $19 300104200
Ultimate Pintuck Pant, polyester/Lycra, available in white
(imported) and black (USA), short and regular
inseam lengths, machine wash, sizes 0-14, $78
regular 300102974 short 300103906
Virtue Necklace, imported, $38 300104161
Princess Earring, post, imported, $18 300062031

Expansive views and strong perspective lines add a architectural feel to White House | Black Market's catalog. Tables, windows and railings —even the streets of Los Angeles— angle into the shots, leading the eye to the merchandise.

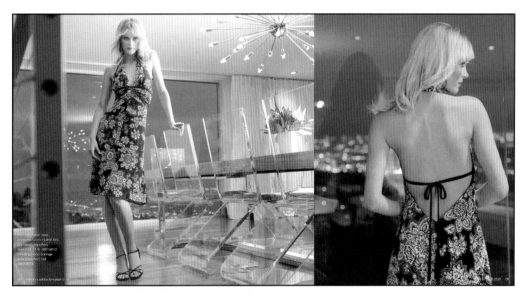

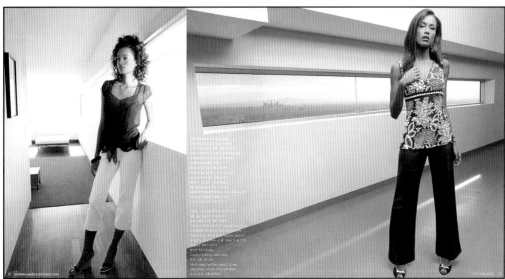

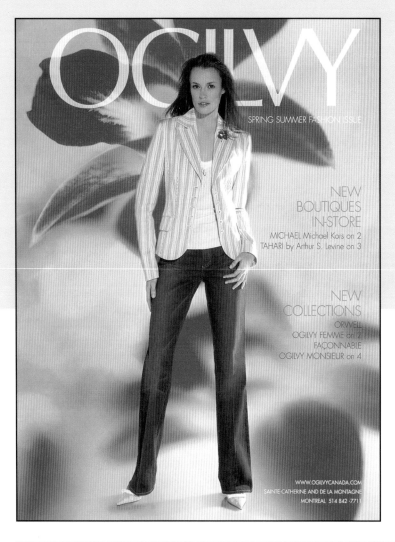

Ogilvy

Ogilvy appropriately fills its spring catalog with spring flowers—huge, page-filling blooms in various bright spring shades. A letter on the first spread (below), warmly welcomes the consumer and points out new products. An interesting bit of information included on each page is the phone number *and* extension for the department in which the items can be found.

Women's specialty store

MEDIA: catalog
DIMENSIONS: 8 3/4" x 10 7/8"
PAGES: 36
WEBSITE: www.ogilvycanada.com

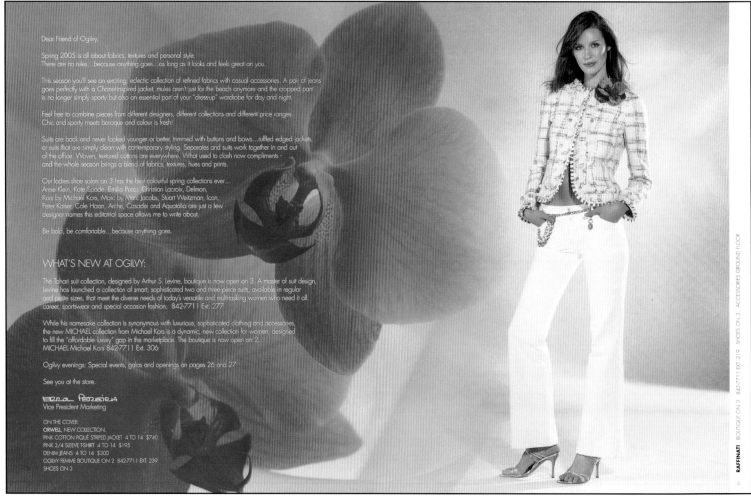

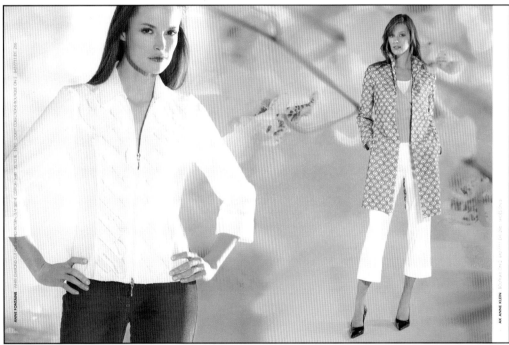

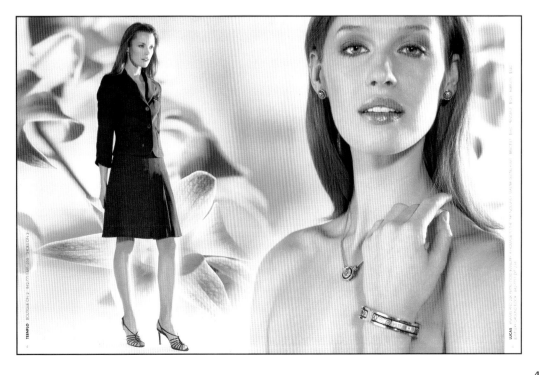

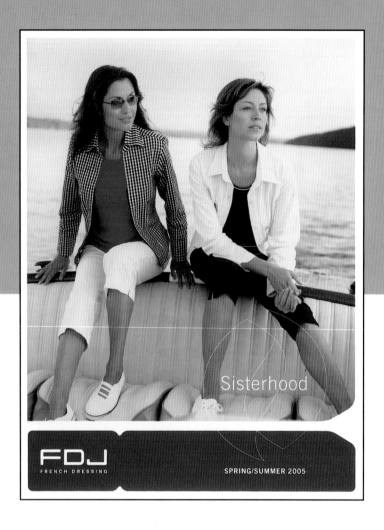

Sisterhood

FDJ
FRENCH DRESSING

SPRING/SUMMER 2005

FDJ French Dressing

Sisterhood is the theme of this catalog from Canadian manufacturer FDJ French Dressing—a theme in keeping with a company committed to designing women's clothing for actual women. A combination of small and large shots ensures visual interest while neat, white borders frame every page. The floral motif—knocked-out to white—add a feminine touch.

Sportswear manufacturer

MEDIA: catalog
DIMENSIONS: 8 ½" x 11
PAGES: 20
WEBSITE: www.fdj.ca

Escape

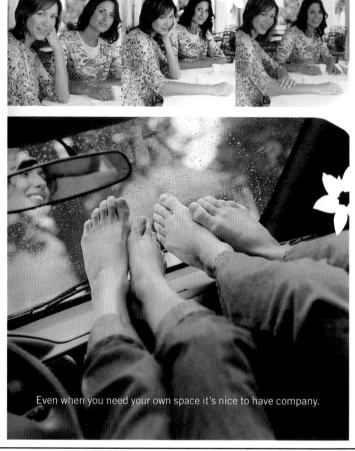

Even when you need your own space it's nice to have company.

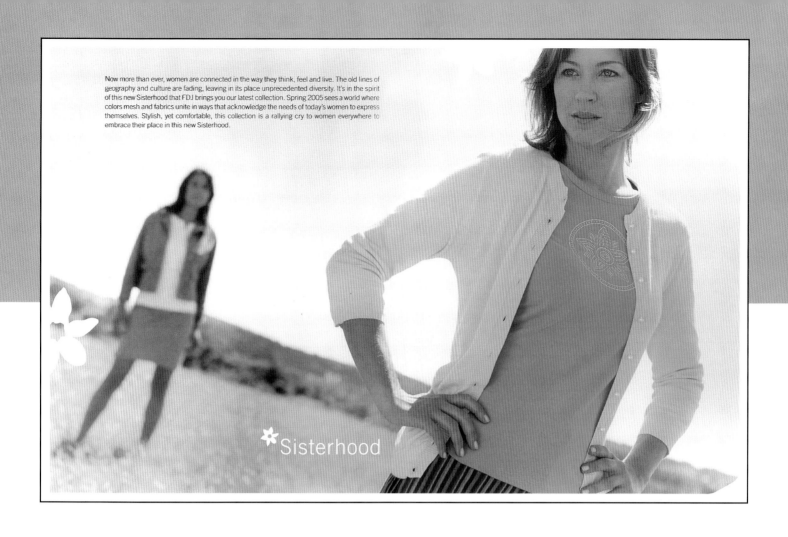

Now more than ever, women are connected in the way they think, feel and live. The old lines of geography and culture are fading, leaving in its place unprecedented diversity. It's in the spirit of this new Sisterhood that FDJ brings you our latest collection. Spring 2005 sees a world where colors mesh and fabrics unite in ways that acknowledge the needs of today's women to express themselves. Stylish, yet comfortable, this collection is a rallying cry to women everywhere to embrace their place in this new Sisterhood.

✳ Sisterhood

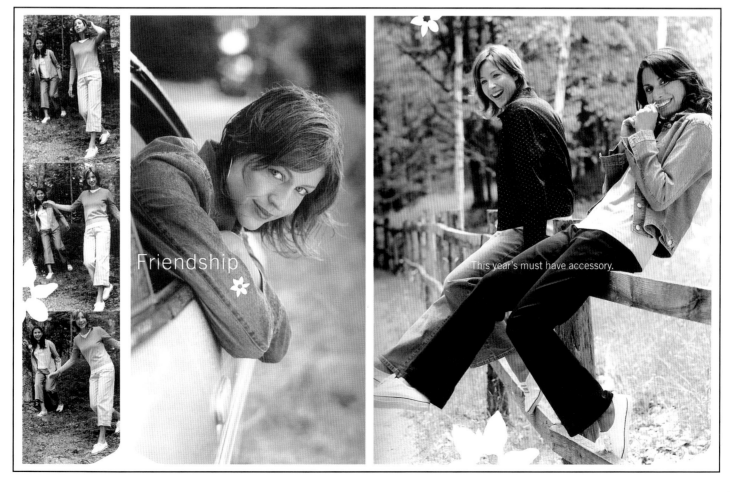

Friendship

This year's must have accessory.

PREFERRED CARDMEMBER SPRING 2006 PREVIEW

BANANA REPUBLIC

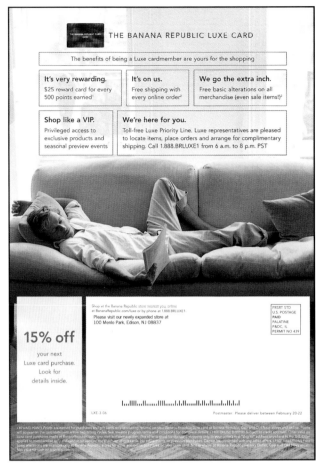

Banana Republic

Apparel and accessories

MEDIA: catalog
DIMENSIONS: 7½" x 10½"
PAGES: 16
WEBSITE: www.bananarepublic.com

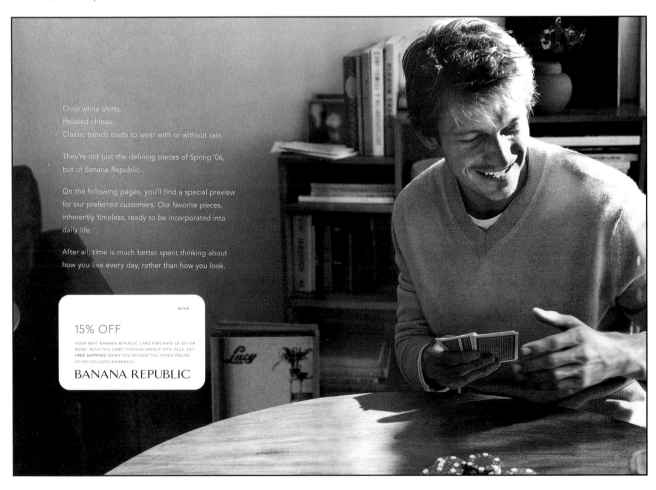

Crisp white shirts.
Relaxed chinos.
Classic trench coats to wear with or without rain.

They're not just the defining pieces of Spring '06, but of Banana Republic.

On the following pages, you'll find a special preview for our preferred customers. Our favorite pieces, inherently timeless, ready to be incorporated into daily life.

After all, time is much better spent thinking about how you live every day, rather than how you look.

15% OFF
YOUR NEXT BANANA REPUBLIC CARD PURCHASE OF $75 OR MORE, WITH THIS CARD THROUGH MARCH 15TH. PLUS, GET FREE SHIPPING WHEN YOU REDEEM THIS OFFER ONLINE. OFFER EXCLUDES HANDBAGS.

BANANA REPUBLIC

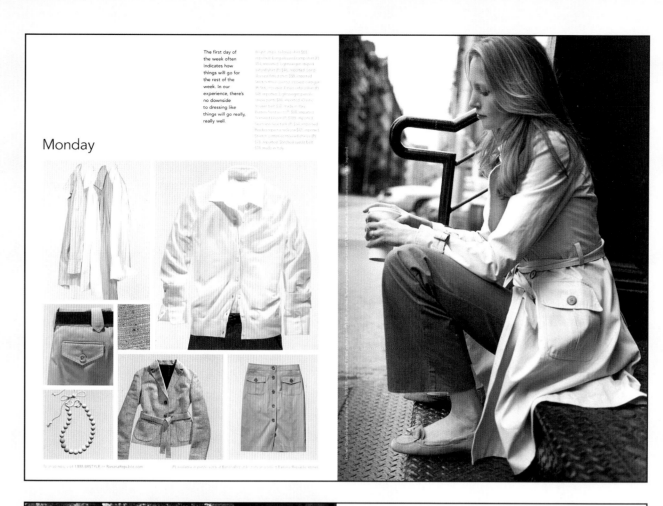

Monday

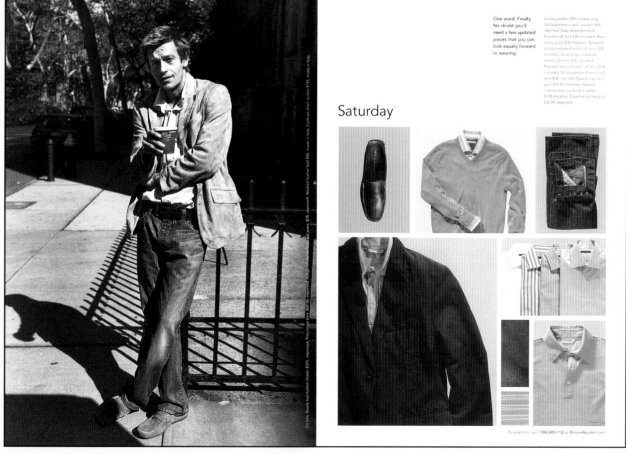

One word: Finally.
No doubt you'll
need a few updated
pieces that you can
look equally forward
to wearing.

Saturday

Banana Republic's preferred cardmember catalog/mailer starts things off with a goodie—a gummed-in card offering 15% off the customer's next purchase of $75 or more. The piece continues with a day-of-the-week theme and appealing lifestyle photos—these are people you might know. How easy, then, for a consumer to imagine themselves in the same merchandise.

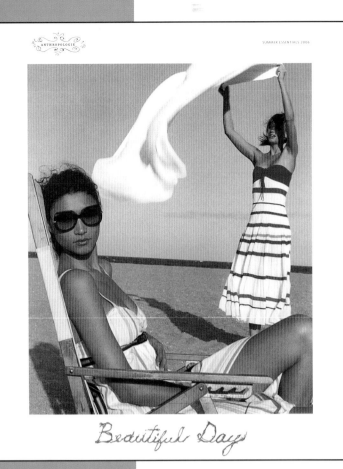

Beautiful Days

Anthropologie

Anthropologie evokes the "Beautiful Days" of summer in its Summer Essentials catalog. In particular, beautiful and carefree days spent at the beach—the perfect place to show off the company's softly flowing merchandise.

Apparel and accessories

MEDIA: catalog
DIMENSIONS: 9¼" x 10½"
PAGES: 36
WEBSITE: www.anthropologie.com

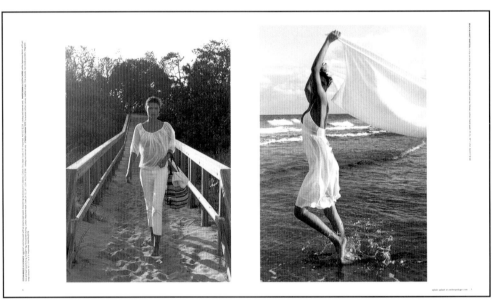

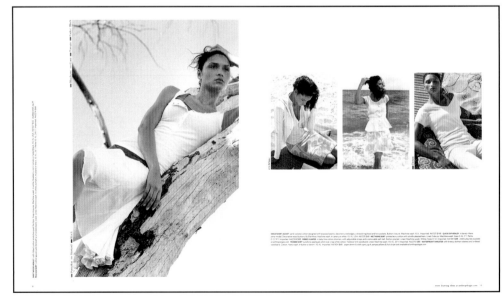

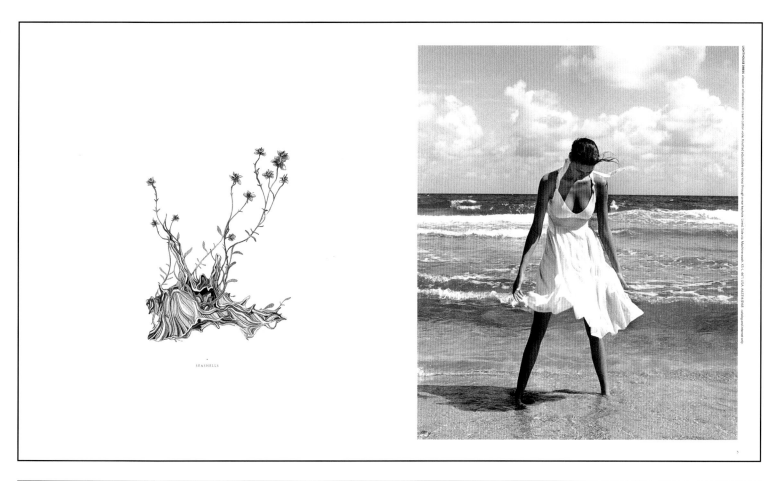

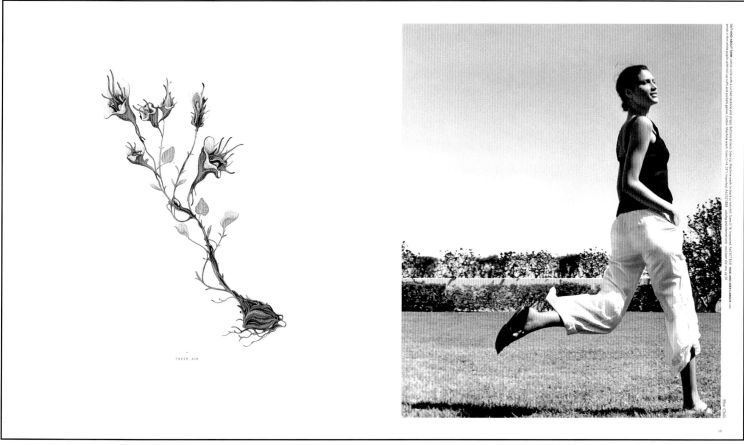

Cheerful botanical illustrations are interspersed throughout the catalog, adding contrast to the model shots while keeping the viewer in a summer frame of mind. Each illustration gets a page to itself on which to show off its colorful and fanciful root systems.

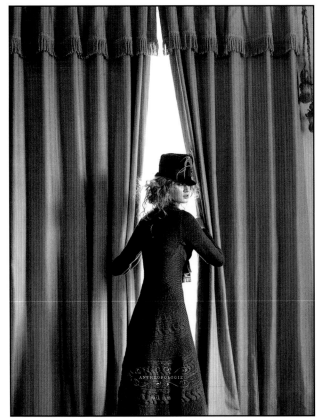

As this selections of covers demonstrates, Anthropologie never fails to adorn its catalogs with imagery that sets a very distinct mood. From the paper stock (mate) to the set decoration and model attitude all clearly convey a mood and identify the company.

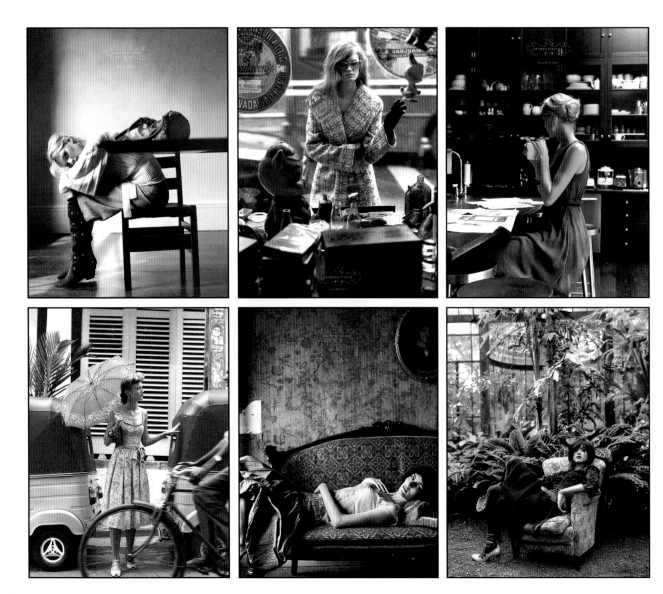

The Anthropologie website incorporates that same imagery and mood. Many photos come directly from the company's catalog.

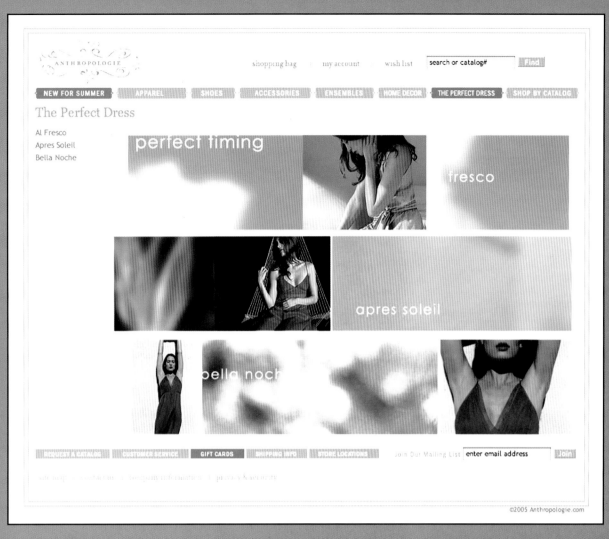

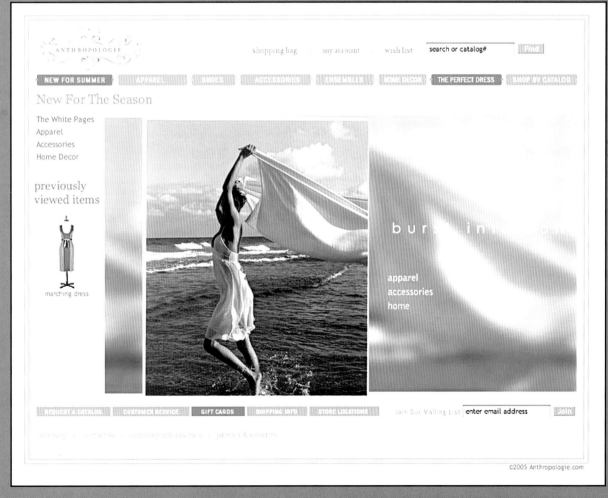

Off-figure photography and soft, lifestyle shots perfectly complement each other in these tiny in-store pieces. The off-figure is on the front cover; lifestyle on the back. Each of the five pieces is geared to a different merchandise segment and they unfold to various sizes.

Rachel Riley

Children's and womenwear

MEDIA: In-store collateral
DIMENSIONS: 4¹/₈" x 6"
WEBSITE: www.rachelriley.com

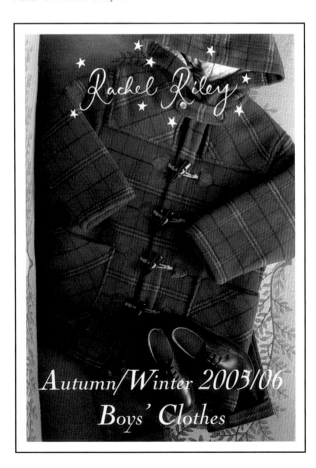

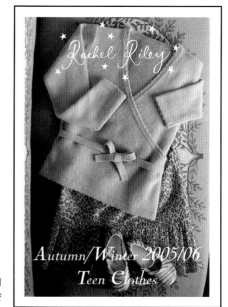

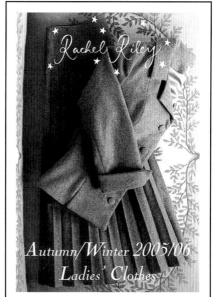

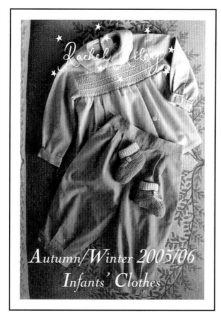

The front and back covers of the teen, ladies' and infants' lines.

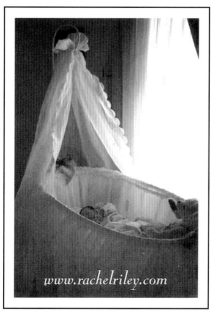

Product and pricing information is provided on the inside.

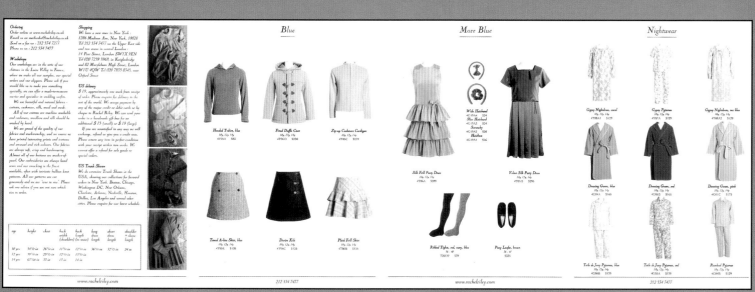

Ann Taylor LOFT

Women's apparel
MEDIA: catalog
DIMENSIONS: 9" x 11"
PAGES: 24
WEBSITE: www.anntaylorloft.com

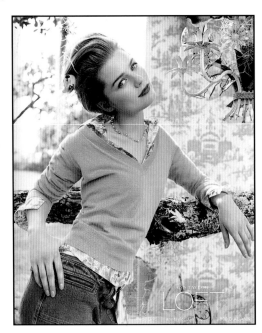

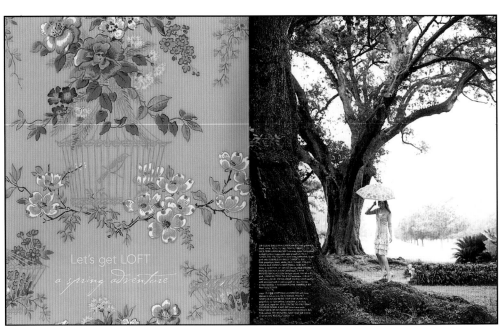

Spring pours from every page of Ann Taylor LOFT's catalog—even the interior shots pop with bright colors. Birds (not real ones, but the sort made to stick in planters and floral arrangements) appear in unexpected places. On one spread they are lined up on top of a screen (opposite page, top) and on other pages they add their presence to still life arrangements. Overall, the mood is one of whimsy and fun.

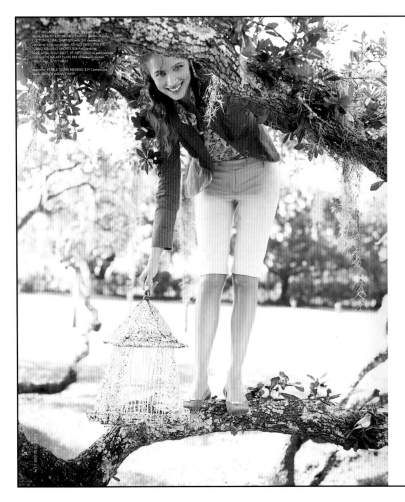

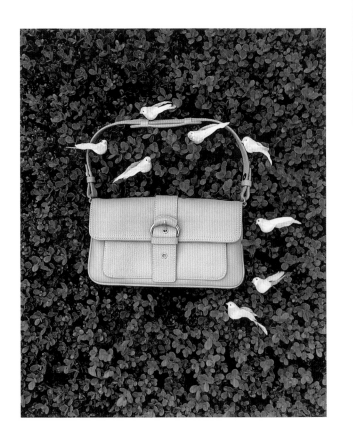

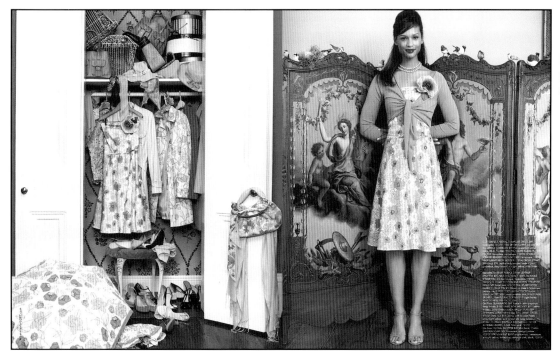

Note the birdies perched on the screen.

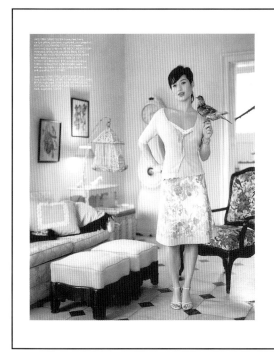

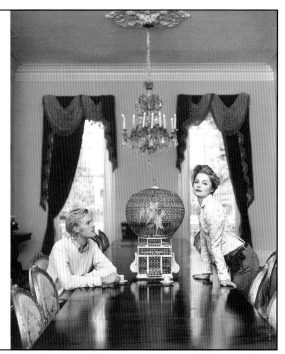

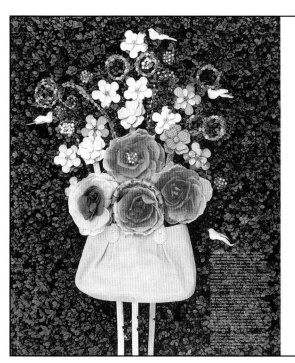

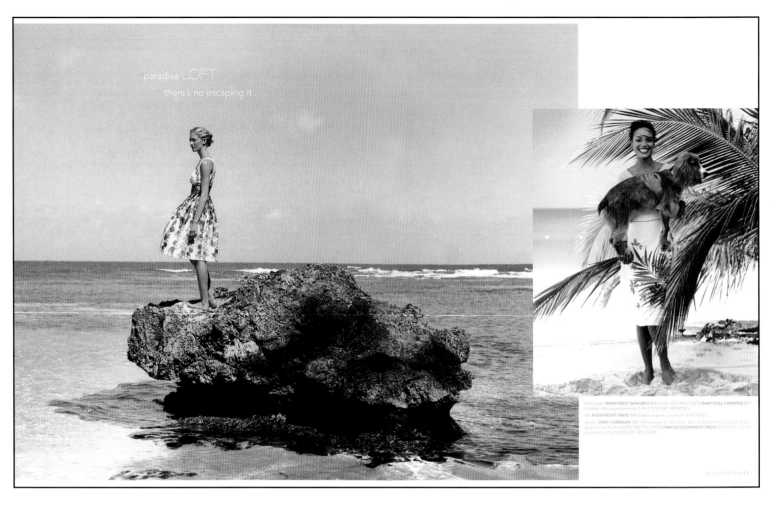

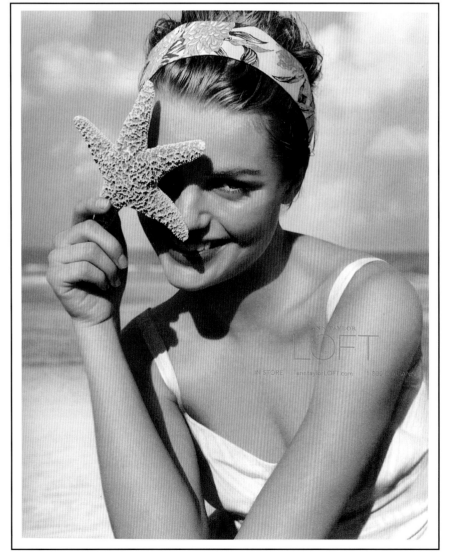

Down by the sea, the blue, blue sea. That's where Ann Taylor LOFT takes viewers with this summer catalog. Huge photos presenting an irresistible landscape are accented with smaller, fun-filled shots—all clearly display the merchandise.

Ann Taylor LOFT

Women's apparel
MEDIA: catalog
DIMENSIONS: 9" x 11"
PAGES: 16
WEBSITE: www.anntaylorloft.com

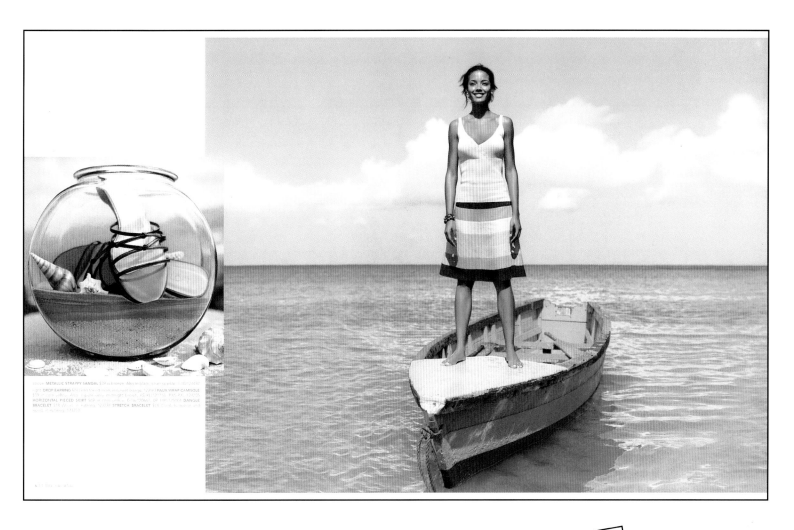

A related postcard adds the
enticement of 50% off to the
general fun of a day at the beach.

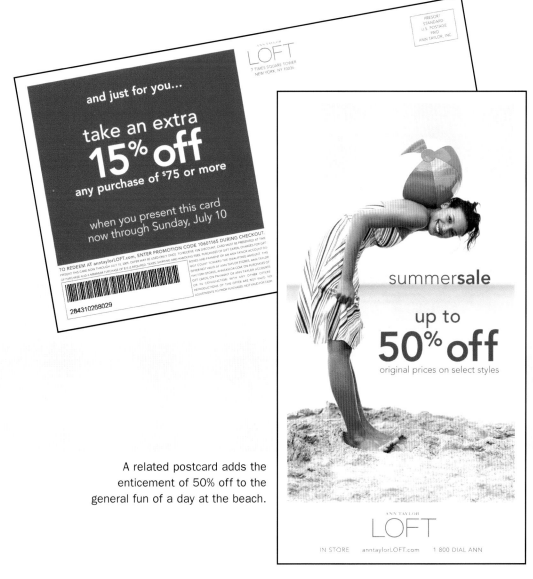

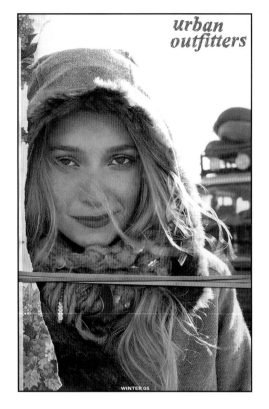

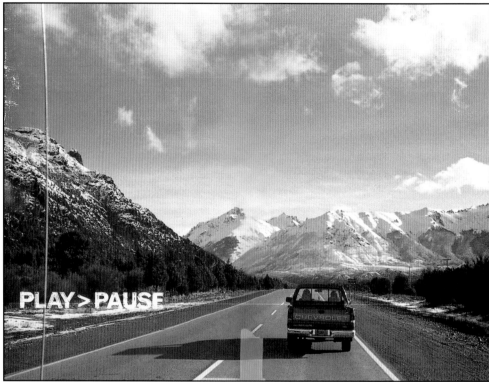

Not always showing product can create quite a punch.

Urban Outfitters

Apparel and accessories

MEDIA: catalog
DIMENSIONS: 6" x 9¹/₈"
PAGES: 68
WEBSITE: www.urbanoutfitters.com

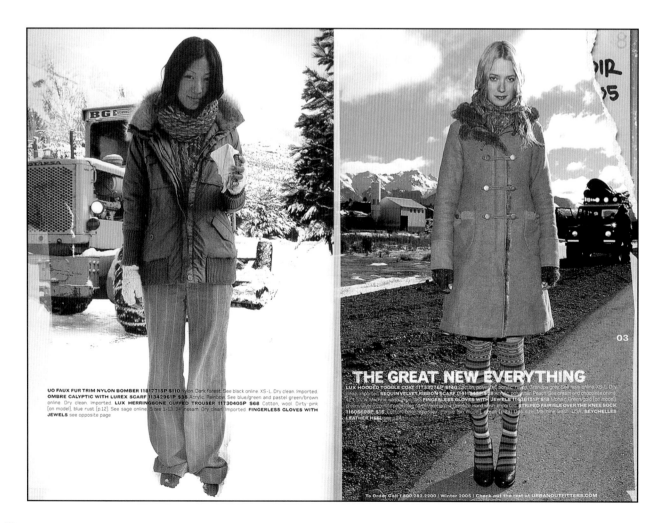

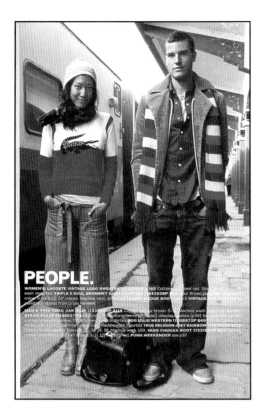

PEOPLE.

WOMEN'S LACOSTE VINTAGE LOGO SWEATER 11233283P $165 Cotton, enamel red. Size XS-XL. Machine wash. Imported. TRIPLE 5 SOUL GROMMET SASH CLLDI1289 11642628P $10 Wool. Brown plaid. See sapphire online. Sizes 0-12. 20" inseam. Machine wash. Imported. LOAFER WEDGE BOOT see p.6 VINTAGE HAT available in stores from Urban Renewal.

MEN'S: FINE-CORD CAR COAT 11539051P $119 Cotton, orange brown. S-XL. Machine wash. Imported. RUGBY STRIPE SCARF 11438827P $30 Acrylic, navy/coral/orange/ice model, olive/aqua/yellow (p.58). See steel brown/tan and tan-grey/navy online. 71" long. Hand wash. Imported. BDG SOLID WESTERN 11209972P $49 Cotton, carbon (on model, online (p.4)). See brown online. S-XL. Machine wash. Imported. TRUE RELIGION JOEY RAINBOW 11633939P $310 Cotton, muddy waters. Sizes 30, 32, 33, 34, 38. Machine wash. USA. VANS CHUKKA BOOT 11210892P $60 Cotton, rubber. Grey white and half sizes 8, 9, 11, 12. Imported. PUMA WEEKENDER see p.67

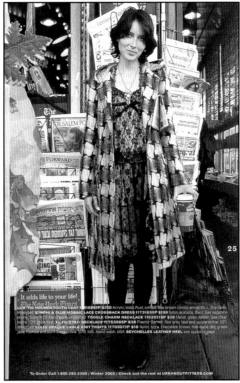

LUX '70s HOUNDSTOOTH COAT 11811688IP $150 Acrylic, wool. Rust, combo. See brown combo online. XS-L. Dry clean. Imported. KIMCHI & BLUE MOSAIC LACE CROSSBACK DRESS 11731635P $198 Nylon, acetate. Black. See sapphire online. Sizes 2-13. Hand wash. Imported. TOGGLE CHARM NECKLACE 11639318P $28 Metal, glass. Amber. See clear below. 27" imported. XL FACETED NECKLACE 11753985P $38 Plastic. Garnet. See grey, teal and purple online. 20". Imported. SOLID OPAQUE CABLE KNIT TIGHTS 11703071P $18 Nylon, lycra. Chocolate brown. See apple red, green, jade, fuschia and emerald online. S/M, M/L. Hand wash. USA. SEYCHELLES LEATHER HEEL see opposite page.

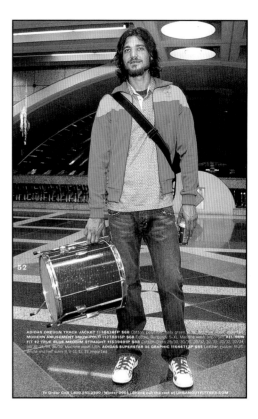

ADIDAS OREGON TRACK JACKET 11354748IP $68 Cotton, poly. Kelly green. See navy/white online. S-XL. Machine wash. Imported. MODERN AMUSEMENT SNOW POLO 11278151P $68 Cotton, navy. S-XL. Machine wash. Imported. ALL-90% FIT #2 TRUE BLUE MEDIUM STRAIGHT 11534491P $88 Cotton. Sizes 28/30, 30/30, 30/32, 32/32, 33/34, 34/32. 34" inseam. 96.0% Machine wash. USA. ADIDAS SUPERSTAR 35 GRAPHIC 11644712P $85 Leather, rubber. Multi, white and half sizes 9, 9-11, 13. Imported.

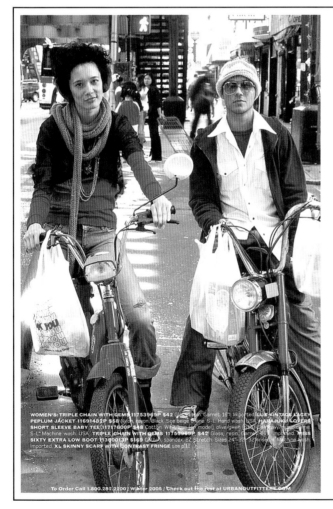

WOMEN'S: TRIPLE CHAIN WITH GEMS 11753969P $42 Glass, resin. Garnet. 16". Imported. LUX VINTAGE LACEY PEPLUM JACKET 11691482P $58 Nylon, rayon. Black. See beige online. S-L. Hand wash. USA. HARAJUKU LOVERS SHORT SLEEVE BABY TEE 11717600P $48 Cotton. White (on model), olive/gwen (p.41). See navy/love online. S-XL. Machine wash. USA. TRIPLE CHAIN WITH GEMS 11753969P $42 Glass, resin. Garnet. 16". Imported. MISS SIXTY EXTRA LOW BOOT 11390013P $169 Calfa, spandex. Stretch. Sizes 24"-32" inseam. Machine wash. Imported. XL SKINNY SCARF WITH CONTRAST FRINGE see p.13

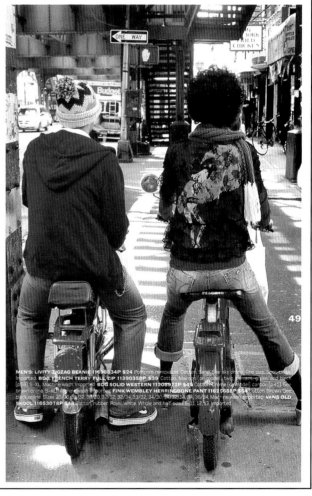

MEN'S: LIVITY ZIGZAG BEANIE 11698834P $24 Pompom removable. Cotton. Sand. See sky online. One size. Spot clean. Imported. BDG FRENCH TERRY FULL ZIP 11390358P $39 Cotton. Maroon (on model, two), emerald-green and black (p.59). S-XL. Machine wash. Imported. BDG SOLID WESTERN 11209972P $49 Cotton, chino (corroded), carbon (p.4). See brown online. S-XL. Machine wash. Imported. FINK WEMBLEY HERRINGBONE PANT 11620688P $54 Cotton. Brown. See black online. Sizes 30/30, 30/32, 32/30, 32/32, 32/34, 33/32, 34/30, 34/32, 34/34. 36/32, 36/34. Machine wash. Imported. VANS OLD SKOOL 11653078P $48 Cotton, rubber. Royal/white. Whole and half sizes 8-13, 12, 13. Imported.

This might be called the catalog of the non-posed pose or the un-modeling model. Participants stand, face the camera (usually) and smile. Locations range from gritty city streets, to train platforms, to snow filled mountain roads (complete with snow plow).

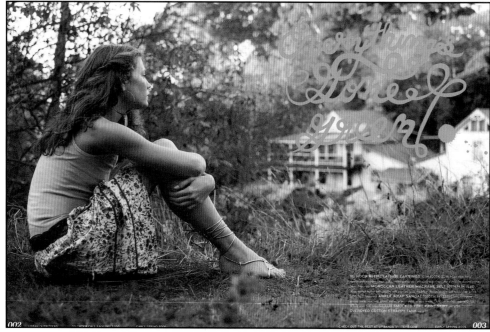

The cover and first inside spread hold masses of greenery. The copy reads, "Everything's Gone Green."

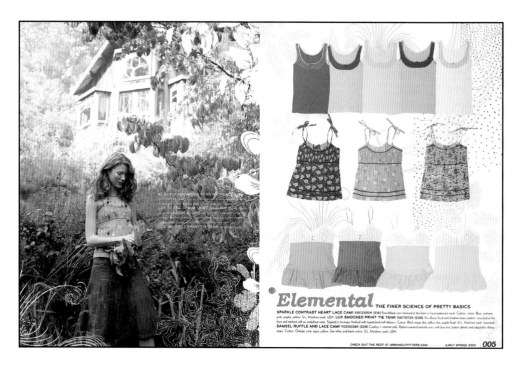

Urban Outfitters

Apparel and accessories

MEDIA: catalog
DIMENSIONS: 8" x 10½"
PAGES: 68
WEBSITE: www.urbanoutfitters.com

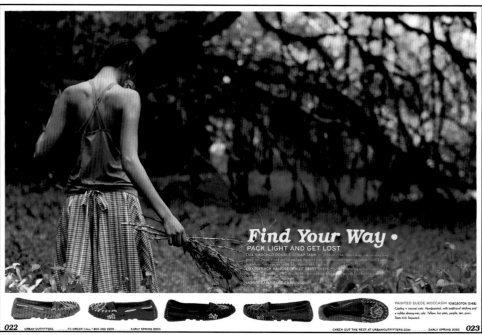

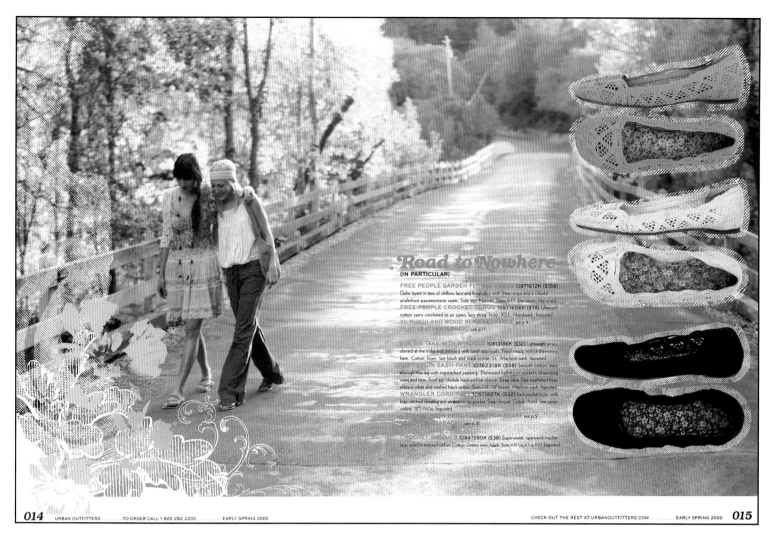

Road to Nowhere
(IN PARTICULAR)

FREE PEOPLE GARDEN FLORAL DRESS 10971612K ($158) Girlie layers in tiers of chiffon, lace and floral silk – with sheer straps and a colorful underbust passimenterie seam. Side zip. Natural. Sizes 0-12. Dry clean. Imported.
FREE PEOPLE CROCHET SHRUG 10971604K ($78) Ultra-soft cotton yarns crocheted to an open, lacy shrug. Ivory. XS-L. Handwash. Imported.
XL KUKUI AND WOOD BEAD NECKLACE see p.4
FLAT LEATHER SANDAL see p.17

LUX BIB TANK WITH APPLIQUE 10813186K ($32) Lightweight jersey, shirred at the yoke and detailed with tonal appliqués. Fixed straps, with a drawstring hem. Cotton. Ivory. See blush and black online. S-L. Machine wash. Imported.
LUX SATIN SASH PANT 10762318K ($58) Smooth cotton, easy through the leg with topstitched seaming. Distressed half-moon pockets, drawstring waist and hem, front zip, double hook-and-bar closure. Deep olive. See weathered blue, antique white and washed black online. Sizes 1-13. 32" inseam. Machine wash. Imported.
WRANGLER CORD TOTE 10801827K ($32) Back pocket tote, with logo-stitched detailing and an interior zip pocket. Snap closure. Cotton. Pond. See camel online. 12½-15½"w. Imported.
WOVEN PRINT DRAWSTRING SCARF see p.9
PAISLEY BANDANA see p.18

CROCHET SKIMMER 10847580K ($38) Super-sweet, openwork crochet laces soled in textured rubber. Cotton. Green, ivory, black. Sizes 6-10 (no 6.5 or 9.5). Imported.

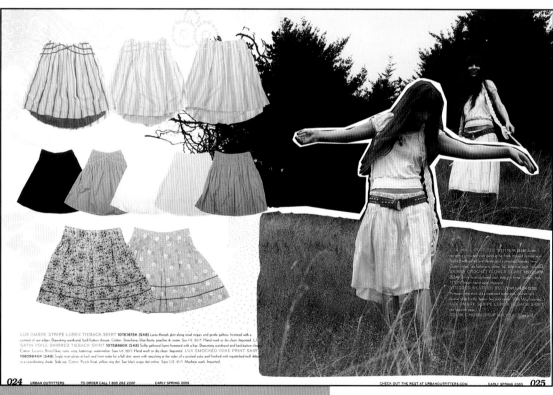

LUX OMBRE STRIPE LUREX TIEBACK SKIRT 10761815K ($48) Lurex threads glint along tonal stripes and gentle gathers, hemmed with a contrast of raw edges. Drawstring waistband, back button closure. Cotton. Strawberry, blue frost, peaches & cream. Sizes 1-13. 16½". Hand wash or dry clean. Imported. LUX SATIN VOILE SHIRRED TIEBACK SKIRT 10758860K ($48) Softly spritzed layers hemmed with a kiss. Drawstring waistband and back button closure. Cotton. Licorice, Brazil blue, nutre, ivory, buttercup, watermelon. Sizes 1-13. 22½". Hand wash or dry clean. Imported. LUX SMOCKED YOKE PRINT SKIRT 10809846K ($48) Single inset pleats at back and front make for a full skirt, sewn with smocking at the sides of a peaked yoke and finished with topstitched twill ribbon in a coordinating shade. Side zip. Cotton. Purple floral, yellow ring dot. See black ivory dot online. Sizes 1-13. 16½". Machine wash. Imported.

LUX VOILE PUFF TEE 10711767K ($38) Ivory voile puff to the waist panel at the front. Imported in crystal to finish it with pull and an easement of a smocked, rounded hem. Cotton. Ivory. Green online. See ballet pink online. S-L. Machine wash. Imported. SHIRRED CROCHET FLOWER SCARF 10972537K ($24) ... Sizes 1-13. Hand wash... Imported. STUDDED WESTERN BELT 10841628K ($30) ... LUX OMBRE STRIPE LUREX TIEBACK SKIRT ... DOUBLE HORN DROP NECKLACE see p.11

Location plays an important role in this early spring catalog from Urban Outfitters. The location in question being a lushly-green mountain retreat—perhaps reminiscent of a carefree summer camp. The company is, after all, geared to the very young. The designers beautifully combine this idealized locale with the add-on graphics and line illustrations that appear in most of the company's creative output.

61

Barneys New York

Specialty Store

MEDIA: direct mail
DIMENSIONS: 5½" x 7"
12-panel accordion fold
WEBSITE: www.barneys.com

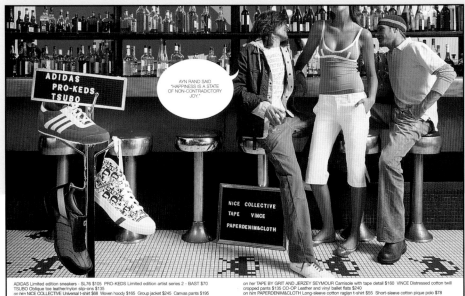

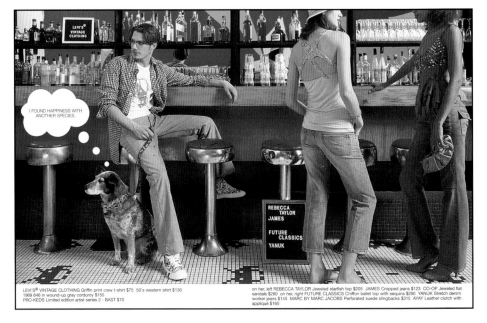

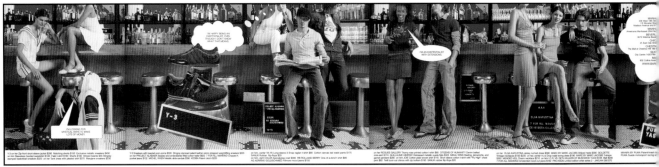

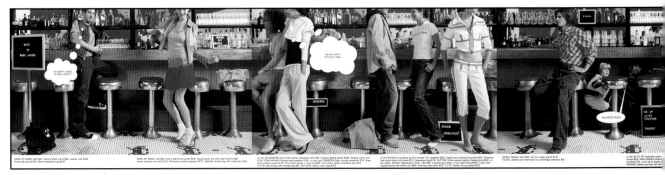

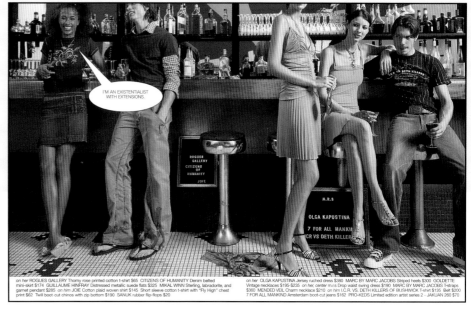

on her ROGUES GALLERY Thorny rose printed cotton t-shirt $65 CITIZENS OF HUMANITY Denim belted mini-skirt $174 GUILLAUME HINFRAY Distressed metallic suede flats $325 MIKAL WINN Sterling, labradorite, and garnet pendant $285 on him JOIE Cotton plaid woven shirt $145 Short sleeve cotton t-shirt with "Fly High" chest print $62 Twill boot-cut chinos with zip bottom $190 SANUK rubber flip-flops $20

on her OLGA KAPUSTINA Jersey ruched dress $380 MARC BY MARC JACOBS Striped heels $300 GOLDETTE Vintage necklaces $195-$235 on her, center m.r.s Drop waist swing dress $190 MARC BY MARC JACOBS T-straps $360 MENDED VEIL Charm necklace $210 on him I.C.R. VS. DETH KILLERS OF BUSHWICK T-shirt $135 Belt $200 7 FOR ALL MANKIND Amsterdam boot-cut jeans $162 PRO-KEDS Limited edition artist series 2 - JAKUAN 260 $70

Barneys is so New York and this direct mail piece is so Barneys with its cooler than thou attitude. Here the retailer presents its designer clothing at a never-ending bar, complete with beautiful young New Yorkers, their dogs and their thought balloons. (The thought balloons also appear on the envelope the piece was mailed in.) The hipsters' "thoughts" range from the philosophical, to the hilarious, to the mundane.

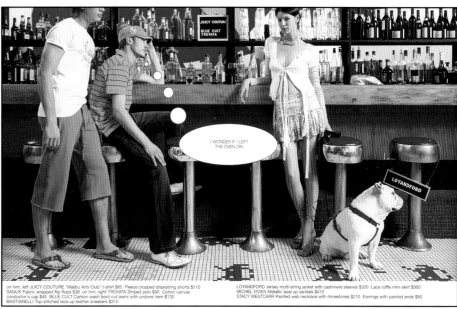

on him, left JUICY COUTURE "Malibu Arts Club" t-shirt $65 Fleece cropped drawstring shorts $110 SANUK Fabric wrapped flip-flops $38 on him, right TROVATA Striped polo $90 Cotton canvas conductor's cap $45 BLUE CULT Carbon wash boot-cut jeans with undone hem $130 BASTIANELLI Top-stitched lace-up leather sneakers $315

LOYANDFORD Jersey multi-string jacket with cashmere sleeves $320 Lace ruffle mini-skirt $300 MICHEL VIVIEN Metallic lace-up sandals $410 STACY WESTCARR Painted web necklace with rhinestones $210 Earrings with painted ends $80

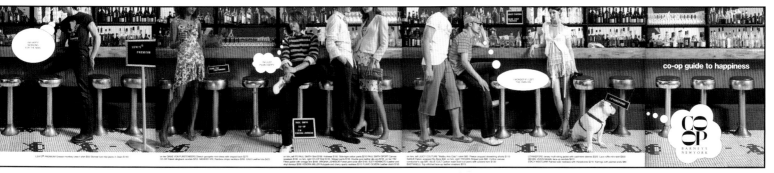

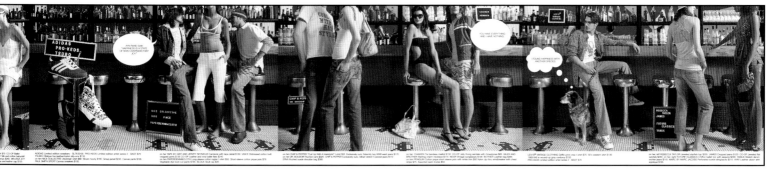

The Galeries Victoria

Students from an acting school were enlisted to portray whimsical scenarios or vignettes throughout this catalog from The Galeries Victoria, a shopping center in Sydney. Pushing the melodrama factor way past strict realism makes for a lighthearted mood and a fun read.

Shopping center

MEDIA: catalog
AGENCY: Cumming Agency & Studios Pty, Sydney, Australia
DIMENSIONS: 7 3/4" x 7 3/4"
PAGES: 14
WEBSITE: www.tgv.com.au

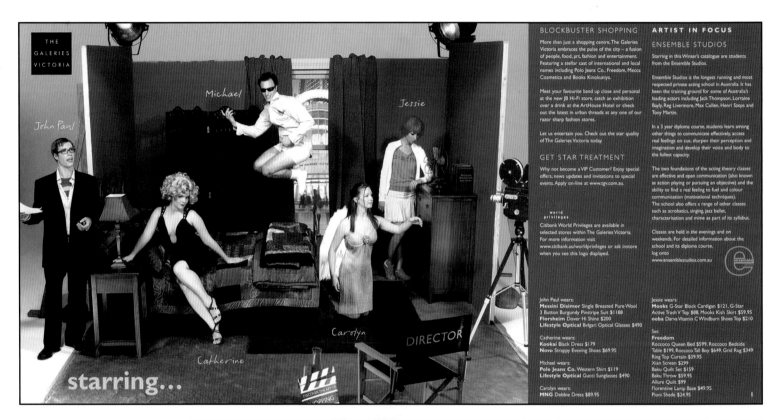

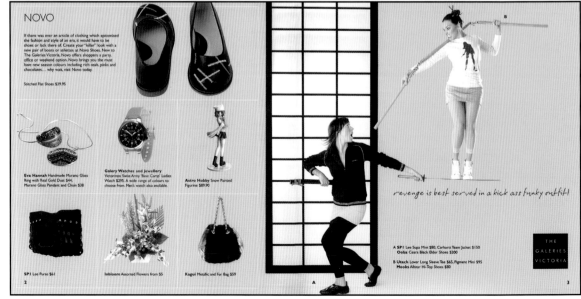

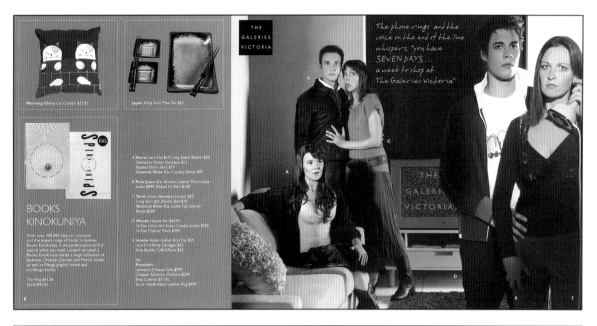

Morning Glory Cat Cushion $15.95

Japan City Sushi Plate Set $65

BOOKS
KINOKUNIYA

With over 300,000 titles on one level and the largest range of books in Sydney, Books Kinokuniya is the perfect place to find exactly what you need. Located on Level 2, Books Kinokuniya stocks a large collection of Japanese, Chinese, German and French books as well as Manga graphic novels and art/design books.

The Ring $41.36
Spiral $42.03

A **Koom** Lace Top $15, Long Sleeve Bolero $30
Diamante Flower Necklace $15
Beaded Ethnic Skirt $79
General Shoe Co. Cowboy Boots $90

B **Polo Jeans Co.** Brixton Leather Motorcycle Jacket $999, Ribbed LS Shirt $149

C **Temt** Green Sleeveless Jumper $20
Long Skirt $25, Woven Belt $10
General Shoe Co. Ladies Full Leather Boots $200

D **Mooks** Hanna Tee $44.95
G-Star Union Art Sweat Combat Jacket $286
G-Star Charter Pants $300

E **Insane** Halter Gather Bust Top $29
Lace Trim Wrap Cardigan $25
Strip Buckle Cuffed Pants $25

Set:
Freedom
Lawrence 2 Seater Sofa $999
Chequer Television Platform $299
Beta Cushion $31.95
Sioux Handknotted Leather Rug $499

6
7

Legally
fabulous

MNG Camisa Top $99.95
Falda Satin Skirt $119.95
Novo Stitched Pointed Toe Shoes $49.95
Lifestyle Optical Versace Glasses $449.95
Ties & Things Pink Bag $49.95

Anshin Dermalogica Multi Vitamin Power Recovery 74ml $66, Daily Microfoliant 74ml $73

Just Beautiful Payot Bi-Phase Eye & Lip Make-Up Remover $55.35, Hydravit Original $92.40, Lightening Toner $65.10

Mecca Cosmetica
Stila Lip Glaze $45, Lip Pot $35, Rouge Pot $40

The Perfume Connection
Cinema by Yves Saint Laurent 50ml $128
Ruby Lips by Salvador Dali 100ml $116

Alaylah Hair Design Nak Aqua Hydrating Shampoo $19.50, Conditioner $19.50

MNG

Strut out on the red carpet in something gorgeous from MNG. Indulge in their new 2005 Autumn Winter collection and discover the latest fashion trends for jeans, t-shirts, accessories, sportswear as well as evening and suiting. Add a sophisticated note to your wardrobe and enjoy a range of warm and earthy colours, or neutral colouring in taupe, smoke, stone and the omni-present black. Don't forget an item to attract attention – passion red.

ARTIST IN FOCUS

ART AND TECHNOLOGY
OF MAKE-UP COLLEGE

The make-up throughout this catalogue has been specially created by the Art and Technology of Make-up students Suzanne Ozolins and Lily Sharp.

Established in 1966, the Art and Technology of Makeup College (3 Arts Make-up Centre) is the longest running professional make-up college in Australia with a world class reputation in the industry.

The aim of the College is to supply the film, television, theatre, special effects and fashion industries with well educated and trained personnel who are constantly striving for excellence and innovation and who are capable of making Australia the world leader in make-up and effects technology. Leading Make-up Artists not only teach at the College; they also contribute to the development of the course curriculum, ensuring the courses are relevant to industry standards.

For detailed information about full and part time courses and opportunities, please log on to www.makeupeffectscollege.com

8
9

JB HI-FI

If you're in need of an adrenalin rush then slink into the brand new 1,000 square metre JB Hi-Fi store. You'll be overcome by the enormous range of digital stuff, digital video, compact and SLR cameras, plus over 50,000 CDs and 5,000 DVDs. And, if you want Hi-Fi to go, choose from an extensive collection of simple personal CD players, through to MP3s, with and without hard drives, to mini disc players, headphones, tapes and accessories – it's the place to go!

Reservoir Dogs Collector's Edition DVD $12.98
Pulp Fiction Collectors Edition CD $26.99

A **Messini** diaimor Black Pure Wool 3 Piece Suit $1588, Silk Tie $148
Leone Italy Leone Double Cuff Shirt $125
Lifestyle Optical Ray-Ban Aviator Sunglasses $186

B **Messini** diaimor 2 Piece Pinstripe Suit $1298, Silk Tie $148
Leone Italy Arturo Scarpetta Double Cuff Shirt $185
Lifestyle Optical Ray-Ban Sunglasses $299

C **Leone Italy** Exclusive Daniele Valente Superfine 140's Wool in Soft Pinstripe $899, Leone Double Cuff Shirt $125, Handmade Silk Ties from $49
Lifestyle Optical Ray-Ban Sunglasses $299

D **Leone Italy** Exclusive Ermisio Ottone Super 100's Wool in Bold Pinstripe Introductory price $699, Leone Double Cuff Shirt $125, Handmade Silk Ties from $49
Lifestyle Optical Ray-Ban Sunglasses $299

Leone Italy Leone Double Cuff Shirt $125

Ties & Things Silk Woven Ties $29.95 or 2 for $44.95

Florsheim Dorset Classic Imperial Shoes $200

Four perfect strangers, two suit shops and a mission to look stylish

10
11

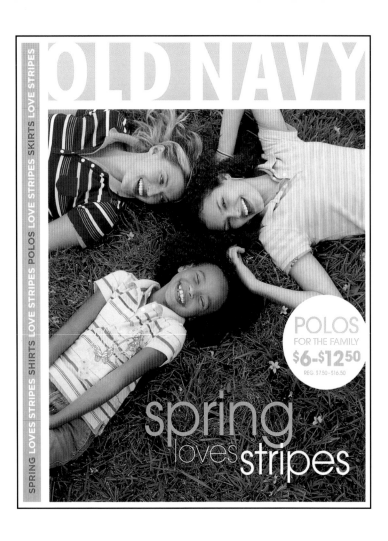

SPRING LOVES STRIPES SHIRTS LOVE STRIPES POLOS LOVE STRIPES SKIRTS LOVE STRIPES

OLD NAVY

POLOS
FOR THE FAMILY
$6-$12⁵⁰
REG. $7.50-$16.50

spring
loves stripes

Old Navy

Who doesn't love stripes? This fun
and happy insert promotes Old
Navy's fun and happy stripes for
spring. Bright colors and happy kids
bring a smile to the face.

Apparel and accessories

MEDIA: newspaper insert
DIMENSIONS: 8³/₄" x 11"
PAGES: 8
WEBSITE: www.oldnavy.com

shirts love stripes

BUTTON-FRONT SHIRTS
just $19⁵⁰

SHORTS & CAPRIS
just $19⁵⁰-$24⁵⁰

most styles also in **women's plus!**
PLUS SIZES 16-26
in select stores & online

skirts love stripes

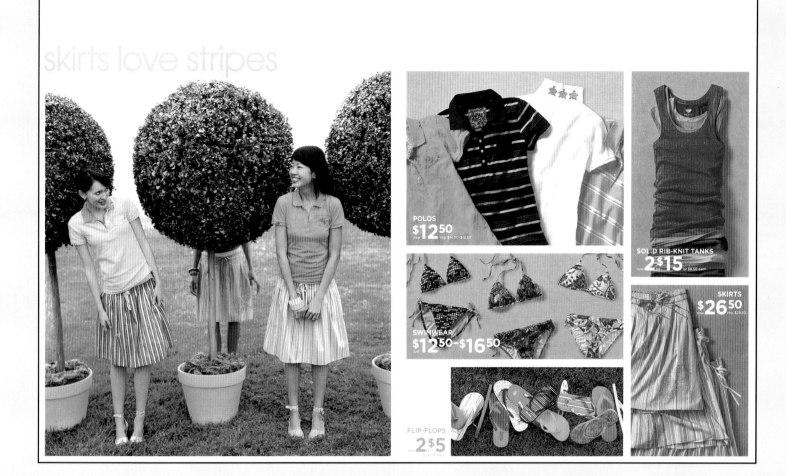

POLOS
now **$12**.50 reg. $14.50-$16.50

SOLID RIB-KNIT TANKS
2 $15
or $8.50 each

SWIMWEAR
$12.50-$16.50

SKIRTS
now **$26**.50 reg. $29.50

FLIP-FLOPS
2 $5

kids love stripes

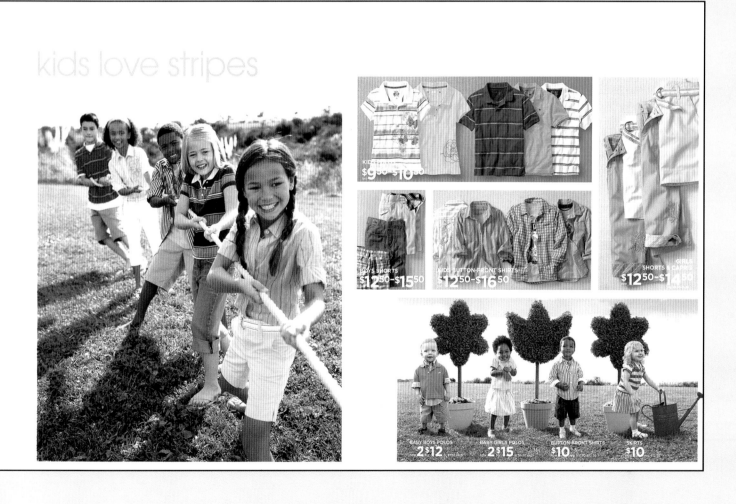

KIDS POLOS
$9.50-$10.50

BOYS SHORTS
$12.50-$15.50

KIDS BUTTON-FRONT SHIRTS
$12.50-$16.50

GIRLS SHORTS & CAPRIS
$12.50-$14.50

BABY BOYS POLOS
2 $12

BABY GIRLS POLOS
2 $15

BUTTON-FRONT SHIRTS
$10

SKIRTS
$10

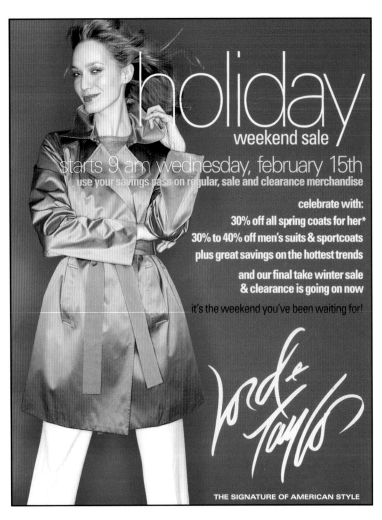

Lord & Taylor

Selling a sale can take a nasty turn: merchandise crammed into every square inch and prices screaming from every corner. Not here. Lord & Taylor uses pleasant colors, a mixture of model shots and off-figure photos and white space to create a piece that is easy on the eyes.

Specialty Store

MEDIA: direct mail
DIMENSIONS: 8½" x 10⅞" (gatefold)
WEBSITE: www.lordandtaylors.com

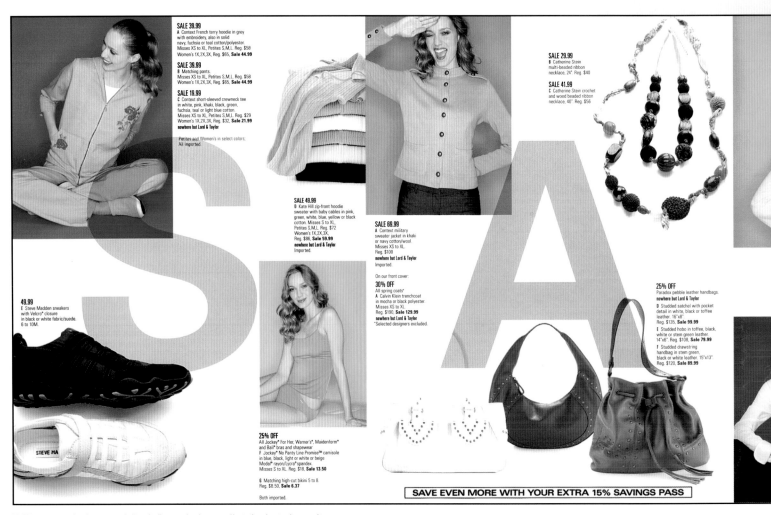

Fully opened, the word "sale" reads immediately, but doesn't overpower.

Opened once, a coupon panel and (smiling) model shot complement each other nicely.

Marshall Field's

Department Store

MEDIA: direct mail
DIMENSIONS: 8¹/₂" x 5"
PAGES: 36
WEBSITE: www.fields.com

I WILL... LOOK GREAT GET FIT FEEL ENERGIZED

Marshall Field's

EVERY 20 MINUTES

The Surgeon General advises that we exercise 3 to 4 times a week for 20 minutes to maintain good health.
And the longer you exercise the more fat you burn.

First 20 minutes: You burn 80% carbs to 20% fat.
20 to 40 minutes: You burn 50% carbs to 50% fat.
40 to 60 minutes: You burn 20% carbs to 80% fat.

If your goal is to lose weight, your exercise routine should be at least 45 minutes long.

NIKE

A. Lightweight jacket, S–XL. Nylon. 285-820652394575, $100.
B. Sphere React tank, S–XL. Polyester/spandex. 285-820652387744, $45.
C. Sphere React capris, S–XL. Polyester/spandex. 285-820652395145, $55.
Women's Active

Marshall Field's

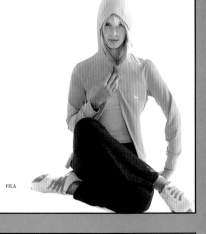

I WILL FIND HARMONY

FILA

QUICK-FIX HEARTY SOUP

Calories per serving: 148 Total fat: 3g

15-oz. can Great Northern beans
14 ½-oz. can diced tomatoes with green peppers
and onions
1 cup water

1 ⅛ tsp. dried basil
½ tsp. chicken bouillon granules
2 tsp. olive oil

Place all ingredients in medium saucepan. Bring to a boil over high heat. Reduce heat and simmer
5 minutes, uncovered. Remove from heat. Makes 4 servings.

AXCELERATE ENGINEERED BY SPEEDO

A. Zip-front vest with mesh, S–XL. Nylon/spandex. 201-827782536929, $48.
B. Midwaist boyshorts, S–XL. Micropolyester/Lycra® spandex. 201-827782537520, $46.
C. Engineered-stripe racerback halter-top, S–XL. Polyester/spandex. 201-827782539012, $46.
D. Engineered-stripe banded hipster, S–XL. Polyester/spandex. 201-827782539319, $44.
Women's Coats & Swim

Marshall Field's

I WILL FEEL ENERGIZED

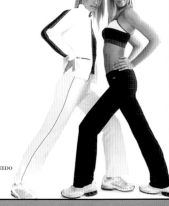

AXCELERATE ENGINEERED BY SPEEDO

GET YOUR HEART PUMPING

Aerobic exercise can be anything that keeps your heart beating fast for 30 minutes or more,
including running, fast walking, dancing, cycling and more. It's the only form of exercise where you
burn both carbohydrates and fat. Don't push yourself too hard though. A good aerobic zone allows
you to still have a conversation with a workout partner without losing your breath.

AXCELERATE ENGINEERED BY SPEEDO

A. Track jacket, S–XL. Plated polyester/cotton. 285-827782569552, $78.
B. Seamless tank, S–XL. Nylon/Lycra® spandex. 285-827782530507, $48.
C. Track pants, S–XL. Plated polyester/cotton. 285-827782569705, $58.
D. Seamless sport top, S–XL. Nylon/Lycra® spandex. 285-827782487641, $44.
E. Core pants, S–XL. Polyester/Lycra® spandex. 285-827782571562, $42.
Women's Active

Marshall Field's

I WILL BE FOCUSED

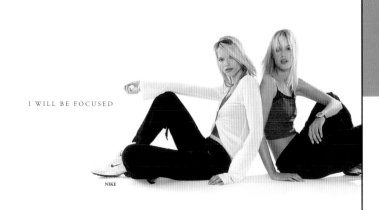

NIKE

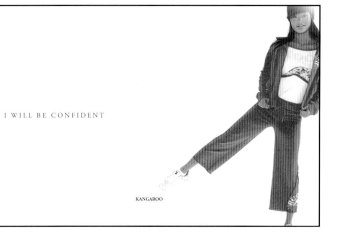

BLUEBERRY FRENCH TOAST
Calories per serving: 314 Total fat: 4g

8 slices whole grain bread
1 cup skim milk
¼ cup sugar-free maple syrup

1 tsp. cinnamon
1 cup blueberries

Cut bread slices into triangles. Arrange slices in baking pan. Combine milk, syrup and cinnamon in bowl
and pour over bread. Allow bread to soak up liquid (up to 20 minutes). Using a nonstick skillet,
heat slices until bread turns brown and crispy. Garnish with blueberries. Makes 4 servings.

JOCKEY*
A. Wrap tunic top, S–XL. Cotton/Lycra® spandex. 285-086323364326. $30.
B. Boot-leg pants with crossover waist, S–XL. Cotton/Lycra® spandex. 285-086523364449. $32.
Women's Active

Marshall Field's

I WILL BE CONFIDENT

KANGAROO

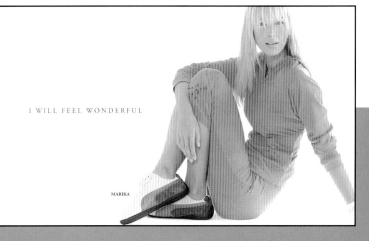

PITA SALAD SANDWICH
Calories per serving: 370 Total fat: 6.5g

2 cups Romaine lettuce, chopped
1 cup tomatoes, chopped
½ cup carrots, chopped
½ cup cucumber, chopped

1 cup fat-free cheddar cheese
2 Tbsp. fat-free Italian dressing
4 whole wheat pita pockets

Steam lettuce, tomatoes, carrots and cucumber. In bowl, mix vegetables with cheese and dressing. Stuff pitas.
If desired, warm in microwave for up to 30 seconds. Makes 4 servings.

PONY
A. Tropical jacket, S–XL. Polyester/satin. 285-885543129865. $80.
B. Short-sleeved V-neck jersey T-shirt, S–XL. Cotton. 285-885543130601. $30.
C. Tricot skirt, S–XL. Polyester. 285-885543128417. $36.
Women's Active

Marshall Field's

I WILL FEEL WONDERFUL

MARIKA

This small direct mail piece from Marshall Field's caters to the fitness-minded consumer. In recognition of the determination of this group, the retailer begins each headline (including the cover line) with the words "I will..." In addition to showing the activewear on offer, each spread includes exercise tips, healthy recipes or other fitness info. The last pages of the piece contain a chart on which a customer can track her daily training schedule, caloric intake and weight—giving her a nice incentive to keep the piece handy.

FITNESS LOG MONTH _____ MY GOAL: I WILL _____

WEEK 1

	Strength Training	Aerobic Exercise (Minutes)	Daily Caloric Intake	Weight
M	☐	☐	_____	_____
T	☐	☐	_____	_____
W	☐	☐	_____	_____
Th	☐	☐	_____	_____
F	☐	☐	_____	_____
Sa	☐	☐	_____	_____
Su	☐	☐	_____	_____

WEEK 2

	Strength Training	Aerobic Exercise (Minutes)	Daily Caloric Intake	Weight
M	☐	☐	_____	_____
T	☐	☐	_____	_____
W	☐	☐	_____	_____
Th	☐	☐	_____	_____
F	☐	☐	_____	_____
Sa	☐	☐	_____	_____
Su	☐	☐	_____	_____

Shoe retailer

MEDIA: newspaper insert
DIMENSIONS: 10⅜" x 8½"
unfolds four times
WEBSITE: www.dswshoes.com

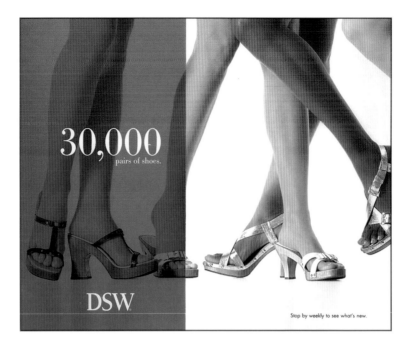

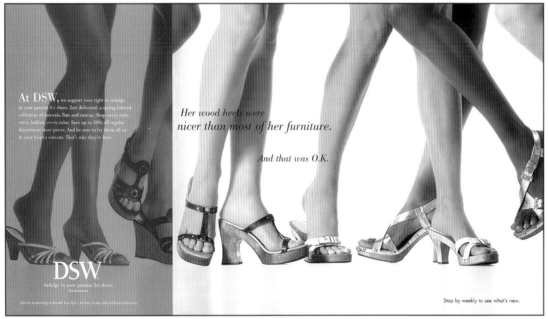

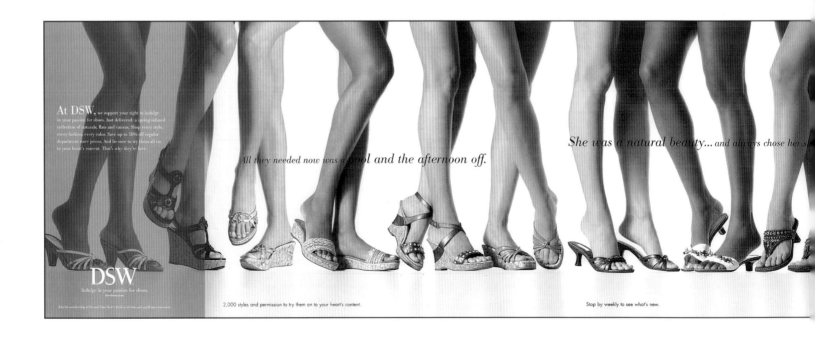

The cover of this DSW insert promises 30,000 pairs of shoes and seems to show a good number of them. No fuss or cramming required, just a long line of fashionably-clad feet. Copy is sparse, but effective. Headlines are catchy and funny but the much smaller type at the bottom of each panel is also effective selling copy. For example: "Permission to try on to your heart's content." "Stop by weekly to see what's new." "Save up to 50% off regular department store prices." and "Indulge in you passion for shoes."

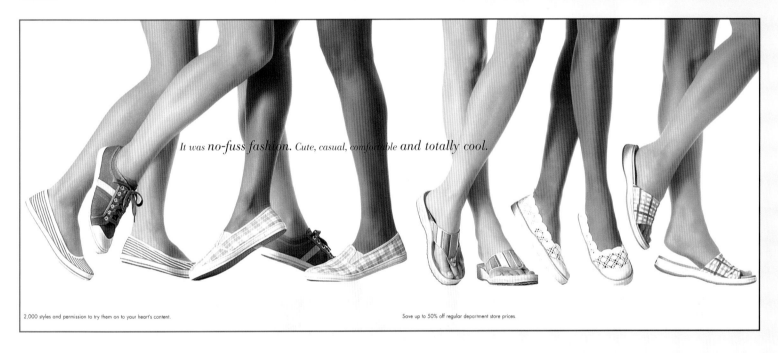

It was *no-fuss fashion*. Cute, casual, comfortable *and totally cool.*

2,000 styles and permission to try them on to your heart's content.

Save up to 50% off regular department store prices.

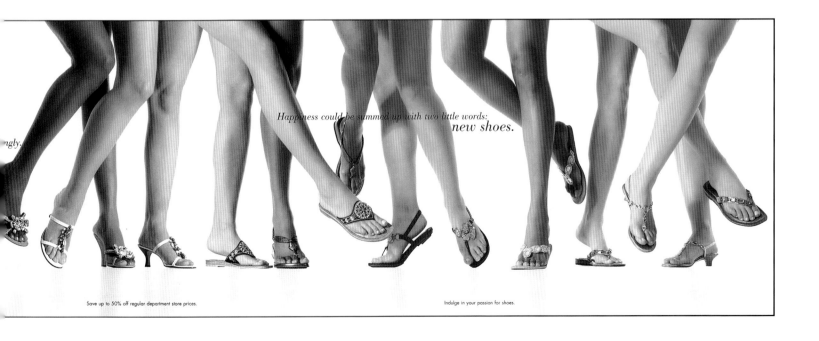

Happiness could be summed up with two little words:
new shoes.

Save up to 50% off regular department store prices.

Indulge in your passion for shoes.

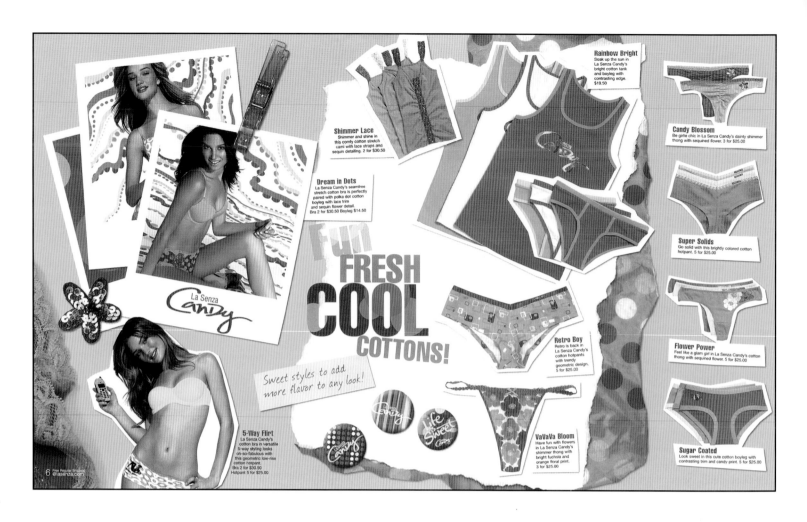

La Senza

Intimate Apparel

MEDIA: catalog
DIMENSIONS: 9" x 10¾"
PAGES: 20
WEBSITE: www.lasenza.com

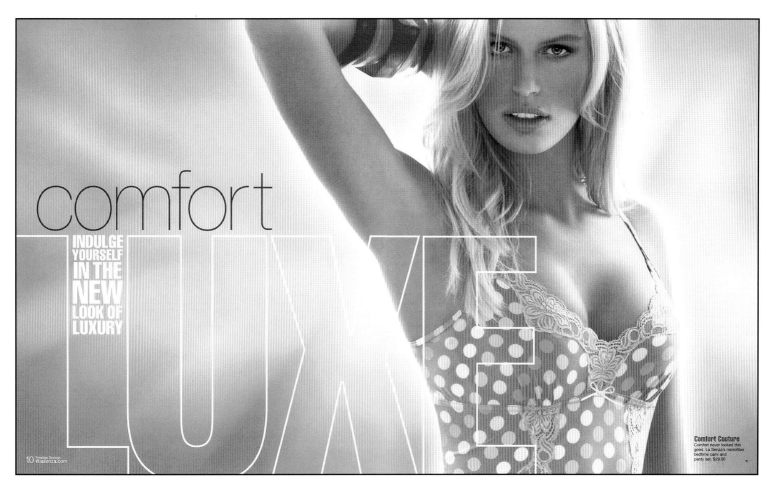

Comfort Couture
Comfort never looked this good. La Senza's microfiber bedtime cami and panty set. $29.50

La Senza gears its merchandise, and this catalog, to the young, fashion-conscious woman. Many pages, including the cover imitate the layout of a celebrity 'zine, with graphics, product shots and model photos jostling for attention. Other pages go for the pin-up look—all are in eye-popping colors.

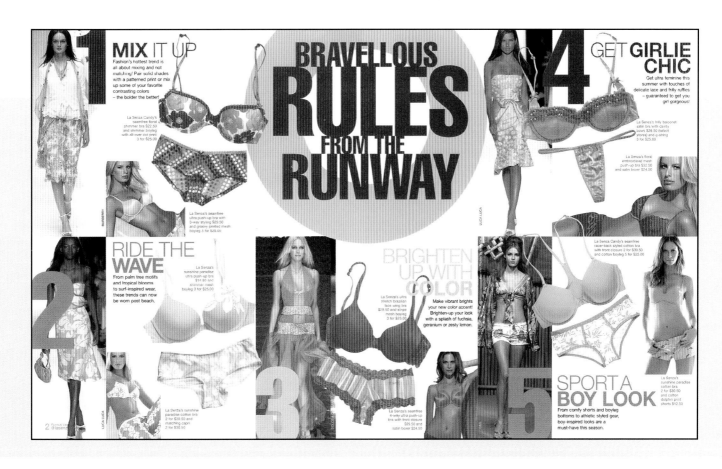

1 MIX IT UP
Fashion's hottest trend is all about mixing and not matching! Pair solid shades with a patterned print or mix up some of your favorite contrasting colors – the bolder the better!

La Senza's seamfree floral shimmer bra $22.50 and shimmer boyleg with all-over cat print 3 for $25.00

La Senza's seamfree ultra push-up bra with 3-way styling $29.50 and groovy printed mesh boyleg 3 for $25.00

BRAVELLOUS RULES FROM THE RUNWAY

4 GET GIRLIE CHIC
Get ultra feminine this summer with touches of delicate lace and frilly ruffles – guaranteed to get you girl gorgeous!

La Senza's frilly balconet satin bra with dainty bows $29.50 (select stores) and g-string 3 for $25.00

La Senza's floral embroidered mesh push-up bra $32.50 and satin boxer $24.50

La Senza Candy's seamfree racer-back styled cotton bra with front closure 2 for $30.50 and cotton boyleg 5 for $25.00

2 RIDE THE WAVE
From palm tree motifs and tropical blooms to surf-inspired wear, these trends can now be worn post beach.

La Senza's sunshine paradise ultra push-up bra $19.50 and shimmer mesh boyleg 3 for $25.00

La Senza's sunshine paradise cotton bra 2 for $30.50 and matching capri 2 for $30.50

BRIGHTEN UP WITH COLOR
Make vibrant brights your new color accent! Brighten-up your look with a splash of fuchsia, geranium or zesty lemon.

La Senza's stretch brazilian lace wing bra $19.50 and stripe mesh boyleg 3 for $25.00

3

La Senza's seamfree 4-way ultra push-up bra with front closure $29.50 and satin boxer $24.50

5 SPORT A BOY LOOK
From comfy shorts and boyleg bottoms to athletic styled gear, boy-inspired looks are a must-have this season.

La Senza's sunshine paradise cotton bra 2 for $30.50 and cotton dolphin print shorts $12.50

Hermès

Accessories

MEDIA: catalog
DIMENSIONS: 7⅝" x 10⅛"
PAGES: 24
WEBSITE: www.hermes.com

THE TIE

HERMÈS

All the things a man can do
with an Hermès tie

Lie on the ground and gaze at the sky.

Have (or think you have) a great idea every two minutes.

Forget to shave.

Look down through the airplane window

at the miniature cars creeping along in single file below.

Chew on a pencil and muse.

Be serious.

Pretend to be serious.

Pretend to be pretending to be serious.

Listen to the same CD over and over.

Nail your colors to the mast.

Go out to get the bread.

Scratch your head. Start again from scratch.

Cross the road thinking of your father.

Decide you want the tortoise pattern instead.

End up buying both patterns.

Sneak home quiet as a mouse at three in the morning.

Take time to do more sports.

Take time to fall in love.

Forget to do the shopping.

Decide not to wear it.

Decide to wear it.

Be amazed at all the things a man can do

with an Hermès tie.

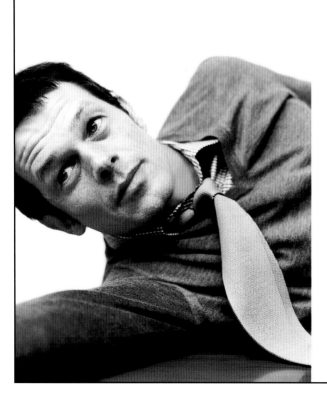

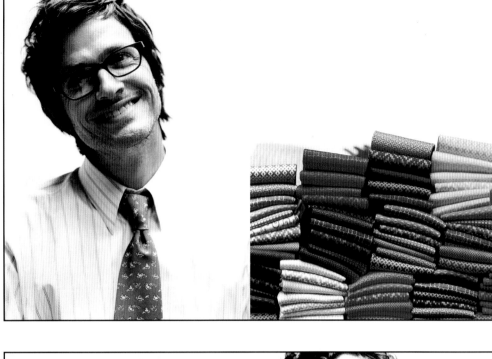

Who says ties are stuffy? Certainly not Hermès. As evidence see the drawing on the cover of the company's tie catalog. Also irreverent is the listing of all the things a man can do with a Hermés tie (both opposite page). The photography throughout—both product and model shots—is arresting.

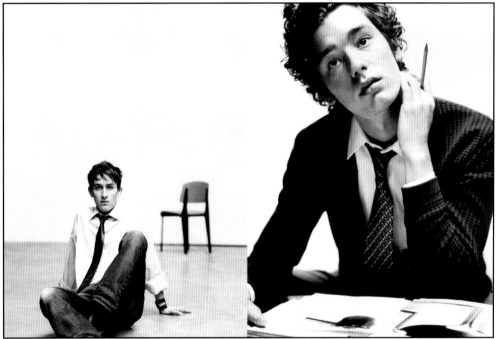

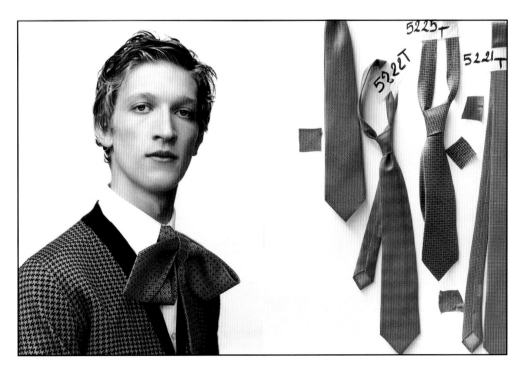

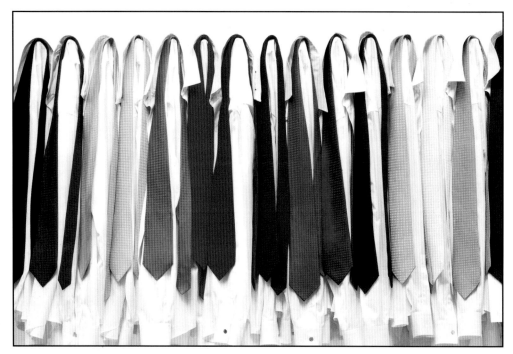

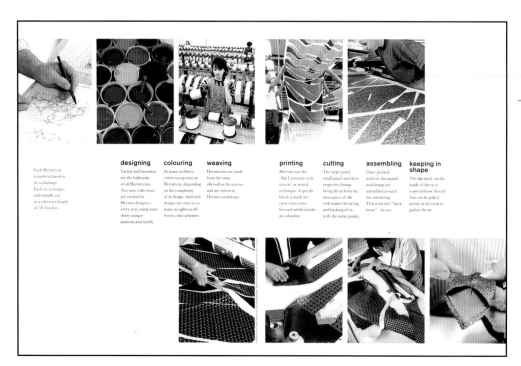

More images from the Hermès tie catalog. One spread near the end of the catalog takes viewers to the Hermès workshop in which the ties are handmade.

Each Hermès tie is made by hand in its workshops. Each tie is unique, individually cut to a reference length of 58.3 inches.

designing

Variety and invention are the hallmarks of all Hermès ties. Two new collections are created by Hermès designers every year, using some thirty unique patterns and motifs.

colouring

As many as fifteen colors can go into an Hermès tie, depending on the complexity of its design. And each design can come in as many as eighteen different color schemes.

weaving

Hermès ties are made from the same silk twill as the scarves and are woven in Hermès workshops.

printing

Hermès uses the "flat Lyonnaise-style screen" or stencil technique. A specific block is made for each color, even for such subtle details as a shadow.

cutting

The large panel, small panel and their respective linings being all cut from the same piece of silk twill makes the facing and backing of exactly the same quality.

assembling

Once printed and cut, the panels and linings are assembled around the interlining. This is the tie's "backbone" — its core.

keeping in shape

The slip stitch on the inside of the tie is a special loose thread that can be pulled gently at the ends to gather the tie.

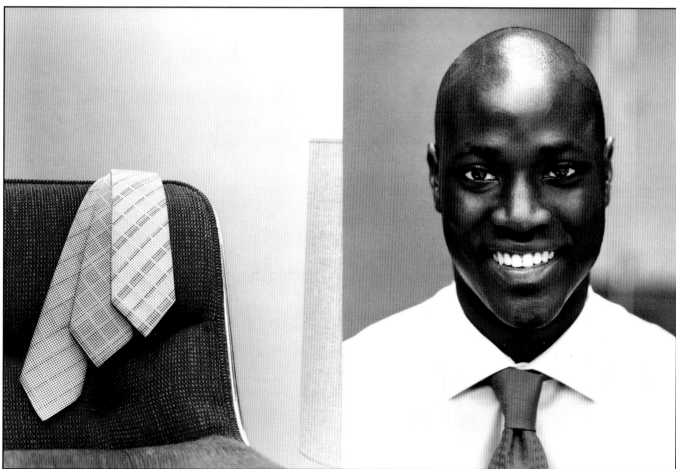

Two spreads combine product shots, ties carefully arranged on interesting furniture, and even more interesting full-face portraits.

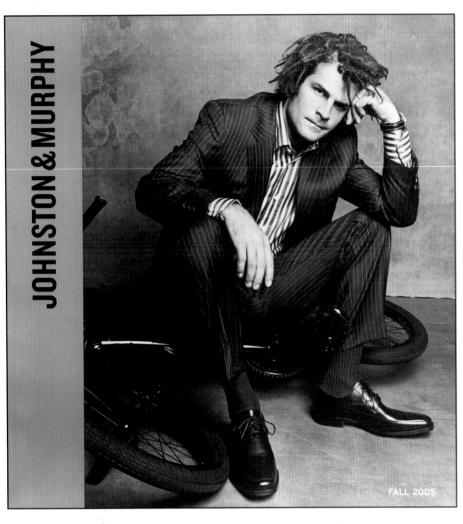

FALL 2005

JOHNSTON & MURPHY

Johnston & Murphy

Mat Hoffman, a Freestyle BMX vert rider (he's really, really good with a bicycle), provides celebrity presence for Johnston & Murphy, although, perhaps, not an obvious one. But, even if one isn't a follower of this particular sport, the incongruous shots of a man-in-a-suit on a bike certainly get attention.

Men's shoes, apparel and accessories

MEDIA: catalog
DIMENSIONS: 9" x 9¹/₂"
PAGES: 20
WEBSITE: www.johnstonmurphy.com

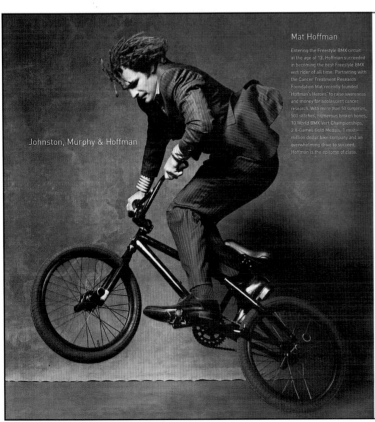

Johnston, Murphy & Hoffman

Mat Hoffman

Entering the Freestyle BMX circuit at the age of 13, Hoffman succeeded in becoming the best Freestyle BMX vert rider of all time. Partnering with the Cancer Treatment Research Foundation Mat recently founded "Hoffman's Heroes" to raise awareness and money for adolescent cancer research. With more than 50 surgeries, 500 stitches, numerous broken bones, 10 World BMX Vert Championships, 2 X-Games Gold Medals, 1 multi-million dollar bike company and an overwhelming drive to succeed, Hoffman is the epitome of class.

1 NEBEL MOC TOE
Black Italian Calf #20-6313
Antique Mahogany Italian Calf #20-6312
Leather/Rubber Outsole
Sizes (M) 8-12, 13 (W) 8-11, 12
$140

2 NEBEL BOOT
Black Italian Calf #20-6317
Antique Mahogany Italian Calf #20-6318
Leather/Rubber Outsole
Sizes (M) 8-12, 13 (W) 8-11, 12
$140

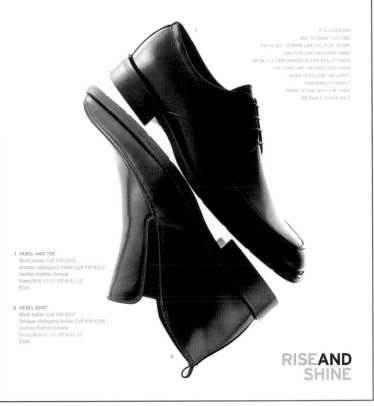

IT IS A NEW DAY
AND TO SHINE THIS TIME
YOU'VE GOT TO WORK LIKE YOU PLAY TO WIN
AND PLAY LIKE YOU WORK HARD
WE'RE ALL PERFORMERS IN THIS REALITY SHOW
THE STARS ARE THE ONES WHO KNOW
WHEN TO FOLLOW THE SCRIPT
AND WHEN TO WING IT
WHEN TO SING WITH THE CHOIR
OR TAKE A GUITAR SOLO

RISEAND
SHINE

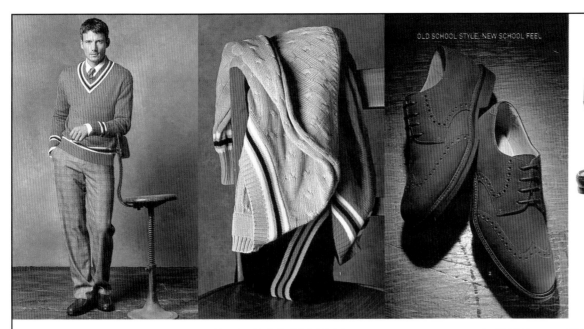

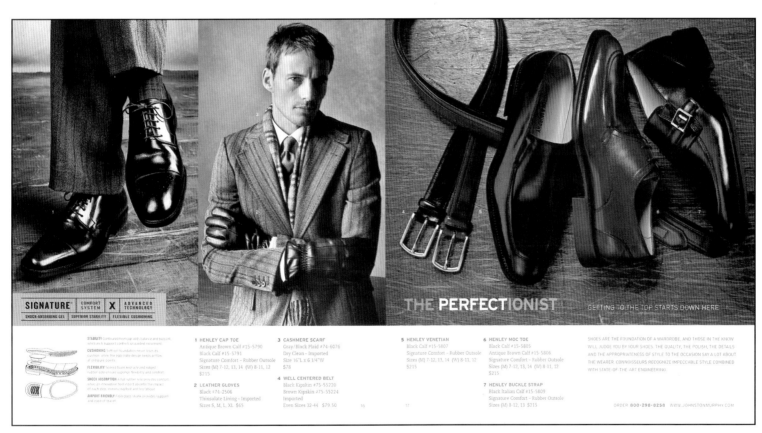

The use of color on the headlines suggests various readings and emphasizes portions of them. Two others, not shown here, were "Oxford Classics" and "Comfortably Cool" with the words "Class" and "Comfort" pulled out with color.

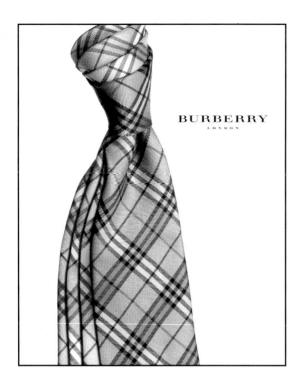

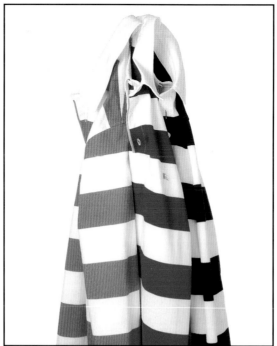

Burberry

The product and nothing but the product, please. Ample amounts of white space enclose the merchandise throughout Burberry's menswear and accessories catalog, focusing all attention onto the product. A few jackets even seem to levitate in mid air.

Apparel and accessories

MEDIA: catalog
DIMENSIONS: 8½" x 10¼"
PAGES: 24
WEBSITE: www.burberry.com

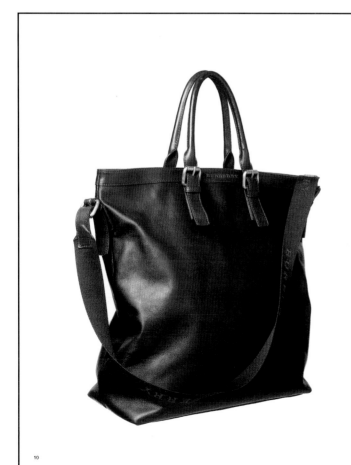

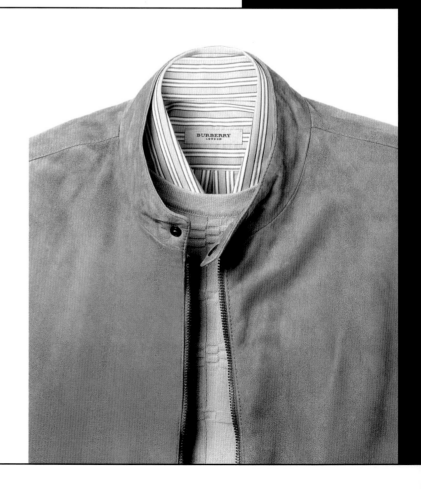

16

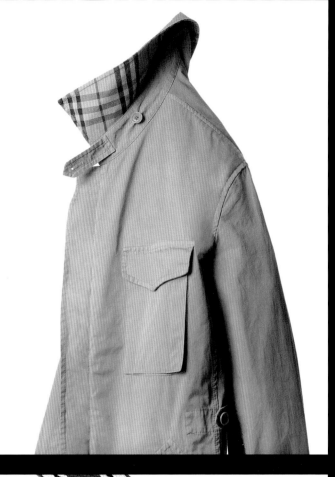

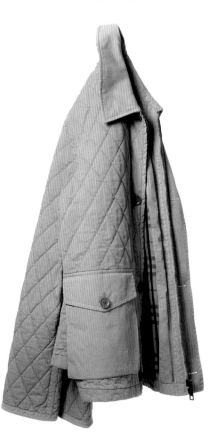

Men's Wearhouse

Menswear retailer
MEDIA: catalog
DIMENSIONS: 9" x 12"
PAGES: 16
WEBSITE: www.menswearhouse.com

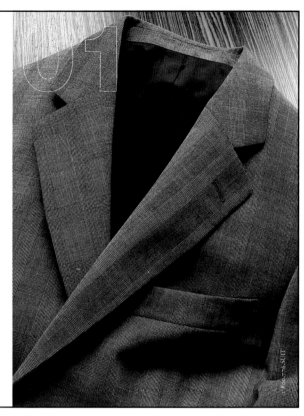

A label is the last thing that's added to any garment.

Whether it's a famous designer like Donna Karan or an invented name
that only *rhymes* with a famous designer, a garment's quality was built in—or left out—
long before the label was stitched on the lining.

Like it or not, we all have to buy clothes. Whether you wear suits or sportswear,
whether you spend a lot or a little, your wardrobe is an investment.
Given this fact, doesn't it make sense to understand a little more about the clothing you buy?
What should you look for? What should you avoid? What can you ask for?
And what should you expect?

After 30 years in the suit business, we at Men's Wearhouse have learned
the answers to these questions; the truths and the fictions. And considering that
last year we sold more suits than any other men's clothier in America,
we think the least we can do is share what we know. After all, if the clothing makes the man,
shouldn't the man know a little something about the quality of his clothing?
And whether he really got what he paid for?

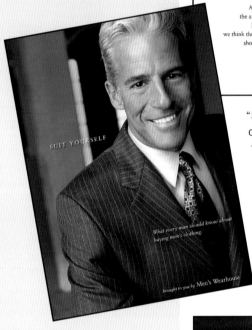

"Suit Yourself" is the instruction given on the cover of this Men's Wearhouse catalog. On the first spread (above), the retailer goes on to ask, "What's in a name?" and discusses the importance, or lack thereof, of a designer label. What emerges is a true voice, reaching out to each, individual customer. This is especially evident on small sheets of card-stock that are stapled in throughout the catalog (below). These contain information about quality, service and style.

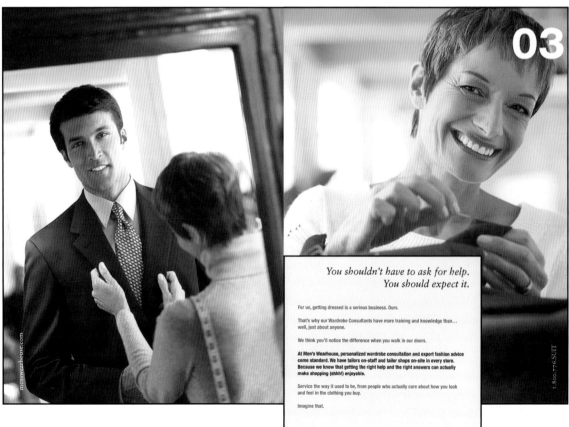

You shouldn't have to ask for help.
You should expect it.

For us, getting dressed is a serious business. Ours.

That's why our Wardrobe Consultants have more training and knowledge than...
well, just about anyone.

We think you'll notice the difference when you walk in our doors.

At Men's Wearhouse, personalized wardrobe consultation and expert fashion advice
come standard. We have tailors on-staff and tailor shops on-site in every store.
Because we know that getting the right help and the right answers can actually
make shopping (shhh!) enjoyable.

Service the way it used to be, from people who actually care about how you look
and feel in the clothing you buy.

Imagine that.

You get what you pay for.

(unless you pay too much)

Let's compare.

We shopped around.
A suit. A shirt. A polo sweater. And a tie.
Bought at well-known men's clothing stores.
Then we compared them to our own.
Three of ours versus one of theirs.

The differences were hard to find.
Except for one.

If the garments were made
for Men's Wearhouse, chances are
we sell them for less.
Without sacrificing quality.

Why?

Because when you sell more tailored clothing
than any other men's clothier in America,
you can do that.

Can you tell the difference?

All comparisons are based on regular retail prices.

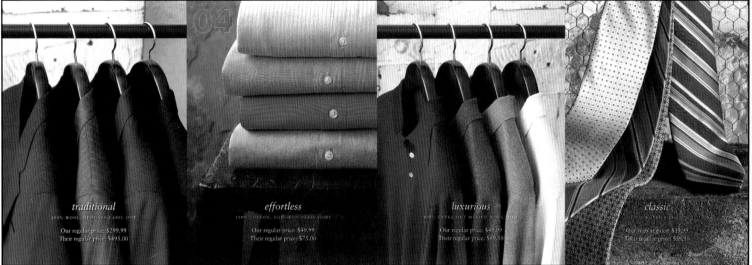

traditional
100% WOOL, DESIGNER LABEL SUIT
Our regular price: $299.99
Their regular price: $495.00

effortless
100% COTTON, NON-IRON DRESS SHIRT
Our regular price: $49.99
Their regular price: $75.00

luxurious
100% EXTRA FINE MERINO WOOL POLO
Our regular price: $49.99
Their regular price: $69.50

classic
Our regular price: $39.99
Their regular price: $59.50

Value is stressed on a gatefold in the center of the catalog.

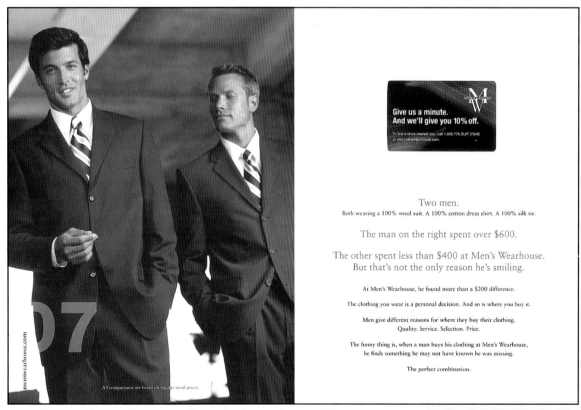

Give us a minute.
And we'll give you 10% off.

To find a store nearest you, call 1.800.776.SUIT (7848)
or visit menswearhouse.com.

Two men.
Both wearing a 100% wool suit. A 100% cotton dress shirt. A 100% silk tie.

The man on the right spent over $600.

The other spent less than $400 at Men's Wearhouse.
But that's not the only reason he's smiling.

At Men's Wearhouse, he found more than a $200 difference.

The clothing you wear is a personal decision. And so is where you buy it.

Men give different reasons for where they buy their clothing.
Quality. Service. Selection. Price.

The funny thing is, when a man buys his clothing at Men's Wearhouse,
he finds something he may not have known he was missing.

The perfect combination.

menswearhouse.com

All comparisons are based on regular retail prices.

In addition to offering 10 percent off, the final spread also reinforces the idea of quality at reasonable prices.

Antica Murrina Venezia

Glass and jewelry manufacturer

MEDIA: catalog
DIMENSIONS: 8⅝" x 8⅝"
PAGES: 44
WEBSITE: www.anticamurrinaveneziana.com

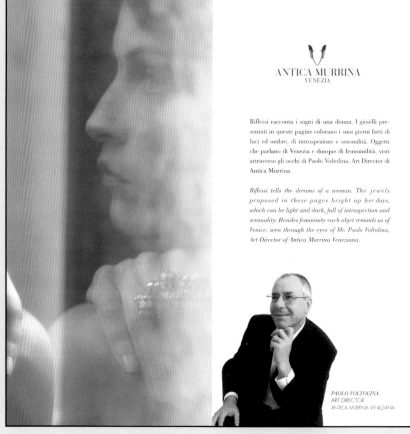

Riflessi racconta i sogni di una donna. I gioielli presentati in queste pagine colorano i suoi giorni fatti di luci ed ombre, di introspezione e sensualità. Oggetti che parlano di Venezia e dunque di femminilità, visti attraverso gli occhi di Paolo Voltolina, Art Director di Antica Murrina.

Riflessi tells the dreams of a woman. The jewels proposed in these pages bright up her days, which can be light and dark, full of introspection and sensuality. Besides femininity each objet reminds us of Venice. seen through the eyes of Mr. Paolo Voltolina, Art Director of Antica Murrina Veneziana.

PAOLO VOLTOLINA
ART DIRECTOR
ANTICA MURRINA VENEZIANA

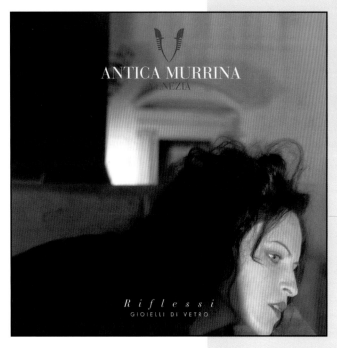

Antica Murrina, a manufacturer of colorful artistic glass, here showcases its jewelry to beautiful effect with stunning product photography and model shots. The cover, an interesting composition of light and shadow, shows no merchandise whatsoever. In an usual twist, Antica introduces the company's art director on page three of the catalog (above).

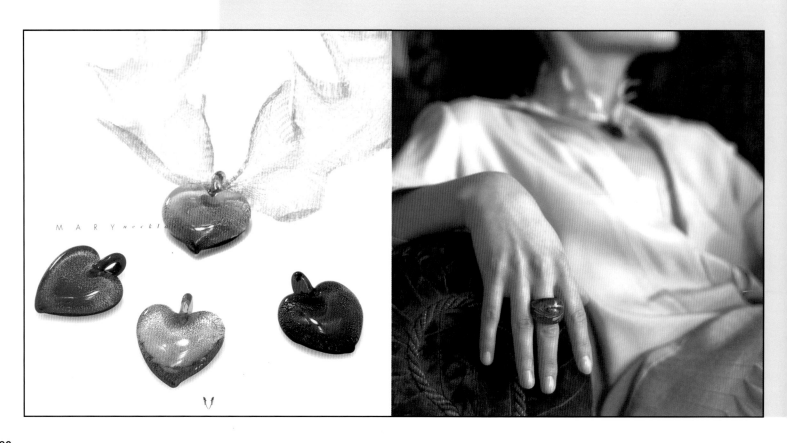

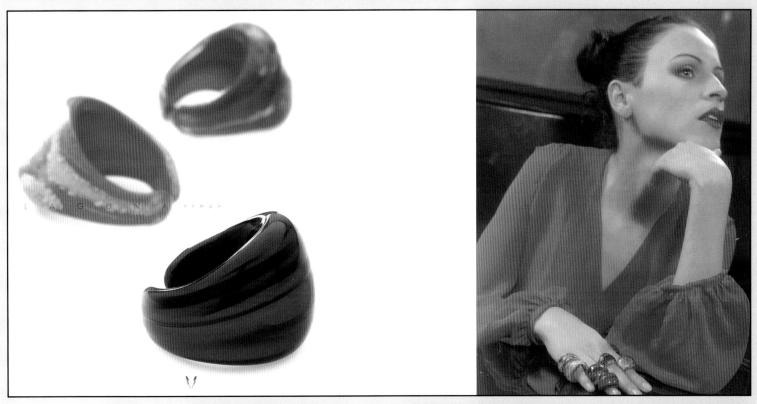

LAGUNA *rinza*

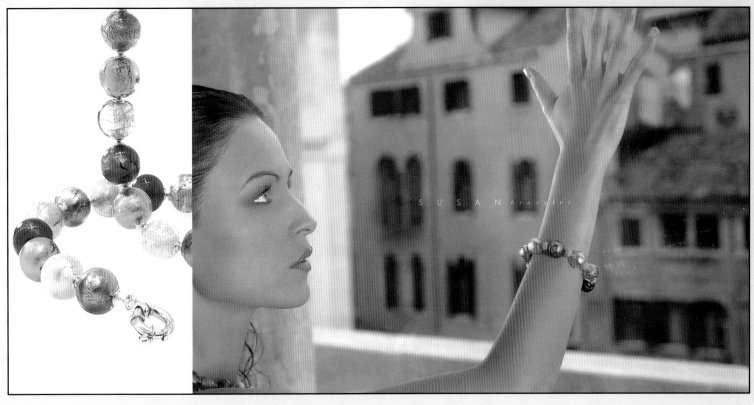

SUSAN *bracelet*

Jeweler

MEDIA: catalog
DIMENSIONS: 8 ½" x 8 ½"
PAGES: 28
WEBSITE: www.whitehalljewellers.com

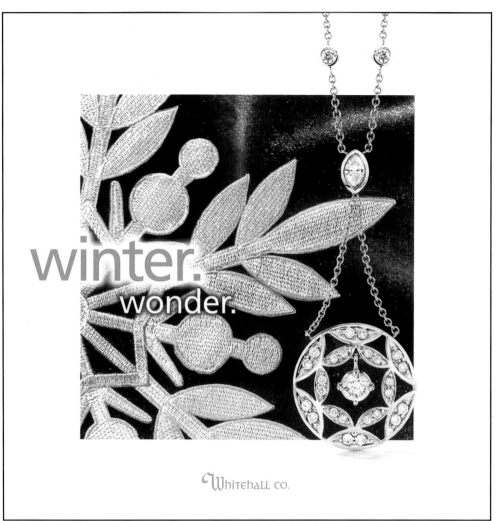

The crispness and clarity of diamonds work well with the idea of winter. Here Whitehall Co. adds in snippets of fancy needlework to decorate the cover, and also to serve as accents on the interior pages. These pages, which display multiple items, never look crowded and the mixture of sizes adds interest.

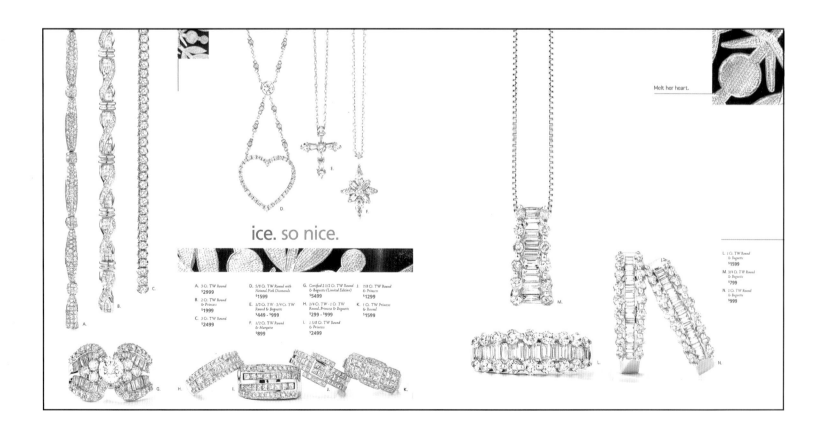

twinkle. stars.

A. Certified 1/4 Ct. – 1/2 Ct. Round
$449 – $1099

B. 1/4 Ct. TW – 1 Ct. TW
Round or Princess
$199 – $1499

C. Certified 1/4 Ct. – 1/2 Ct. Princess
$449 – $1099

D. 1/10 Ct. – 1/4 Ct. Round
$99 – $1299

E. 3/8 Ct. TW – 7/8 Ct. TW Round
$399 – $1299

F. Certified Colorless 3/8 Ct. – 1 Ct. Round or Princess
$999 – $4999

G. Certified 1/2 Ct. TW – 1 Ct. Radiant
$1599 – $4999

H. Certified 1/4 Ct. – 1 Ct. Round, Princess or Marquise
$349 – $2999

I. 1/7 Ct. TW Round
$199

WHITESTAR™ COLLECTION
J. 1/2 Ct. TW – 1 Ct. TW Princess or Round
$1299 – $6999

our whitestar™ diamond.
perfect in every detail.

everything. nice.

A. Freshwater Pearl
$399

B. Freshwater Pearl
$129

C. Freshwater Pearl & Diamond
$999

D. Freshwater Pearl & Diamond
$599

E. Freshwater Pearl & Diamond
$349

F. Freshwater Pearl & Diamond
$169

G. Freshwater Pearl & Diamond
$99

H. Freshwater Pearl & Diamond
$149

I. Freshwater Pearl & Diamond
$129

J. Freshwater Pearl & Diamond
$249

K. Freshwater Pearl & Diamond
$199

L. Freshwater Pearl & Diamond
$99

M. Freshwater Pearl & Diamond
$149

N. Freshwater Pearl
$199

O. Freshwater Pearl
$39

P. Freshwater Pearl
$49

Q. Freshwater Pearl
$69

On her list.

Rolex

Watches

MEDIA: magazine insert
DIMENSIONS: 8" x 10 7/8"
PAGES: 12
WEBSITE: www.rolex.com

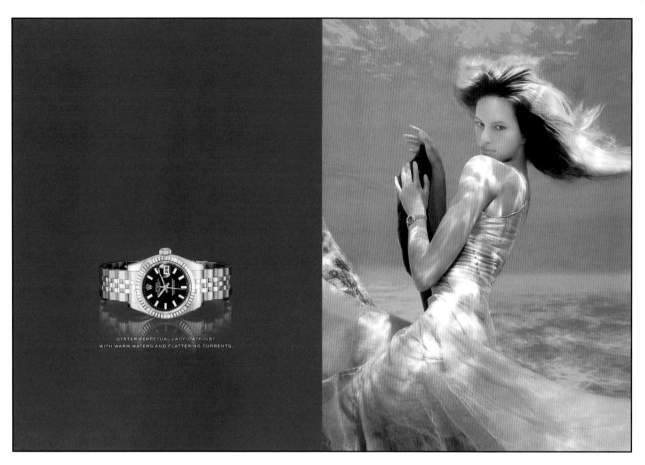

OYSTER PERPETUAL LADY-DATEJUST
WITH WARM WATERS AND FLATTERING CURRENTS.

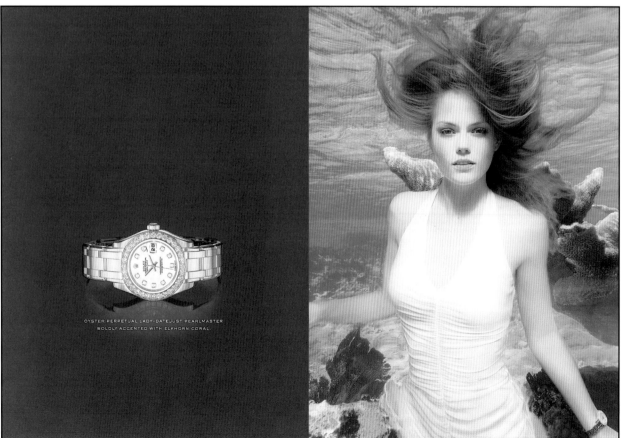

OYSTER PERPETUAL LADY-DATEJUST PEARLMASTER
BOLDLY ACCENTED WITH ELKHORN CORAL.

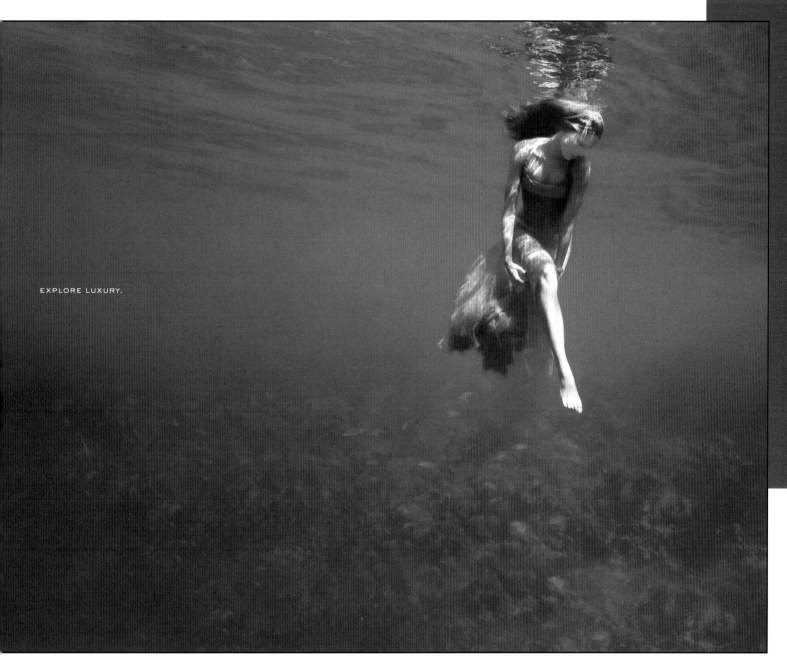

EXPLORE LUXURY.

In this magazine insert Rolex promotes its women's watches with striking underwater photography. The line of copy under each watch relates to the underwater shot with which it's paired. For instance: "…with warm water and flattering currents" is shown with a gal who appears to be sitting in an underwater current (opposite page, top) and "…boldly accented with elkhorn coral" goes with a model with bright hair and some coral over her shoulder (opposite, bottom). The last spread of the insert (above) is elegant and breathtaking.

Fine jewelry

MEDIA: catalog
DIMENSIONS: 5³/₄" x 8¹/₄"
PAGES: 16
WEBSITE: www.hoyacrystal.co.jp

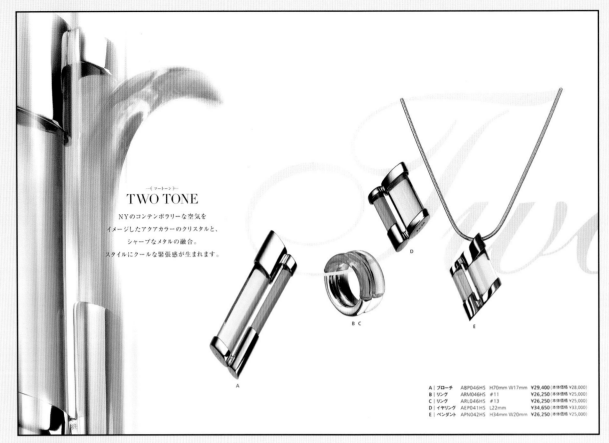

― イ ツートーント ―
TWO TONE

NYのコンテンポラリーな空気を
イメージしたアクアカラーのクリスタルと、
シャープなメタルの融合。
スタイルにクールな緊張感が生まれます。

A	ブローチ	ABP046HS	H70mm W17mm	¥29,400 (本体価格 ¥28,000)
B	リング	ARM046HS	#11	¥26,250 (本体価格 ¥25,000)
C	リング	ARL046HS	#13	¥26,250 (本体価格 ¥25,000)
D	イヤリング	AEP041HS	L22mm	¥34,650 (本体価格 ¥33,000)
E	ペンダント	APN042HS	H34mm W20mm	¥26,250 (本体価格 ¥25,000)

Various elements, both large and small, are
combined to beautiful effect in Hoya Crystal's
jewelry catalog. Merchandise dangles from
words set in large script type while large, soft-
focus shots provide color and contrast.

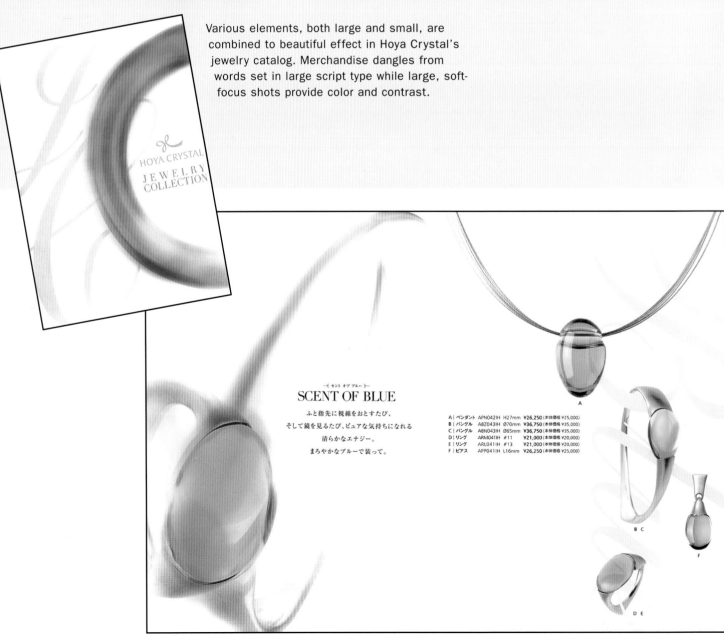

― イ セント オブ ブルー ト ―
SCENT OF BLUE

ふと指先に視線をおとすたび、
そして鏡を見るたび、ピュアな気持ちになれる
清らかなエナジー。
まろやかなブルーで装って。

A	ペンダント	APN042IH	H27mm	¥26,250 (本体価格 ¥25,000)
B	バングル	ABZ043IH	Ø70mm	¥36,750 (本体価格 ¥35,000)
C	バングル	ABN043IH	Ø65mm	¥36,750 (本体価格 ¥35,000)
D	リング	ARM041IH	#11	¥21,000 (本体価格 ¥20,000)
E	リング	ARL041IH	#13	¥21,000 (本体価格 ¥20,000)
F	ピアス	APP041IH	L16mm	¥26,250 (本体価格 ¥25,000)

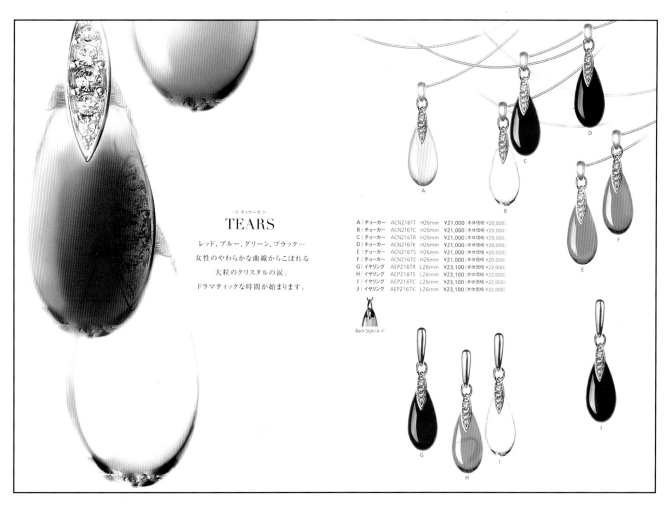

TEARS

― ティアーズ ―

レッド、ブルー、グリーン、ブラック…
女性のやわらかな曲線からこぼれる
大粒のクリスタルの涙。
ドラマティックな時間が始まります。

A	チョーカー	ACN216TT	H26mm	¥21,000（本体価格 ¥20,000）
B	チョーカー	ACN216TC	H26mm	¥21,000（本体価格 ¥20,000）
C	チョーカー	ACN216TR	H26mm	¥21,000（本体価格 ¥20,000）
D	チョーカー	ACN216TK	H26mm	¥21,000（本体価格 ¥20,000）
E	チョーカー	ACN216TS	H26mm	¥21,000（本体価格 ¥20,000）
F	チョーカー	ACN216TE	H26mm	¥21,000（本体価格 ¥20,000）
G	イヤリング	AEP216TR	L26mm	¥23,100（本体価格 ¥22,000）
H	イヤリング	AEP216TE	L26mm	¥23,100（本体価格 ¥22,000）
I	イヤリング	AEP216TC	L26mm	¥23,100（本体価格 ¥22,000）
J	イヤリング	AEP216TK	L26mm	¥23,100（本体価格 ¥22,000）

Back Style A-F

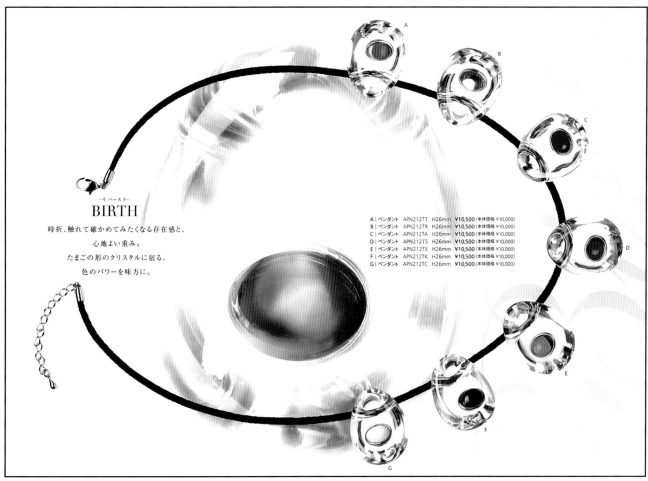

BIRTH

― バース ―

時折、触れて確かめてみたくなる存在感と、
心地よい重み。
たまごの形のクリスタルに宿る、
色のパワーを味方に。

A	ペンダント	APN212TT	H26mm	¥10,500（本体価格 ¥10,000）
B	ペンダント	APN212TR	H26mm	¥10,500（本体価格 ¥10,000）
C	ペンダント	APN212TA	H26mm	¥10,500（本体価格 ¥10,000）
D	ペンダント	APN212TS	H26mm	¥10,500（本体価格 ¥10,000）
E	ペンダント	APN212TE	H26mm	¥10,500（本体価格 ¥10,000）
F	ペンダント	APN212TK	H26mm	¥10,500（本体価格 ¥10,000）
G	ペンダント	APN212TC	H26mm	¥10,500（本体価格 ¥10,000）

Cartier

Fine jewelry

MEDIA: catalog
DIMENSIONS: 8¹/₈" x 9³/₈"
PAGES: 68
WEBSITE: www.cartier.com

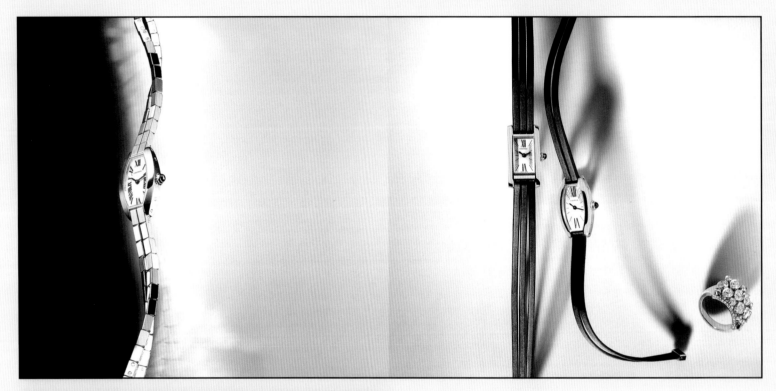

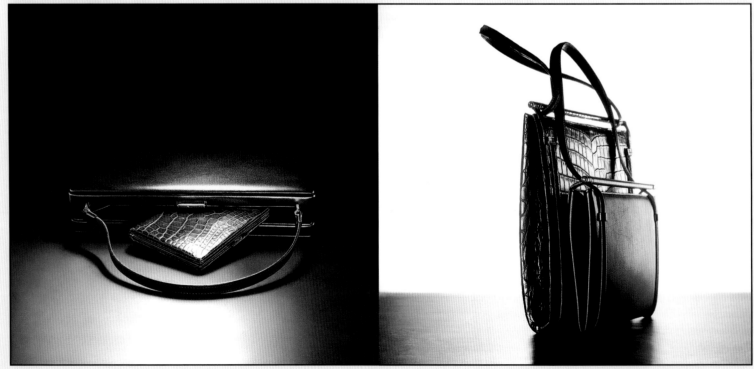

Simply irresistible! This Cartier catalog could double as a primer on how to make stunning merchandise even more alluring. Some pages burst with color while others keep a more muted palette—shadows and ghost images create unusual and beautiful shapes. But nothing pulls attention away from that merchandise.

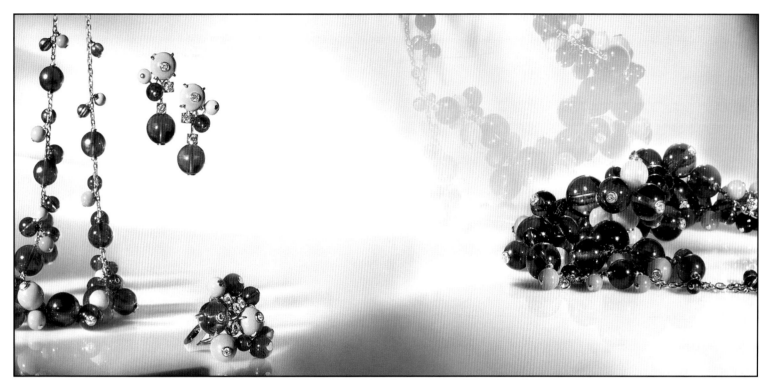

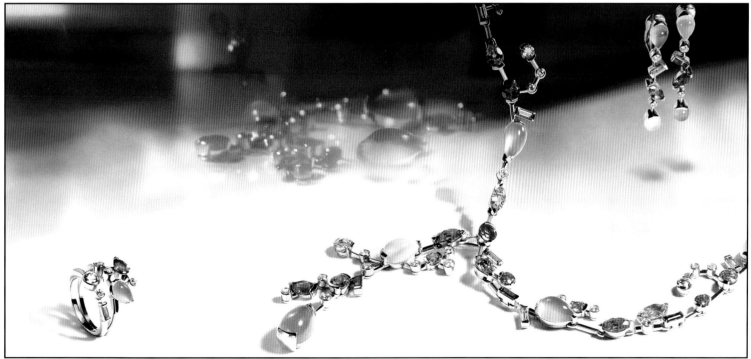

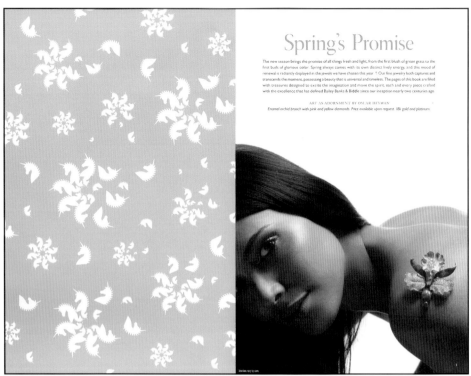

The Bailey Banks & Biddle unicorn logo forms a flower on the catalog cover (multiplied on the inside front cover) that goes spinning off into space, or at least onto the upper corner of each page.

Bailey Banks & Biddle

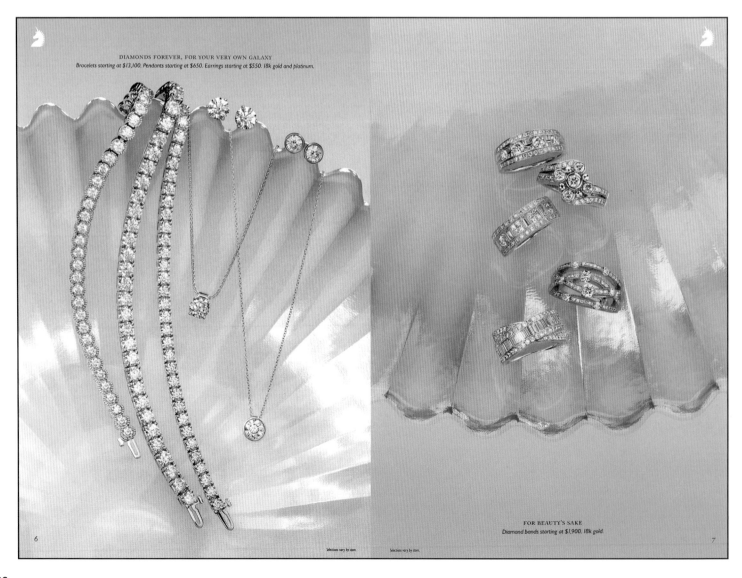

Inside the merchandise appears against beautiful and subtle backgrounds of what in places appears to be glass and … elsewhere it's not quite clear what the objects are. More importantly, the items themselves stand out.

Jeweler

MEDIA: catalog
DIMENSIONS: 6³/₄" x 10"
PAGES: 38
WEBSITE: www.baileybanksandbiddle.com

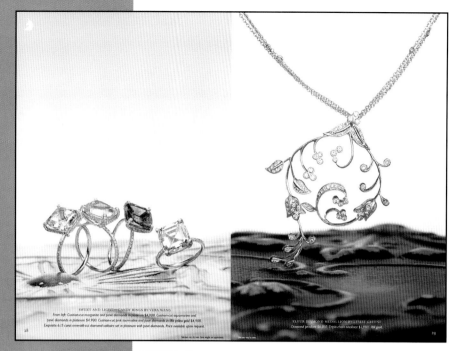

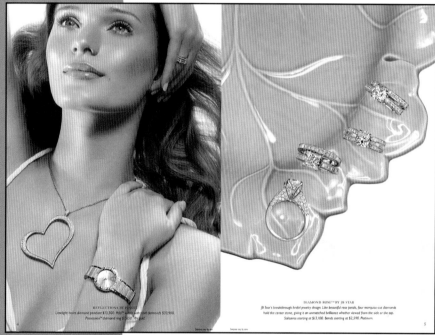

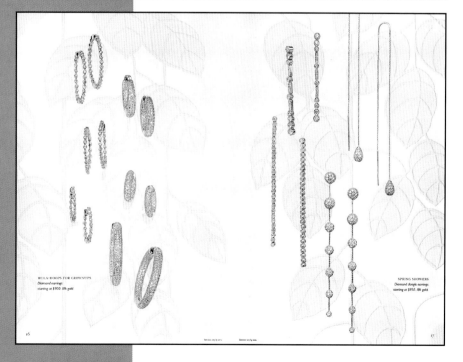

TASTE

Autumn 2005

FALLING FOR CHEESE
Our Best Cheese Dishes

PARSLEY, SAGE, ROSEMARY & THYME
Timeless Autumn Herbs

FALL FEASTS
Recipes for the Holiday Table

SOUTH COAST PLAZA

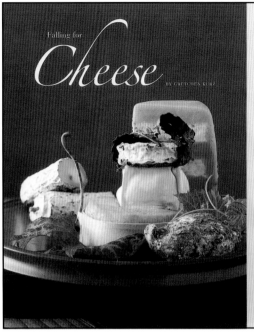

Falling for
Cheese
BY GRETCHEN KURZ

Chat Noir

Corner Bakery

Claim Jumper

South Coast Plaza

Shopping Center

MEDIA: magalog
DIMENSIONS: 8 3/8" x 10 7/8"
PAGES: 24
WEBSITE: www.southcoastplaza.com

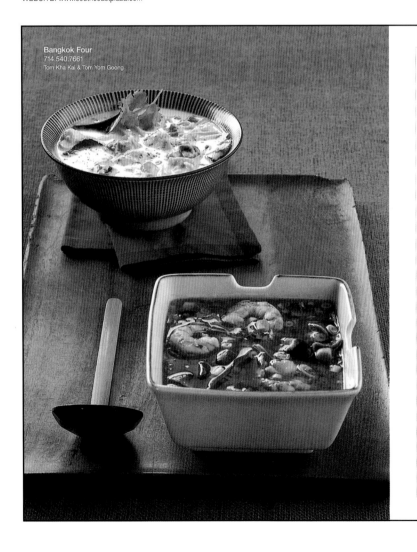

Bangkok Four
714.540.7661
Tom Kha Kai & Tom Yom Goong

Culinary Kudos

Orange Coast magazine's 2005 annual "Restaurant Raves" selected by restaurant columnist Phyllis Ann Marshall:

Antonello Ristorante
" A powerhouse since 1979 because of the attention to detail of owner Antonio Cagnolo and executive chef Franco Barone. "

Chat Noir
" The Black Cat is casting a big shadow on the culinary scene as two talents merge. Owner David Wilhelm has invited talented chef Yvon Goetz to join his team... "

Darya
" Our best and most beautiful Persian restaurant...where all cultures gather to celebrate Middle Eastern favorites. "

Morton's, The Steakhouse
" Prime steaks, all-American fare, and a deep wine list are still tops... "

Pinot Provence
" Chef Florent Marneau has taken his passion and talent for cooking to new heights, gathering a local following, moving this dining room up a notch each year....and he's done it with finesse. "

Royal Khyber
" Our favorite Indian restaurant focusing on healthful dining combinations of healing spices, vegetarian specialties, tasteful meats and naan breads.... "

Troquet
" The sophisticated menu is presented in a handsome but unpretentious space with a charming atrium garden and a new area for private parties across the corridor. "

Turner New Zealand
" ...Indulge cravings for top notch free-range game and fish from New Zealand backed by caring, outstanding service at this sleek showplace... "

The *Los Angeles Times Magazine* special restaurant issue and 2005 dining guide surveyed Southern California for its top dining spots. **South Coast Plaza's Antonello Ristorante, Royal Khyber** and **Troquet** were among a select group of Orange County restaurants to be included in the prestigious list.

The *Wine Spectator's* annual restaurant awards issue has bestowed special recognition on four restaurants at South Coast Plaza for their superb wine lists. **Chat Noir, Morton's, The Steakhouse** and **Scott's Seafood Grill & Bar** were honored with Awards of Excellence. **Pinot Provence** at the Westin South Coast Plaza received the Best of Award of Excellence.

· 15 ·

Troquet

Pinot Provence

Turner New Zealand

Morton's, The Steakhouse

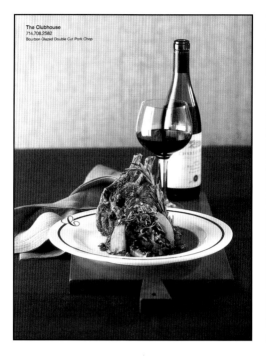

The restaurants found at South Coast Plaza are of such a high calibre that the center produces a magalog, *Taste,* devoted entirely to them and the other purveyors of fine food located within the center. In addition to full-page photos of the goodies, editorial includes extensive articles on such subjects as cheese and herbs, quotes from restaurants reviews and tips for entertaining.

ENTERTAINING

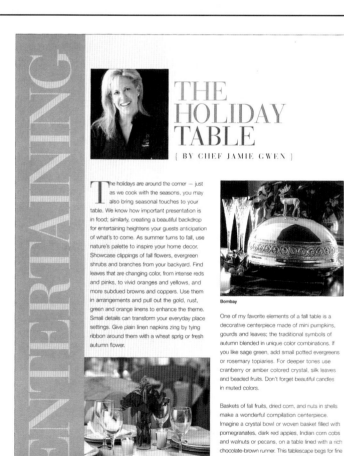

THE HOLIDAY TABLE

[BY CHEF JAMIE GWEN]

The holidays are around the corner — just as we cook with the seasons, you may also bring seasonal touches to your table. We know how important presentation is in food; similarly, creating a beautiful backdrop for entertaining heightens your guests anticipation of what's to come. As summer turns to fall, use nature's palette to inspire your home decor. Showcase clippings of fall flowers, evergreen shrubs and branches from your backyard. Find leaves that are changing color, from intense reds and pinks, to vivid oranges and yellows, and more subdued browns and coppers. Use them in arrangements and pull out the gold, rust, green and orange linens to enhance the theme. Small details can transform your everyday place settings. Give plain linen napkins zing by tying ribbon around them with a wheat sprig or fresh autumn flower.

Bombay

One of my favorite elements of a fall table is a decorative centerpiece made of mini pumpkins, gourds and leaves; the traditional symbols of autumn blended in unique color combinations. If you like sage green, add small potted evergreens or rosemary topiaries. For deeper tones use cranberry or amber colored crystal, silk leaves and beaded fruits. Don't forget beautiful candles in muted colors.

Baskets of fall fruits, dried corn, and nuts in shells make a wonderful compilation centerpiece. Imagine a crystal bowl or woven basket filled with pomegranates, dark red apples, Indian corn cobs and walnuts or pecans, on a table lined with a rich chocolate-brown runner. This tablescape begs for fine glasses of Cabernet and plates filled with roast duck!

Since we often celebrate fall with roasted game, it's important to have quality cutlery. This is the time to make sure you have a stylish and functional carving fork and knife set in your collection. Look for a set made of high-grade carbon steel. Beautiful serving pieces are a worthy investment that add to family traditions. Take inventory of your stemware — wine, champagne, and mineral water look and taste better when served in high-quality crystal.

Don't forget to sprinkle the rest of the house with autumn too. Add a few leaves and pumpkins to the entryway and sidepieces in the dining room. For a fragrant home, combine a half cup of granulated sugar and a teaspoon of cinnamon in a disposable pie pan and place it in a 300°F oven about 10 minutes before your guests arrive. The inviting aroma will waft through the air and get stomachs rumbling for dinner. My gingered pecans are another crowd pleaser — serve them before or after a holiday repast.

Be sure to bring fall indoors by shifting from summer yellow to autumn gold, from summer food to comfort food. Here's to a spirited season filled with family and friends and fabulous feasts!

More recipes may be found at www.chefjamie.com

Gingered Pecans

These nuts make a wonderful nibble with wine before a special dinner, a nice complement to a cheese plate, or a thoughtful hostess gift or table favor.

5 C pecan halves
½ C granulated sugar
2 T Kosher or sea salt
1 T ground dried ginger
2 tsp honey
2 T water
2 T canola oil

Preheat oven to 325°F. Place nuts on a rimmed baking sheet and toast until fragrant, about 15 minutes, tossing nuts halfway through cooking. Combine sugar, salt and ginger in a large bowl, set aside. Combine honey, water and oil in a large saucepan and bring to a boil over high heat. Add the roasted pecans and cook until all of the liquid has evaporated, 3 minutes. Transfer the nuts to the sugar mixture and toss well. Spread on parchment paper to cool. Store airtight. Yields 5 cups.

For the Holiday Table

Bombay

Christofle

Crate & Barrel

Illuminations

Pottery Barn

Bombay

- 16 -

- 17 -

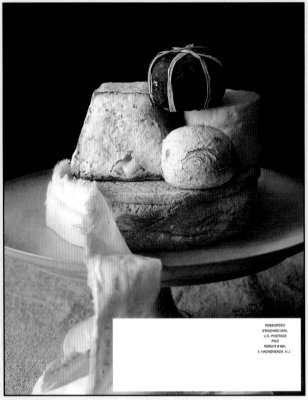

PREBORTED
STANDARD MAIL
U.S. POSTAGE
PAID
PERMIT # 004
S. HACKENBACK, N.J.

Artisanal Premium Cheese

Food

MEDIA: catalog
DIMENSIONS: 6¹/₂" x 8¹/₄"
PAGES: 20
WEBSITE: www.artisanalcheese.com

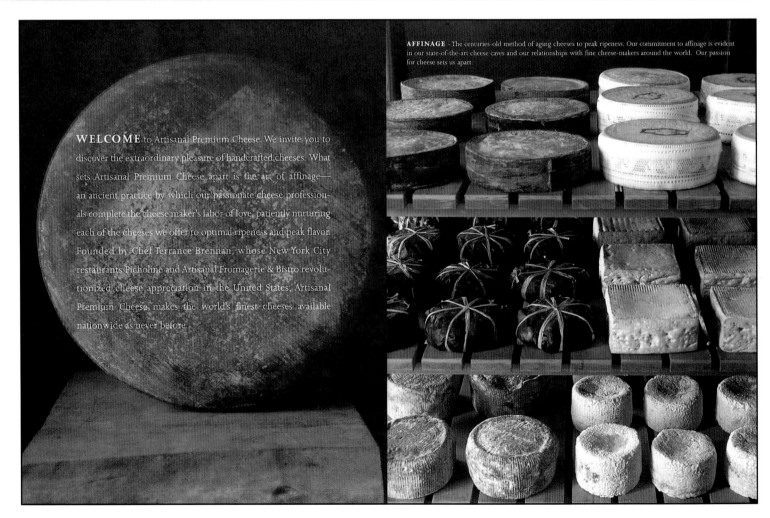

WELCOME to Artisanal Premium Cheese. We invite you to discover the extraordinary pleasure of handcrafted cheeses. What sets Artisanal Premium Cheese apart is the art of affinage—an ancient practice by which our passionate cheese professionals complete the cheese maker's labor of love, patiently nurturing each of the cheeses we offer to optimal ripeness and peak flavor. Founded by Chef Terrance Brennan, whose New York City restaurants Picholine and Artisanal Fromagerie & Bistro revolutionized cheese appreciation in the United States, Artisanal Premium Cheese makes the world's finest cheeses available nationwide as never before.

AFFINAGE - The centuries-old method of aging cheeses to peak ripeness. Our commitment to affinage is evident in our state-of-the-art cheese caves and our relationships with fine cheese-makers around the world. Our passion for cheese sets us apart.

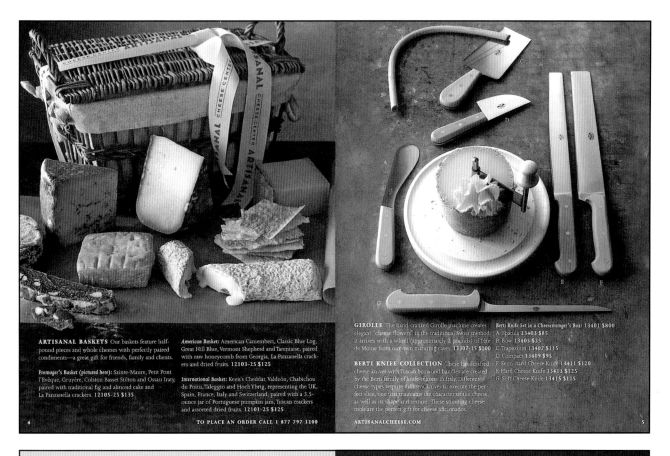

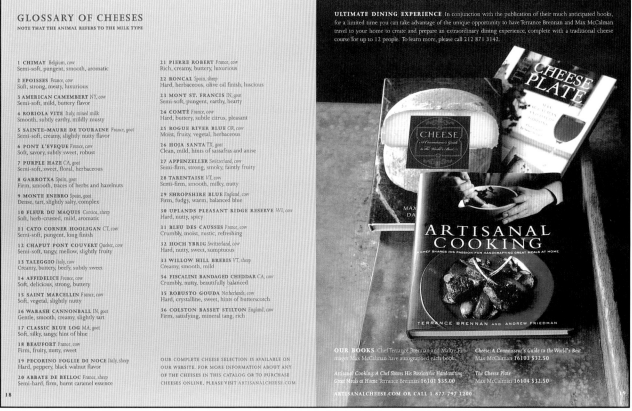

Artisanal Premium Cheese—a company dedicated to making the world's finest cheeses widely available—understands that to the cheese aficionado a mold encrusted hunk of old milk is a thing of great beauty. The presentation is superb, forcing the customer into gut-wrenching indecision over which varieties to buy. The last spread includes a helpful glossary of cheeses.

freshdirect.
23-30 Borden Ave.
Long Island City, NY 11101

PRSRT STD
U.S. POSTAGE
PAID
FRESHDIRECT

$30 FREE FRESH FOOD

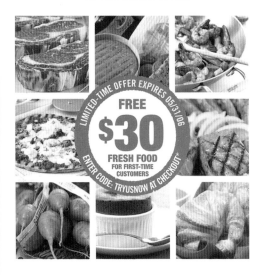

LIMITED-TIME OFFER EXPIRES 05/31/06
ENTER CODE: TRYUSNOW AT CHECKOUT*

FREE
$30
FRESH FOOD
FOR FIRST-TIME
CUSTOMERS

OUR FAVORITES

To welcome you to FreshDirect, we'd like to introduce you to our favorite things. From smoky, thin-crust pizzas crisped on the grill, to light, buttery croissants that'll make you dream of a Sunday stroll through Paris, these are just a few of the things we think we do better than anybody.

$30 FREE FRESH FOOD FOR FIRST-TIME CUSTOMERS

STEP 1
ORDER FROM OUR EASY-TO-USE ONLINE STORE

Choose from thousands of irresistibly fresh foods and popular grocery brands. Order online and save on your weekly shopping.

STEP 2
GET NEXT-DAY DELIVERY IN OUR REFRIGERATED TRUCK

Order today, get it tomorrow. Simply choose a convenient 2-hour window and our delivery professionals will bring your order right to your door.

STEP 3
NEVER SHOP IN A GROCERY STORE AGAIN

You'll eat better food, save tons of money and have more time to spend with your family. Relax and enjoy 100% schlep-free food.

(rotated magazine quotes)

"It's already hard to remember NYC without this upstart Queens-based grocery delivery service, according to surveyors who overwhelmingly vote it 'a great concept brilliantly realized' thanks to the 'uber-convenient,' 'reliable' products."
THE NEW YORK TIMES
Dining In section – April 6, 2005

"It sells natural toothpaste cheaper than Duane Reade does, offers bulk packs of meat and produce like Costco, competes with Whole Foods in organic produce prices and has a big selection of prepared foods, like Citarella and Fairway."

"LIFE ALTERING"
New York Magazine
Best Service - Best of New York Issue 2003

FreshDirect

Anyone who lives in New York City now associates the colors orange and green with the online grocer FreshDirect. These colors are utilized on all direct mail and outdoor advertising, as well as the company's delivery trucks (a frequent sight in the city). This little direct mail booklet explains how easy it is to order from the company and introduces the potential customer to a few of the retailer's "favorite" items. Adding to the incentive is an offer of $30 worth of free fresh food.

Online food retailer

MEDIA: direct mail
DIMENSIONS: 5¼" x 8⅜"
12-page booklet, tabbed
WEBSITE: www.freshdirect.com

LIMITED-TIME OFFER EXPIRES 05/31/06
ENTER CODE: TRYUSNOW AT CHECKOUT*

FREE
$30
FRESH FOOD
FOR FIRST-TIME
CUSTOMERS

WE'RE SURE YOU'LL LIKE US. WE'LL EVEN BET 5 STEAKS ON IT. OR 15 RED PEPPERS.

We're so certain you'll enjoy FreshDirect, we're treating you to a $15 discount on your first and second order. We believe that our love and respect for food, convenient delivery and attentive service will keep you coming back.

On your first order, enter code TRYUSNOW at the checkout screen. You will automatically get $15 off your first order and $15 off your second order. You must place your first order by May 31, 2006, and your second order by June 21, 2006, to be eligible for this offer.

So go ahead and start shopping, and from all of us at FreshDirect, happy eating!

OUR FRESHNESS GUARANTEE
100% SATISFACTION WITH EVERY PRODUCT EVERY TIME.

We take pride in the high quality of our fresh food and packaged goods. That's why we guarantee your satisfaction with every product, every time. If you are dissatisfied with any item in your order, please contact us right away — we want to make it right. E-mail us at service@freshdirect.com

*Limited-time offer. May not be combined with any other offer. Limit: one per customer/household. All standard customer terms and conditions apply. Offer is non-transferable.

OUR STIR-FRY KITS MAKE FAST, FRESH MEALS THAT DAZZLE

Just leave all the mess and fuss to us. Our in-house chefs created quick-cooking stir-fry kits as a perfect mealtime solution for those time-sensitive weeknight dinners. Every kit includes colorful, quick-cooking vegetables, tender pieces of high-quality meat, chicken, tofu or shrimp and savory sauce blends. We prepare these stir-fry kits fresh every day — all you'll need to do is fire up your wok or skillet. You'll look like a kitchen expert in less time than it'd take to order takeout.

Under 500 calories per serving • No hydrogenated oils
Cooks up fresh in 10 minutes (or fewer!) • Made fresh every day

FRESH-CHOPPED VEGETABLE MIXES

BERKSHIRE PORK, TRI-TIP BEEF & ANTIBIOTIC-FREE CHICKEN

MOUTHWATERING SAUCE BLENDS

SMART & SIMPLE MEALS FROM YOUR MICROWAVE IN MINUTES

Why settle for fast food or frozen dinners?
We make Fresh Dining Smart & Simple meals every day so you can enjoy speed and convenience without skimping on nutrition, freshness or flavor. The secret is in the packaging: every Fresh Dining meal uses an innovative steam-valve system to help transform raw meat, vegetables and herbs into a juicy, fully-cooked entrée.

They stay fresh in your refrigerator for four days and heat up in your microwave in four minutes.

Chef-prepared every day with fresh meat, vegetables and herbs

Special steam valve holds in moisture and helps your meal cook to perfection

Stay-fresh microwavable package is portable for on-the-go lunches

Portion-controlled with no hydrogenated oils and under 500 calories per serving

get freshdirect.com

SHOP TODAY FROM OUR FAVORITES

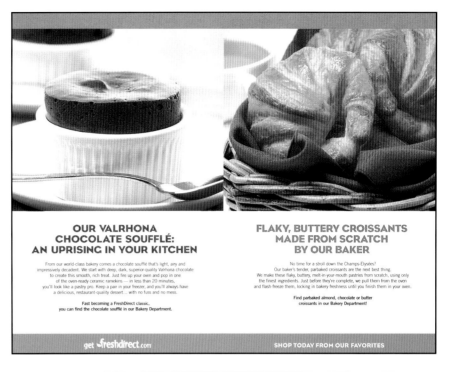

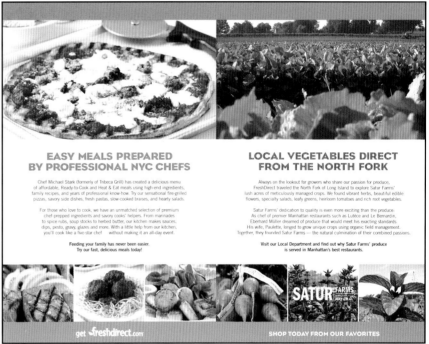

The last page details Quickshop, a convenient benefit found on the site. Since grocery customers buy many of the same items week after week, Quickshop allows returning customers to quickly reorder items from past orders.

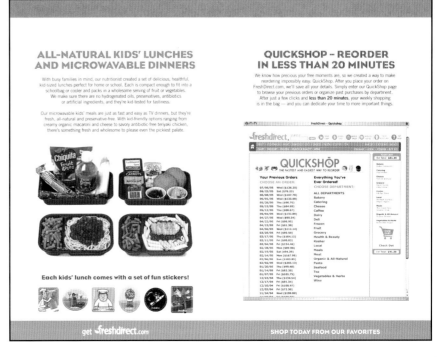

CVS/pharmacy
ExtraCare
PO Box 5596
Ellenton, FL 34222-5005

PRESORTED
STANDARD
U.S. POSTAGE
PAID
CVS/PHARMACY

Exclusive new offer from the UK

pays you back.

Inside — A FREE sample of Britain

Discover the secrets of the
Mediterranean.

The first panel is die-cut.

Pamper yourself
with Boots Health & Beauty

CVS/pharmacy
Boots Mediterranean

Bath and body products
MEDIA: direct mail
DIMENSIONS: 8" x 5"

Boots

mediterranean

Clear blue skies, olive groves, sunny beaches, al-fresco dining and
a healthy, relaxed lifestyle. This is the essence of the Mediterranean,
captured in a wonderful line of bath and body care products from Boots
that pamper your body, stimulate your senses and raise your spirits.

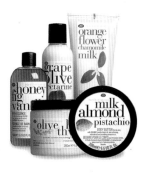

Unfolded once.

CVS/pharmacy and Boots teamed up to produce this direct mail piece for Boots' Mediterranean line of bath and body products. The piece unfolds, panel by panel, to reveal product info, soothing photos and soft-toned graphics. The final reward is a coupon.

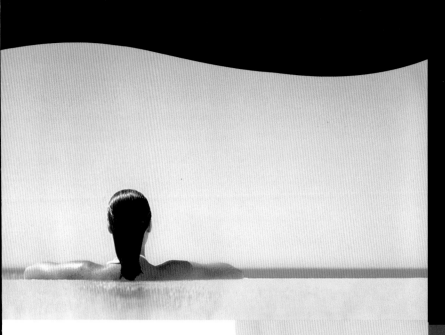

Boots has arrived in the U.S. with over 580 innovative, one-of-a-kind products to make you look and feel beautiful. Our health and beauty brands have been some of the most popular in Britain for over 150 years.

Whether you're looking for the latest cosmetics or revolutionary skincare treatments, Boots has the perfect products to help you look and feel great. They're made from the most natural, highest quality health and beauty ingredients on earth. Boots has something for everyone. Pamper yourself.

Milk, Almond Pistachio Body Butter for Dry Skin

With organic sweet almond oil, milk extract to soften and pistachio oil to smooth, it leaves dry skin feeling wonderfully moisturized and delicately fragranced.

Also available in **Olive, Bergamot & Orange** for normal to dry skin and **Apricot, Olive & Honey Body Butter** for very dry skin.

Fully unfolded.

Discover Boots Mediterranean at select **CVS/pharmacy** locations near you:

Brookfield: White Turkey Road Plaza

Danbury: 146 South Street

Danbury: 303 White Street

Danbury: Danbury Mall

Darien: 964 Post Road

New Canaan: 96 Park Street

New Milford: 41 Main Street

Newtown: 6 Queen Street

Norwalk: 295 Westport Ave.

Ridgefield: 467 Main Street

Riverside: 1239 East Putnam Ave.

Stamford: 229 Hope Street

Stamford: 593 Newfield Ave.

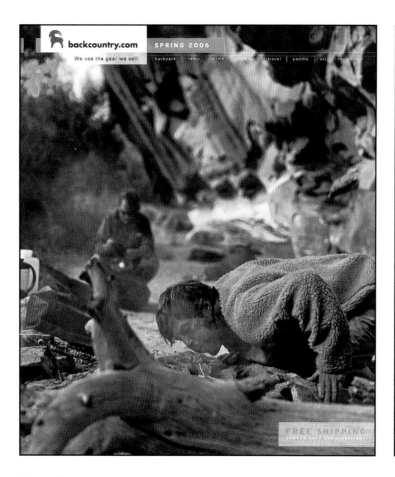

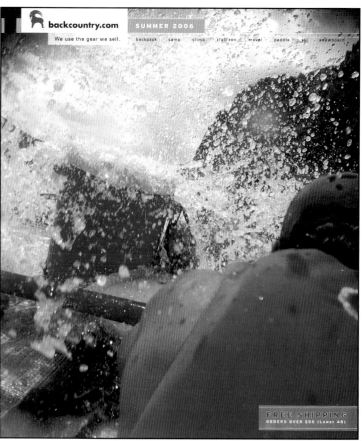

Backcountry.com

Sporting goods and apparel

MEDIA: catalogs
DIMENSIONS: 9¹⁄₈" x 10³⁄₄"
PAGES: 24
WEBSITE: www.backcountry.com

No glamorous outdoor scenes here. The cover shots of these two catalogs from Backcountry.com show the nitty-gritty of outdoor pursuits. The guy trying to start a fire looks a little desperate—and in need of a bath. The whitewater shot just looks cold. This company knows its customers: the non-armchair outdoor enthusiast. The two catalogs are identical except for the covers.

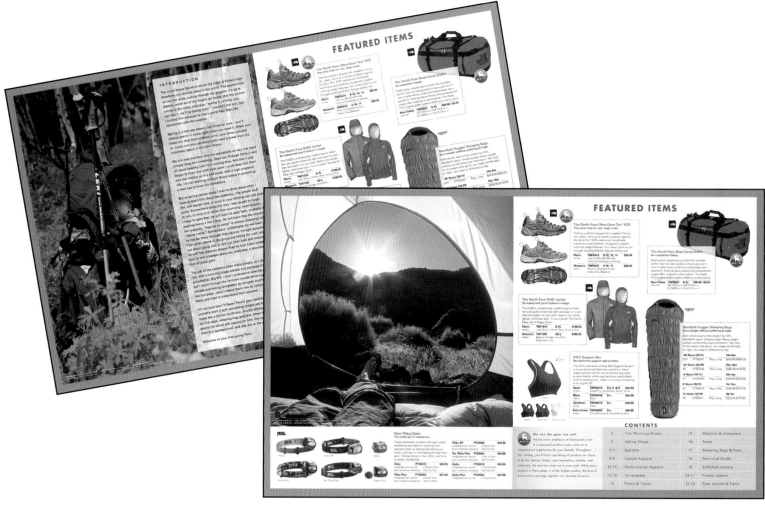

The inside shots make no attempt to soften the message. The outdoors can be harsh, come prepared.

Marmot Oracle Jacket
Foresee protection from gnarly weather.

This is simply one of the toughest light-weight waterproof rain jackets available. The 15oz Oracle is micro-stitched, 100% seam taped, and features stretch fabric in key areas. This shell is ideal for serious hiking, climbing, and backpacking pursuits.

Men's	MAR0433	S-XXL	$149.95
colors	Fog/Lava, Cash/Dark Cedar, Real Red, Ionic Blue/Indigo Blue		
Women's	MAR0439	S-XL	$149.95
colors	Real Red/Garnet, Lava/Black, Meadow/Peridot		

Patagonia Rain Shadow Jacket
A foul-weather fun companion.

A relaxed fit lets you layer fleece under the Rain Shadow on chilly hikes, and pitzips let you vent heat when you're huffing up a climb. Designed to be very packable, it lets you stay out when weather moves in.

Men's	PAT0294	S-XL	$148.95
colors	Sprout, Black, Ocean Blue, Steel, Fire		
Women's	PAT0286	XS-XL	$148.95
colors	Iceland Blue, Steel, Vivid Violet		

The North Face Resolve Jacket
A durable shell that's always comfy.

TNF lined the Resolve rain jacket with a lightweight fleece chamois, so even when it's raining buckets and your jacket is plastered to your skin, you won't feel clammy. With The North Face's legendary durability, it'll keep you dry for years.

Men's	TNF0967	S-XXL	$79.95
colors	Root Green, Black, Lux Blue, Lush Green, Molten Red		
Women's	TNF0973	XS-XL	$79.95
colors	Geisha Red, Black, Moonlight Ivory, Shoreline Blue		

Mountain Hardwear Cohesion Jacket
Batten down the hatches.

Pull the zipper to your chin and close the pit-zips of the Cohesion rain jacket when the wind cranks. Clambering over a boulder or unloading your canoe won't be a problem thanks to stretch panels and an ergo hood that flexes with you.

Men's	MHW0376	XS-XL	$139.95
colors	Pesto, Cayenne, Sapphire, Shark		
Women's	MHW0369	4-14	$139.95
colors	Dark Tomato, Hawaii		

LEE COHEN
> Wasatch Mountains, UT
> Eric McCulley

www.backcountry.com 1.800.409.4527

TOMMY CHANDLER
> Yosemite Valley, CA

The North Face Momentum Jacket
Keep moving.

Head for those who cover lots of ground when they hit the trail, this athletic fit fleece is made with four-way stretch fabric. Equipped with thumb loops and a chest pocket, the Momentum is great for running and biking.

Fleece Weight: Light

Men's	TNF1122	S-XXL	$84.95
colors	Lush Green, Black, Asoll Blue, Molten Red		
Women's	TNF0978	XS-XL	$84.95
colors	Moonlight Ivory, Black, Mars Green, Ionos Purple		

The North Face Pumori Jacket
Four-season fleece.

The Pumori is soft, durable, and more versatile than any other fleece from The North Face. This environmentally-friendly jacket is made with Polartec 200 recycled fleece and is reinforced in critical areas to assure durability. Perfect for year-round use.

Fleece Weight: Mid

Men's	TNF0132	S-XXL	$98.95
colors	Lux Blue, Black, Lush Green, Asphalt Gray		
Women's	TNF0123	XS-XL	$98.95
colors	Geisha Red, Black, Relax Blue, Nouveau Purple		

Mountain Hardwear WindStopper Tech Jacket
Tech meets tough.

More durable than any other fleece in the Mountain Hardwear line, the WindStopper Tech combines windproof performance with excellent warmth. A favorite of climbers, hikers, and skiers who like tough gear, this burly fleece is in for the long haul.

Fleece Weight: Heavy

| Men's | MHW0011 | S-XXL | $184.95 |
| colors | Tiger, Black, Carbon, Sapphire, Cayenne, Espresso, Shark | | |

The North Face Salathe Jacket
Also a steep wall on El Cap.

Add warmth and comfort to your summer backpacking trips with this lightweight, compressible, super-soft fleece. With flat-locked seams and an anti-microbial finish, this 100-weight fleece keeps you comfy and stink-free for days.

Fleece Weight: Light

Men's	TNF1517	XS-XL	$78.95
colors	Marc Blue, Molten Red, Lush Green		
Women's	TNF1526	XS-XL	$78.95
colors	Butterfly Yellow, Black, Ionos Purple, Mars Green, Relax Blue		

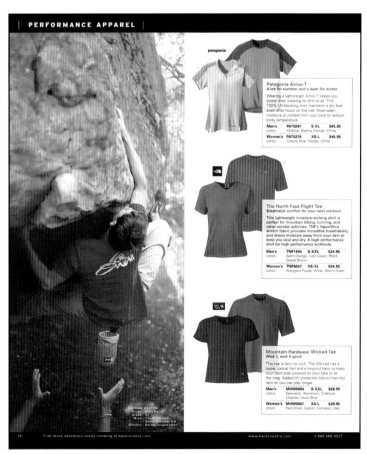

Patagonia Airius-T
A tee for summer and a layer for winter.

Wearing a lightweight Airius-T keeps you cooler than wearing no shirt at all. This 100% UV-blocking shirt maintains a dry feel even after hours on the trail. Heat-laden moisture is wicked from your core to reduce body temperature.

Men's	PAT0281	S-XL	$45.95
colors	Moblue, Blazing Orange, White		
Women's	PAT0276	XS-L	$45.95
colors	Coastal Blue, Mango, White		

The North Face Flight Tee
Breathable comfort for your next workout.

This lightweight moisture-wicking shirt is perfect for mountain biking, running, and other aerobic activities. TNF's VaporWick stretch fabric provides incredible breathability and draws moisture away from your skin to keep you cool and dry. A high-performance shirt for high performance workouts.

Men's	TNF1404	S-XXL	$34.95
colors	Astro Orange, Lush Green, Black, Gravel Brown		
Women's	TNF0647	XS-XL	$34.95
colors	Afterglow Purple, White, Moch Green		

Mountain Hardwear Wicked Tee
Wick it, wick it good.

This tee is born to wick. The Wicked has a loose, casual feel and a long-cut back to keep your back-side covered on your bike or at the crag. Added UV protection blocks harmful rays so you can play longer.

Men's	MHW0684	S-XXL	$28.95
colors	Seaweed, Aluminum, Chamois, Chipotle, Union Blue		
Women's	MHW0967	XS-L	$28.95
colors	Red Onion, Casper, Cumulus, Lilac		

NATHAN WELTON
> Route: Wee Pinch
> Grade: V3 Bouldering
> Santa Barbara, CA
> Climber: Bernd Zeugswetter

Find more adventure-ready clothing at backcountry.com www.backcountry.com 1.800.409.4527

Cover and first spread. Included are table of contents and design credits.

This is a company that is not scared of content. The catalog reproduced here and on the following three pages is packed with copy, photos, photo collages, nifty type faces, detailed product specifications, manufacturer logos, more copy… All this stuff translates into many weeks of life on the coffee tables and nightstands of the active and outdoorsy. The product category introduction spreads (right) are especially eye-catching and the product pages (opposite) are packed. The more one looks the more one sees.

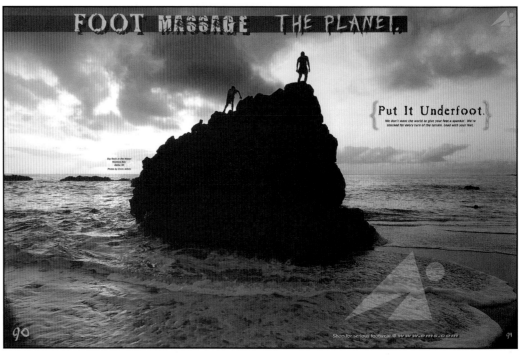

Eastern Mountain Sports

Sporting goods and apparel

MEDIA: catalog
DIMENSIONS: 8 1/2" x 10 3/4"
PAGES: 180
WEBSITE: www.ems.com

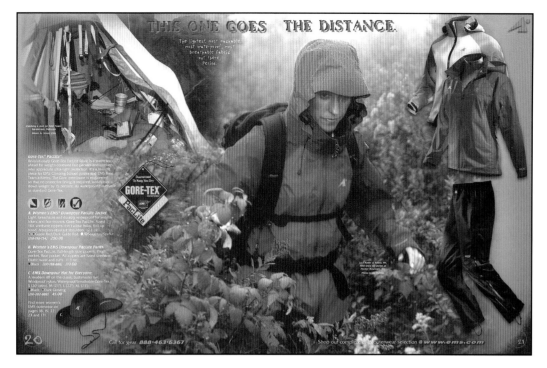

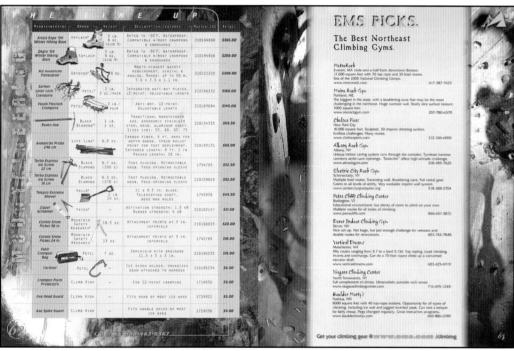

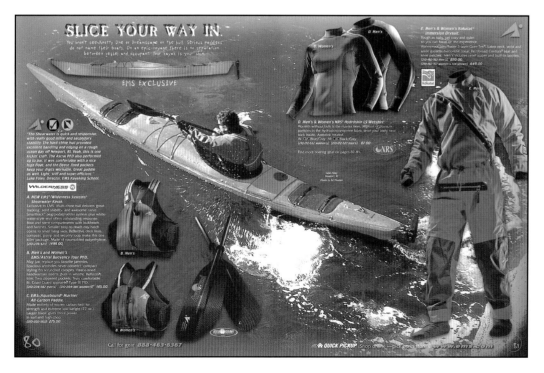

BEST N.E. AFTER-SPORT SPOTS.

What is it that supercharges your pace at the end of the 40-mile, 3-day marathon backpack? How can you flash the 5.12 at twilight? Why do you and your crew power-hike that final 4000-footer when everyone else has bailed? How could you paddle 20 miles on nothing but powdered egg mix?

Deep reserves of inner fortitude and the need to prove your superhuman tenacity? Let's be honest.

It's nothing less than powerful visions of frosty beer-filled mugs on a worn wooden bar. It's oven-baked chicken gorgonzola pizza and buckets of salty pretzels among happily exhausted friendlies. You must refortify. You must know where to do it. Your soul (and other less exalted parts of your body) demands it.

Here then is the very short EMS list of climber-approved New England joints that give good beer and food that's not freeze-dried.

Harlow's
3 School St., Peterborough, NH

Looking for an EMSer here at Base Camp? No, they're not in a skull meeting or field-testing boots on North Pack. They're at nearby Harlow's doing solid fieldwork in the area of barley and hops. This venerable establishment was once a cheese shop, then a dimly lit ground-level hovel that was frequently crammed due to impressive grog and grub and a reliable air of unforced friendliness. A couple of years ago they took over the front of the building, built a big stage for bands, installed a long wooden bar and, amazingly enough, managed not to ruin the preexisting vibe. The cast of characters includes local adventurers; visitors beat from a climb up Mount Monadnock (not as easy as they thought), passersby of the generally charming variety; and, at one point or another, just about everybody in town.

- World-famous chicken burrito plus thematic sandwiches with non-cutesy names
- Regular microbrew rotation, including some adventurous choices
- Some seriously good live music from bands far and wide

Biederman's Deli
83 Main St. (Lower Level), Plymouth, NH

In the past ten years, the steep crags of Rattlesnake Mountain have come to offer the best sport climbing in the Northeast and perhaps the country. Rumney Village, however, does not offer much in the way of recuperation, so most climbers make the fifteen-minute trek over to downtown Plymouth and hit up Biederman's. Fresh Poor Boys and Ruebens (local hardman Joe Kinder says "Get the Balboa") plus equally fresh and local microbrews offer sweet solace along with that wonderful stuffed-to-the-gills feeling.

- Happy hour 2-for-1 appetizer special
- Enough local brews to avoid redundancy
- Local hangout for "Hot" Henry Barber, Mark "Scrapple" Synnott and other local bad-asses

The Moat Mountain Smokehouse
3378 White Mountain Hwy. (Route 16), North Conway, NH

The best granite the East has to offer. Some of the most scenic hiking in the nation. Despite what the average Coloradoan might have to say, the Mount Washington Valley may be unbeatable. Join the local guides and weekenders in the bar room at The Moat and you'll get more beta than you need. If romance is in the air or you plan to put it there, repair to the dining area.

- Fresh sandwiches any way and every way
- Big screen TV (the big games are always on)
- Eclectic mix of coeds, locals, and climbers

Lompoc Cafe & Brew Pub
36 Rodick St., Bar Harbor, ME

Acadia's labyrinth of trails and pink granite cliffs offer an unrivaled coastal playground. Catch the sunrise from atop Cadillac Mountain (no one else in the U.S. can catch it sooner), climb the splitter cracks on South Wall, paddle the rough and rocky coastline alongside lobster boats, and then head to Lompoc Café. You can eat on the patio and hog some more views, but if you sit indoors you can hear some live Downeast jazz and reggae, much of which does not suck. Make sure you're emotionally prepared, though, because first you have to find a place to park in downtown Bar Harbor. That could be tougher than South Wall.

- Great music and eclectic nightlife crowd
- Atlantic Brewing Company ales on tap
- Patio meeting, greeting and, yes, bowling

Lake Placid Pub and Brewery
14 Shore Dr., Lake Placid, NY

Few people realize the massiveness of Adirondack Park in upstate New York. The "Dacks" is the largest stretch of public lands in the lower 48—bigger than Yellowstone, Everglades, Glacier, and Grand Canyon National Parks combined. It's got beaucoup lakes, rivers, creeks, trails and paths, and it needs a watering hole that reflects that magnitude. The LPPB can handle the gig. A short drive from the world-class hikes and pitches of Keene Valley, partakers of the park play pool, slurp local microbrews (like the Ubu) and get fortified for another big day outdoors.

- Dining upstairs with a pool table or a bar-like atmosphere down below
- Practice your French with abundant French Canadians
- Hit the "disco" around the corner, or check out Olympic venues from 1932 and 1980

Bacchus Restaurant
4 S. Chestnut St., New Paltz, NY

New Paltz brings NYC style to the countryside and draws outdoor adventurers from around the globe to its world-class climbing, biking, and trail running. After pumping out on MF (5.9), Madam G's (5.6), or The Buddah (V7), the locals spit stories of bloody flappers, big whippers (and, unavoidably, politics) at Bacchus. With SUNY New Paltz just around the corner, you're likely to see just as many coeds as fellow climbers on the carriage paths. There are few better places in the Northeast to make new friends. Just lose the Bosox cap before you walk in the door. You're in Bombers territory now.

- Vagabonds from all corners, here to work, study and play
- Atypically clean toilets
- Strapped? Catch a cheap slice around the corner at Gourmet Pizza

Locals hang at Harlow's, Peterborough, NH
Photos by Annie Land

28 29

CORE CLIMBING GEAR.

Indian Creek
Canyonlands, UT
Photo by Joe Lentini

Climbing Shoes
Page 59

Chalk Bags
Pages 58, 65

Rope
Page 53

Helmets
Pages 54, 61

Quick Draws & Hardware
Pages 54-55, 61

Stoppers and Cams
Page 60

Harnesses
Pages 58, 61

Belay devices
Pages 54-55

Climbing Hardware
Pages 54-55, 60-61

Apparel
Pages 16-17, 36-37, 70-73

Outerwear
Pages 18-23, 30-35

ABSOLUTELY ESSENTIAL:
Climbing skills and experience and a thorough knowledge of the climbing area. Take the appropriate courses at the EMS Climbing School before you attempt to climb.

TO BOULDER AT WILL:
Pair of climbing shoes; chalk bag; bouldering pad; trained eye for opportunity.

SPORT CLIMBING ON IMPULSE.
Rope; helmet; belay device; eight to twelve quickdraws; hydration system; sun screen; local guidebook; 60m X 9.3mm-10.5mm rope; rope bag; reliable, experienced partner.

MULTI-PITCH CLIMBING:
Thirty regular carabiners; three locking carabiners; six to eight camming units; belay device; twenty stoppers; set of small tri-cams; couple of quickdraws; nut tool for freeing artificial chock stones; half-dozen slings; belay device; local guidebook; 60m X 9.3mm-10.5mm rope; rope bag; harness; helmet.

FOR ALL CLIMBING:
Temperature-appropriate mix of fast-wicking underlayers and waterproof/breathable overlayers. Good friction-inducing shoes with Velcro® closure.

Check out our gear list @ www.ems.com/climbgearlist

TO FALL IS TO LIVE.
Don't Fear the Whipper.

By Joe Lentini

We fall in our dreams, but generally wake before landing. You don't need a psychology textbook to know this signifies something good. It means you get to live. Waking life does not always offer such a cushiony end. Not for climbers.

It's hard to think of another sport in which the overriding objective is so sharply defined. In climbing, not falling is always the priority. You want to get up there without having an unpleasant encounter with gravity. But you can't let the beast take control. You can't let fear-of-the-inevitable take root in your psyche.

In the dream, it's your will to live that saves you. In climbing, it's your will to live plus your well-placed protection. A whipper may be in store. It will remind you of the sweetness and pain of life.

Sometimes protection is not enough. Climbers die—through their own mistakes or overconfidence or latent death wish or bad parenting or some unforeseen obscurity in the rock face—and no life-loving climber forgets that. It's what makes the sport off-limits to the faint of heart (or maybe just the complacent and contented).

Caroline Treadway
Second Coming 5.10a
Chuckawalla Wall, UT
Photo by Tim Kemple

I feared falling when I started climbing—a lot. At ground level, the sleek rope and gleaming gear were reassuring. Earthbound, I had faith. From a vertical perspective, it was a different story. I was sure that if I fell the rope would snap like a fresh carrot.

The first time it happened, the rush of panic had that heart-in-the-mouth taste. As my climbing progressed, a pattern emerged. Just before a fall, the same flash of horror. Was I falling because I was afraid to? Probably yes.

Overcoming my fear of falling remains a work in progress. I work at it regularly. In spring I lead climbs that risk long falls (20 to 50 feet). Probably not lethal, but plenty long. Once I get through them my head cools down. I no longer worry about the yawning abyss and gravity's exclamation point. I concentrate on the next move. When I am climbing well, I don't look down and I don't think down.

I've had a few long-term climbing partners over the years. One in particular was much stronger and more technically proficient. But I could lead harder routes. Above the protection, he slowed down and got nervous. He repositioned his feet and found ways to delay the climb. It usually ended up in a short fall—deliberate maybe, but not consciously so. He preferred the short fall to heading up farther than his connection to the rock and risking a longer one. He could lead 5.12 and was close to 5.13, but not if the protection was below his feet. Then he would fail on 5.10. The beast was in charge.

There was a climb that was calling his name, but the fall was long if you blew the crux. It became a turning point. Methodically, through a series of lesser challenges, he pushed himself up above his protection. He climbed and didn't think about falling. Somehow it worked. It was the breakthrough. These days he's leading 5.13s.

In a good season I take hundreds of falls, most of them five to ten feet. You push yourself to failure, you body-check the rock face, and you get better.

In the Whites, we respect climbers who go big. They've taken falls of 40, 60, even 100 feet, but they never considered hanging up the ropes. Drinking beers at the end of the day, we look there for inspiration.

66 Climb right. Check out our gear list @ **www.ems.com**/climbgearlist Climb with the best in the business @ **www.emsclimb.com** 67

Sprinkled throughout Eastern Mountain Sports' catalog are spreads containing editorial copy that ranges from the best bars in New England to tales from the wilderness.

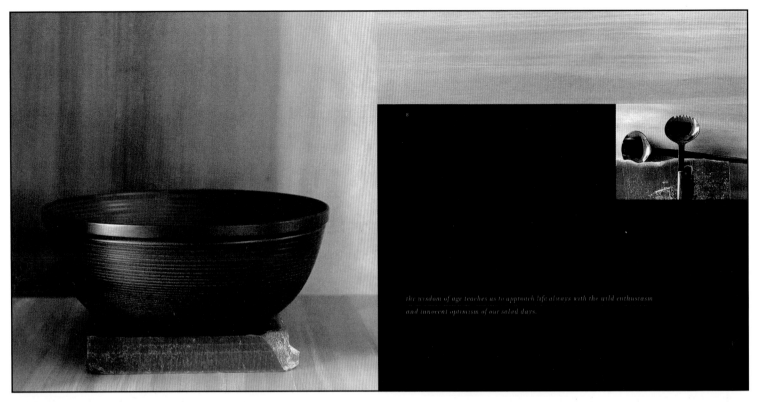

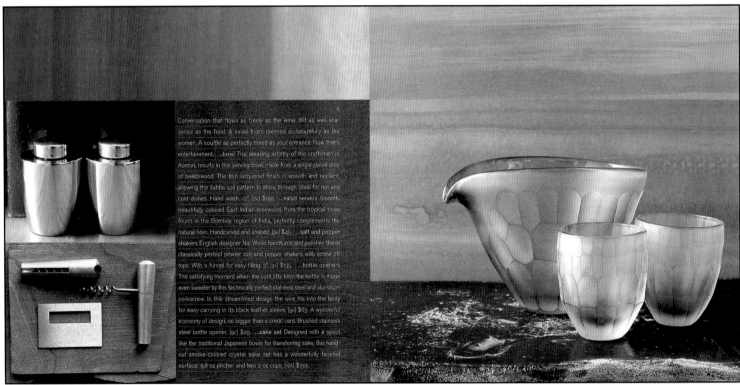

Takashimaya

Specialty Store

MEDIA: catalog
DIMENSIONS: 8¼" x 8"
PAGES: 44
WEBSITE: www.ny-takashimaya.com

Many of the pages in Takashimaya's elegant catalog are trimmed shorter than the outer dimensions of the catalog—some in height, some in width. This allows products and photographs to be slowly revealed as the short pages are turned. For example, a viewer first sees the spread shown at top. On the right-hand side is a page cut two inches shorter then the catalog. Only when this page is turned do the Japanese sake set and product information come into view (above).

This series of pages involves two short cut pages. The first cut two inches short at the top of page; the second (displaying the picture of the cabinet) is cut two inches short in width. Only when both pages are turned is the necklace fully revealed.

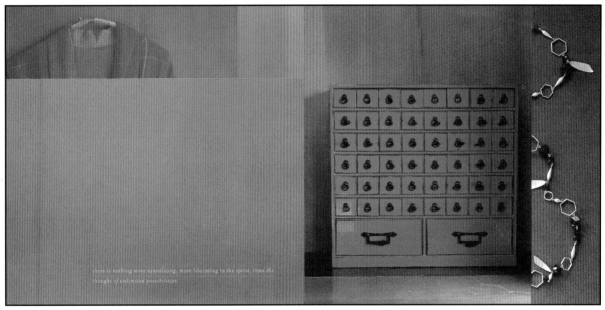

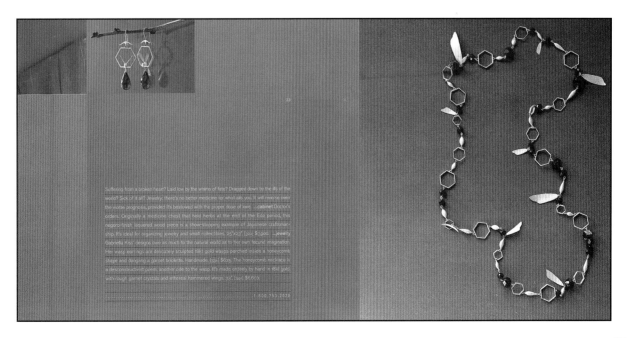

Siemens

Home appliance manufacturer

MEDIA: catalog
DIMENSIONS: 8 1/4" x 8 1/2"
PAGES: 40
WEBSITE: www.siemens-home.com

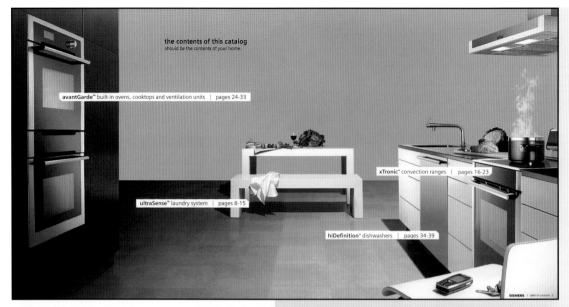

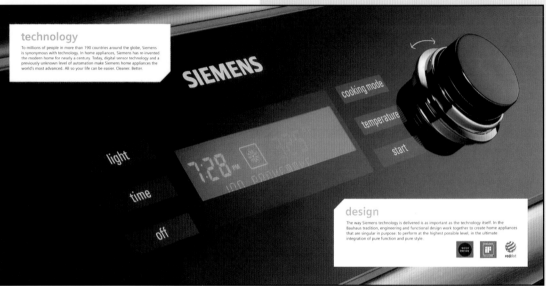

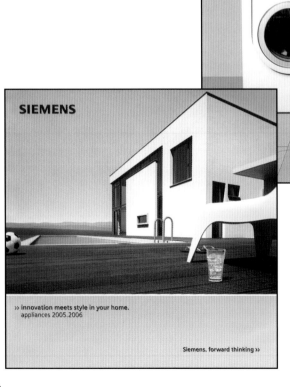

Siemens presents a surreal world in which its appliances shine brightly and the clutter of everyday life is reduced to a few carefully selected and precisely arranged items. The first spread, which serves as a table of contents (top), pares the information down to essentials.

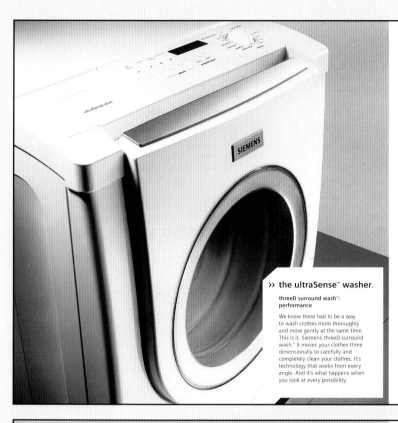

>> the ultraSense™ washer.

threeD surround wash™: performance

We knew there had to be a way to wash clothes more thoroughly and more gently at the same time. This is it. Siemens threeD surround wash.™ It moves your clothes three dimensionally to carefully and completely clean your clothes. It's technology that works from every angle. And it's what happens when you look at every possibility.

threeD surround wash™: cleaner

Your clothes are guided forward by patented angled paddles. They glide back again on the inclined drum. As they tumble, water continually cascades over your clothes. This three-dimensional movement cleans your clothes from all angles for full, even water saturation and a better, more thorough wash.

threeD surround wash™: safer

The water cascades gently. The stainless-steel inclined drum is ultra-smooth. There's no friction, no pulling, no wear and tear. Is it possible for a machine to care more about your clothes than you do?

threeD surround wash™: more efficient

It took Siemens engineers to figure out how to clean better while using fewer resources. The key was developing interacting technologies that work synergistically to use less water and energy combined than any other washer on the market. And we think it's only right that you spend the extra money on more clothes.

15 wash programs: versatility

Individually tailored programs control every aspect of your wash to precisely clean each of the many garments hanging in your closet.

ultraSense™ intelligence: precision

loadSensor.™ sudSensor.™ hydroSensor.™ tempSensor.™ equiSensor.™
A network of digital sensors is watching out for you and your clothes by maintaining the perfect conditions for a perfect wash.

soundCheck™ ultra silence™: quiet

An asynchronous, suspended, brushless powerDrive™ motor, combined with an exceptionally rigid cabinet design, yields an amazing 60 dB of quiet. It's the quietest front-loading washer you've never heard.

>> the avantGarde™ gas cooktop.

xForce™ 15,500 btu burner: versatility

The more versatile your cooktop, the more choices you have for dinner. High heat means you can wok, deep sear, boil quickly and whip up a great meal at the last minute. And with three different sized integrated burner rings, you can select a flame ring that's proportionate to the size of the pan you're using. Huge pasta pot or small saucepan? It's up to you.

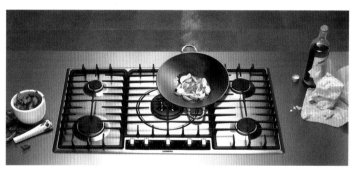

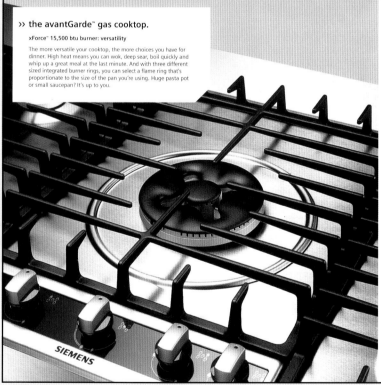

front controls: intelligence

Would you rather have more cooking space or would you rather waste it on knobs? Siemens gives you maximum cooktop width by locating the control knobs in the front, rather than the sides. And would you rather have cool, comfortable fingers or would you rather have them burned? The front knobs will stay cool to the touch.

continuous grates: convenience

Chili is a heavy food. And that's while it's still in the pot. Professional-style xxL continuous grates™ make moving heavy and extra-full pots easy, without spilling a single delectable drop.

recessed top: easy cleaning

When you're right in the middle of a cooking frenzy, you're not really thinking about cleaning up afterward. As it should be. Cook a fantastic meal, then worry about cleaning up later. But don't worry too much. The one-piece top holds even your most frenetic spills, and keeps them where you can conveniently clean them.

smartSpace™ intelligent burner spacing: flexibility

You have many different sized pots and pans. You should use them all. The small rear burner is perfect for melting cheese sauce while the potatoes boil on the large burner in front.

flameSafe™: safety

You're throwing ingredients around in a frenzy, you're like a mad scientist, you're really into it, and then you notice that sudden breeze from the kitchen window blew your flame out. No wonder the creamed spinach doesn't seem to be cooking. The flameSafe™ auto flame shutoff makes sure the cold spinach is the only tragedy.

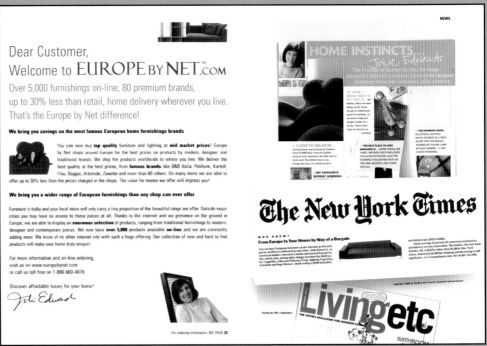

Europe By Net

Home furnishings e-tailer

MEDIA: catalog
DIMENSIONS: 7¹/₂" x 10¹/₄"
PAGES: 72
WEBSITE: www.europebynet.com

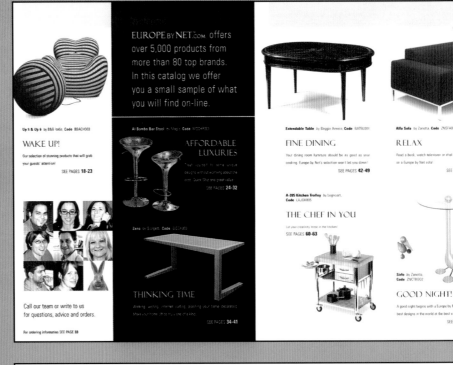

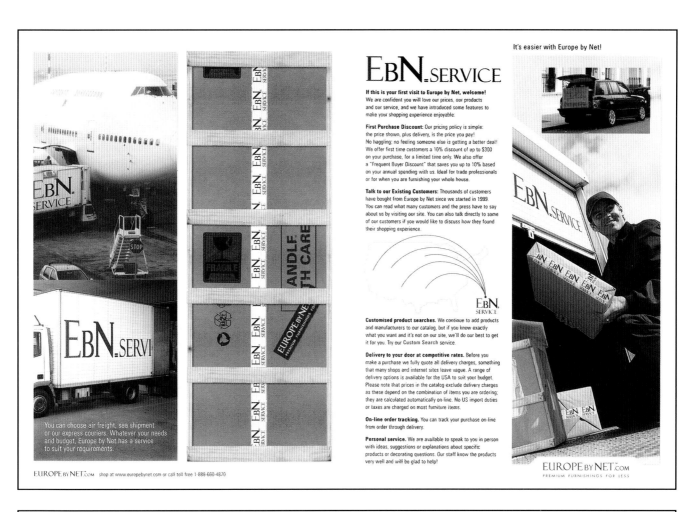

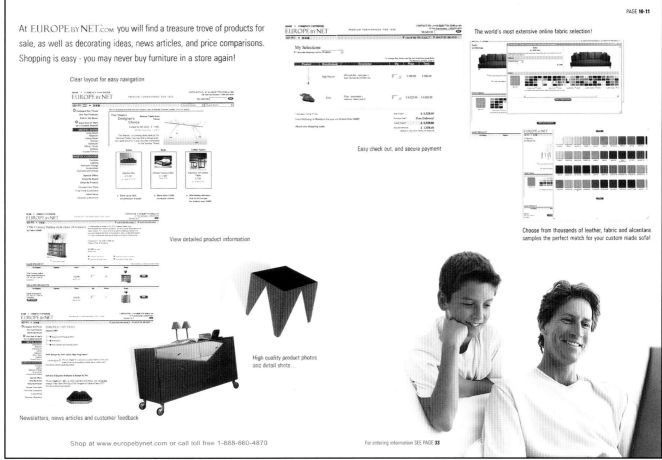

The opening five spreads in this Europe By Net catalog (shown in order, opposite and above) are entirely devoted to building customer goodwill. Beginning with a letter from the founder and continuing to pictures of the staff, detailed shipping information, and a how-to-use-the-site spread, all are geared to making the customer comfortable with purchasing large (and pricey) items over the internet.

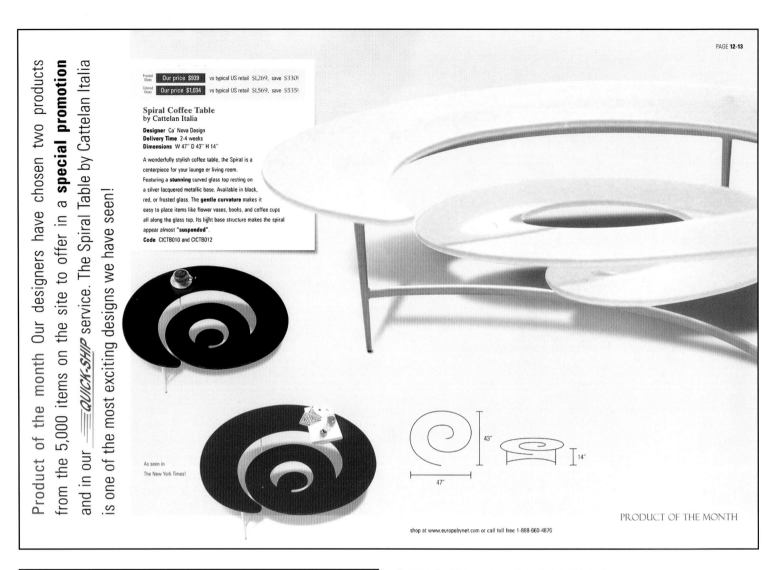

shop at www.europebynet.com or call toll free 1-888-660-4870

PRODUCT OF THE MONTH

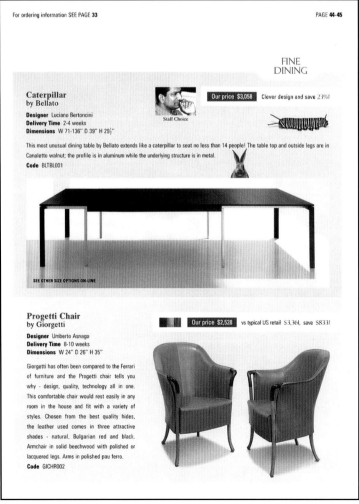

Europe By Net packs a lot of detail into its product pages without them ever looking squeezed or busy. The "Product of the Month" spread (above) combines large and small product photography, detailed product info and measured drawings.

On another page the bunny (representing speedy delivery), the caterpillar (the table extends caterpillar-fashion), and the "Staff Choice" photo are all nice touches—adding interest and perhaps a smile or two.

Note the tiny "I came from…" photo. In this case, Venice.

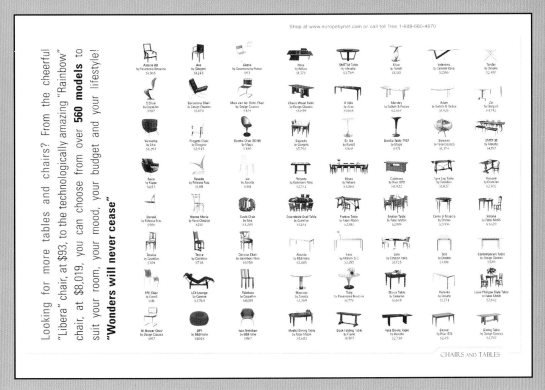

Here's a visually interesting way to show lots and lots of tables and chairs.

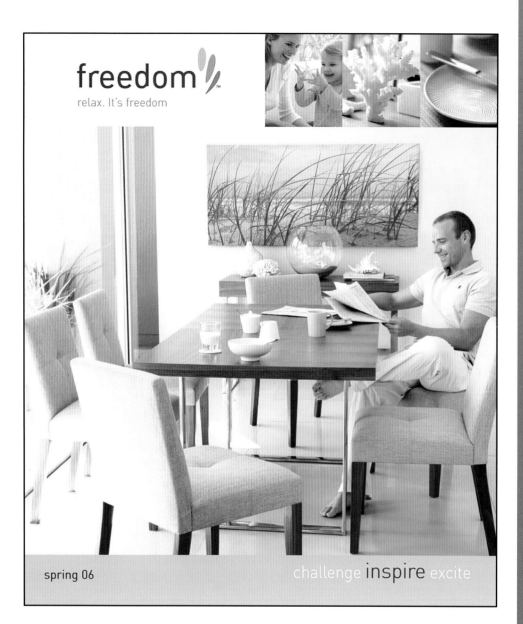

spring 06

challenge inspire excite

freedom

Furniture and home furnishings

MEDIA: catalog
AGENCY: Cumming Agency & Studios
ART DIRECTOR: Phu Nguyen
DIMENSIONS: 9 1/4" x 10 7/8"
PAGES: 68
WEBSITE: www.freedom.com.au

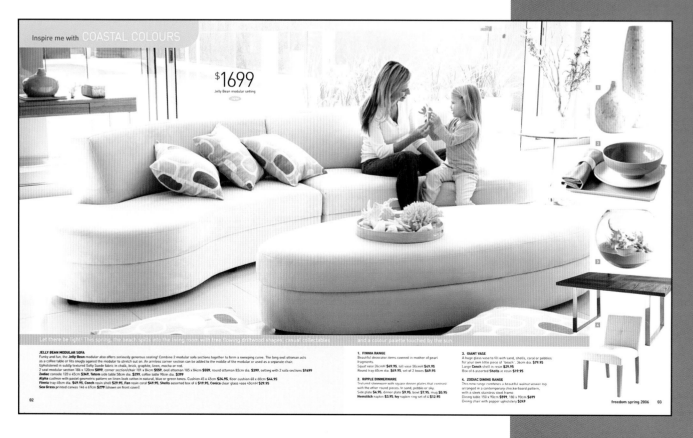

Inspire me with COASTAL COLOURS

$1699
Jelly Bean modular setting

$999
Athena queen bed

1. ORION VASE
Shapely squat ceramic vases with glossy glaze in duck egg, stone, teal, green, tangerine or campari. 12cmH $16.95, 25cmH $36.95

2. FINNIA RANGE
Beautiful decorator items covered in mother of pearl fragments.
Set of 2 boxes $49.95, squat vase 26cmH $49.95, tall vase 50cmH $49.95, round tray 40cm dia. $49.95

3. SEASIDE DECORATIVE RANGE
Inspired by the mysteries of the sea, this range is crafted in pottery with a limewash finish. Wall plaque sculpture 18 x 18cm $11.95, 25 x 25cm $19.95
Shell ornament 11cmH $9.95, 14cmH $15.95, 18cmH $24.95, round sea urchin oil lantern 15cm dia $24.95

ATHENA BED
With a magnificent high bedhead and surround upholstered in Faba leather in ivory, mocha or black.
Queen bed $999, king bed $1199.
Harmony side table 60 x 60cm $329. **Quattro** bookcase 70 x 35 x 190cm $899
Moonscape quilt cover queen set $179, king set $199, euro pillowcase $29.95
Manzanita throw 130 x 150cm $64.95. **Seafoam** cushion 30 x 50cm $24.95
Levanto table light base 28cmH $59.95. **Square** shade 21cmH $24.95
Buca woven open box from 34 x 24 x 21cm $19.95, tall basket from 25 x 25 x 55cm $39.95
Mendong basket from 31 x 30 x 25cm $19.95, **Orion** vase 12cmH $16.95, 25cmH $36.95
Seaside wall plaque sculpture from 18 x 18cm $11.95, shell ornament from 11cmH $9.95
Avalon multi frame 92 x 29cm $99. **Sambre** wool/rayon striped rug 160 x 230cm $349

MOONSCAPE QUILT COVER SET
With coloured panels, pintucking and beautiful sequin details, in cotton. Queen set $179, king set $199, euro pillowcase $29.95
Manzanita throw in textured soft acrylic 130 x 150cm $64.95
Seafoam cushion in duck egg, coral, green, teal, sage, stone or black velvet 30 x 50cm $24.95

MONTAGUE SOFA
A sophisticated, streamlined look with a simple timber plinth base, square back cushions and sink-in seating. Upholstered in essex check fabric in wedgewood, coffee or natural. Armchair 91 x 91cm $759, 2 seat sofa 182 x 91cm $999, 3 seat sofa 212 x 91cm $1199, ottoman 97 x 61cm $399
Quattro range in solid timber with clear lacquer finish. Coffee table 130 x 70cm $499, side table 60 x 60cm $299, buffet 180 x 45 x 80cm $1499
Pinto cushion in brushed faux suede 45 x 45cm $19.95. **Seafoam** cushion 30 x 50cm $24.95. **Pyramid** table light base in timber with white finish 65cmH $129
Drum linen shade 38cmH $39.95. **Avalon** photo frame 25 x 30cm $39.95, mirror 56 x 61cm $99. **Hazel** wool rug 160 x 230cm $449
Noosa folding timber screen with white painted finish 150 x 176cm $199

12 freedom spring 2006 13

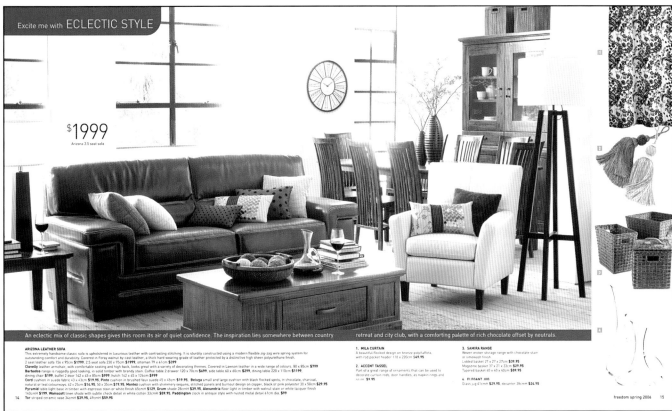

Excite me with **ECLECTIC STYLE**

$1999
Arizona 2.5 seat sofa

An eclectic mix of classic shapes gives this room its air of quiet confidence. The inspiration lies somewhere between country retreat and city club, with a comforting palette of rich chocolate offset by neutrals.

ARIZONA LEATHER SOFA
This extremely handsome classic sofa is upholstered in luxurious leather with contrasting stitching. It is sturdily constructed using a modern flexible zig-zag wire spring system for outstanding comfort and durability. Covered in Foray walnut by-cast leather, a thick hard wearing grade of leather protected by a distinctive high sheen polyurethane finish.
2 seat leather sofa 156 x 95cm $1799, 2.5 seat sofa 230 x 95cm $1999, ottoman 79 x 61cm $399
Clevelly leather armchair, with comfortable seating and high back, looks great with a variety of decorating themes. Covered in Lawson leather in a wide range of colours. 80 x 85cm $799
Barbados range is ruggedly good looking, in solid timber with brandy stain. Coffee table 2 drawer 120 x 70cm $699, side table 60 x 60cm $299, dining table 220 x 110cm $1199, dining chair $199, buffet 2 door 142 x 45 x 85cm $999, hutch 142 x 45 x 126cm $999
Cord cushion in suede fabric 43 x 43cm $19.95. **Pinto** cushion in brushed faux suede 45 x 45cm $19.95. **Beluga** small and large cushion with black flocked spots, in chocolate, charcoal, natural or teal colourways. 42 x 25cm $14.95, 50 x 35cm $19.95. **Montez** cushion with shimmery sequins, stitched panels and burnout design on copper, black or pink polyester 30 x 50cm $29.95
Pyramid table light base in timber with espresso stain or white finish 65cmH $129. **Drum** shade 28cmH $39.95. **Alexandria** floor light in timber with walnut stain or white lacquer finish 140cmH $199. **Wainscott** linen shade with subtle check detail in white cotton 33cmH $59.95. **Paddington** clock in antique style with rusted metal detail 61cm dia $99
Tor striped ceramic vase 34cmH $39.95, 49cmH $59.95

1. **MILA CURTAIN**
A beautiful flocked design on bronze poly/taffeta, with rod pocket header 118 x 220cm $49.95

2. **ACCENT TASSEL**
Part of a great range of ornaments that can be used to decorate curtain rods, door handles, as napkin rings and so on. $9.95

3. **SAMIRA RANGE**
Woven wicker storage range with chocolate stain or limewash finish.
Lidded basket 27 x 27 x 27cm $39.95
Magazine basket 37 x 21 x 33cm $29.95
Tapered basket 40 x 40 x 40cm $59.95

4. **ELEGANT JUG**
Glass jug 41cmH $29.95, decanter 28cmH $24.95

14 freedom spring 2006 15

Every aspect of these pages—and every item of merchandise—contributes to an inviting and soothing mood. Any reader captivated by that mood is sure to find at least one item within the merchandise-packed photographs that they want to own. And that, is what it's all about.

Target

Mass merchandiser

MEDIA: catalog
DIMENSIONS: 7½" x 10½"
PAGES: 52
WEBSITE: www.target.com

This colorful and jammed-packed piece from Target promotes only the company's home collections. The "contemporary" section features the retailer's designer collections: Isaac Mizrahi Home, and Swell by Cynthia Rowley and Ilene Rosenzweig. Both get eye-catching spreads all to themselves (opposite page).

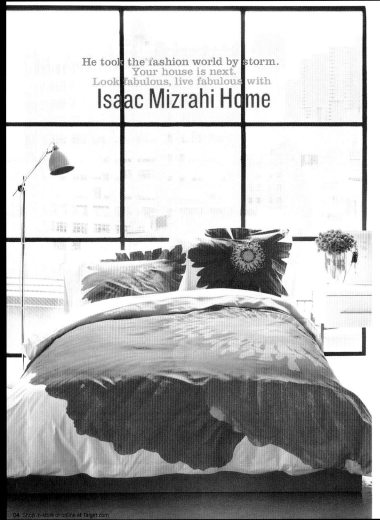

He took the fashion world by storm.
Your house is next.
Look fabulous, live fabulous with

Isaac Mizrahi Home

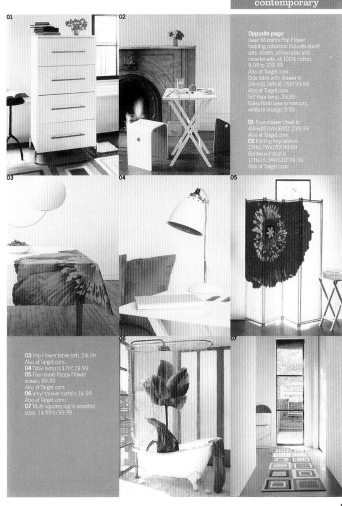

Opposite page:
Isaac Mizrahi's Pop Flower bedding collection includes duvet sets, sheets, pillowcases and coverlet sets, all 100% cotton. 9.99 to 109.99
Also at Target.com.
Side table with drawer is 24Hx15.3Wx16.75D: 99.99
Also at Target.com.
56" floor lamp. 29.99
Glass floral vase in mercury, white or orange. 9.99

01 Four-drawer chest is 48Hx25½Wx16¼D: 239.99
Also at Target.com.
02 Folding tray table is 27Hx17Wx17D: 49.99
Bentwood stool is 17Hx15.3Wx12D: 24.99
Also at Target.com.

03 Pop Flower tablecloth. 24.99
Also at Target.com.
04 Table lamp is 17H: 19.99
05 Four-panel Poppy Flower screen. 99.99
Also at Target.com.
06 Vinyl shower curtain. 14.99
Also at Target.com.
07 Multi-squares rug in assorted sizes. 14.99 to 99.99

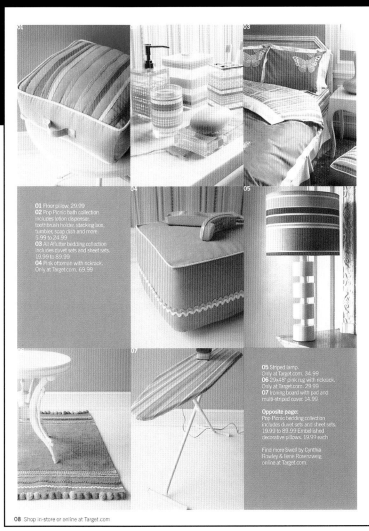

01 Floor pillow. 29.99
02 Pop Picnic bath collection includes lotion dispenser, toothbrush holder, stacking box, tumbler, soap dish and more. 5.99 to 24.99
03 All Aflutter bedding collection includes duvet sets and sheet sets. 19.99 to 89.99
04 Pink ottoman with rickrack. Only at Target.com. 69.99

05 Striped lamp. Only at Target.com. 34.99
06 29x48" pink rug with rickrack. Only at Target.com. 29.99
07 Ironing board with pad and multi-striped cover. 14.99

Opposite page:
Pop Picnic bedding collection includes duvet sets and sheet sets. 19.99 to 89.99 Embellished decorative pillows. 19.99 each

Find more Swell by Cynthia Rowley & Ilene Rosenzweig online at Target.com.

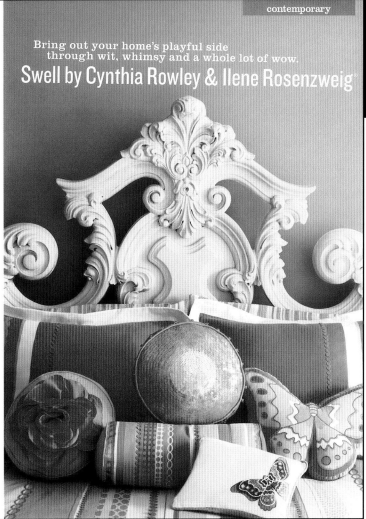

Bring out your home's playful side
through wit, whimsy and a whole lot of wow.

Swell by Cynthia Rowley & Ilene Rosenzweig

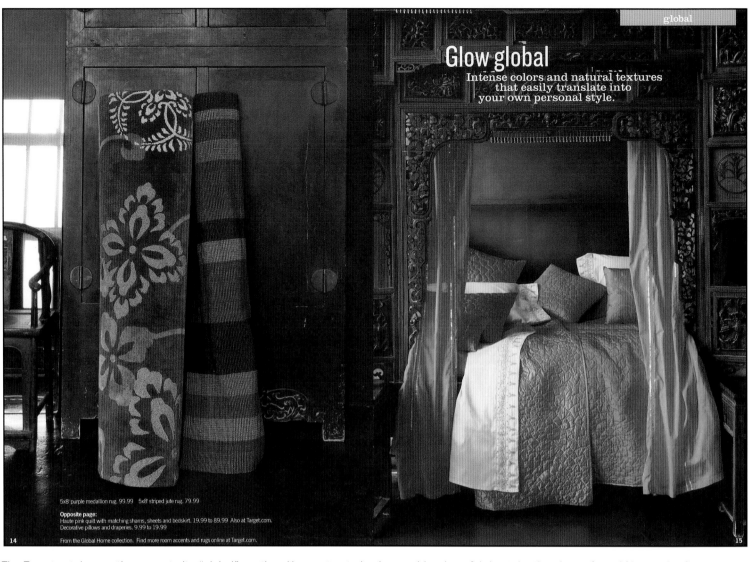

Glow global
Intense colors and natural textures that easily translate into your own personal style.

5x8' purple medallion rug. 99.99 5x8' striped jute rug. 79.99

Opposite page:
Haute pink quilt with matching shams, sheets and bedskirt. 19.99 to 89.99 Also at Target.com.
Decorative pillows and draperies. 9.99 to 19.99

14

From the Global Home collection. Find more room accents and rugs online at Target.com.

15

The Target catalog continues on to its "global" section. Here saturated colors and luscious fabrics take the viewer from Africa to the far east.

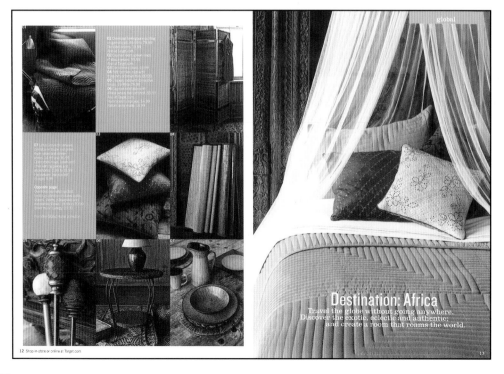

Destination: Africa
Travel the globe without going anywhere.
Discover the exotic, eclectic and authentic;
and create a room that roams the world.

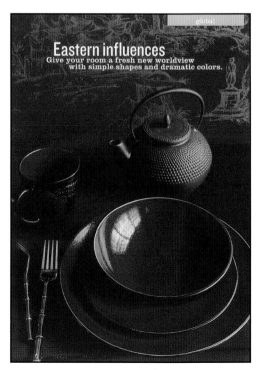

Eastern influences
Give your room a fresh new worldview
with simple shapes and dramatic colors.

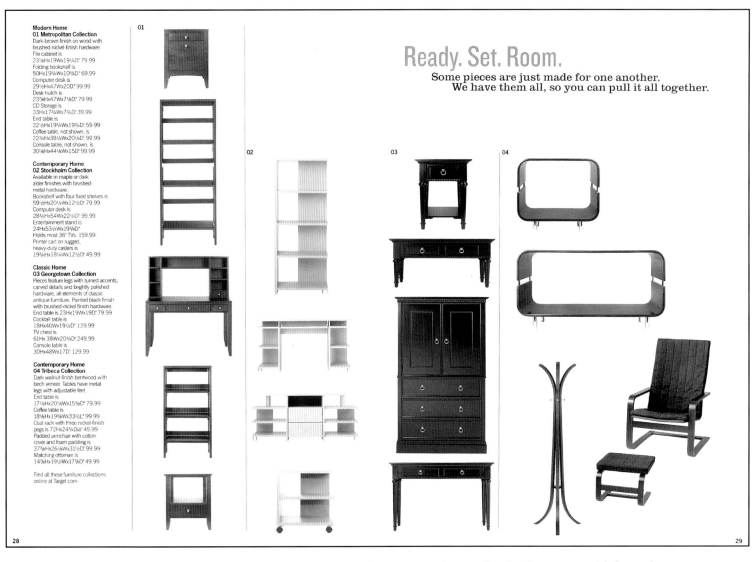

A few spreads forgo the rich colors and elaborate room settings in order to present the merchandise in a very straightforward way.

The last spread of the catalog (below) invites viewers to the website while the back cover gets close and personal with some bed linen.

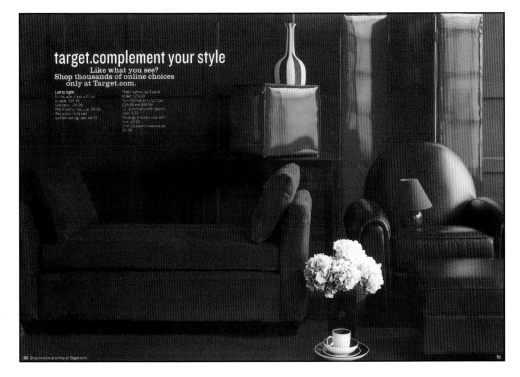

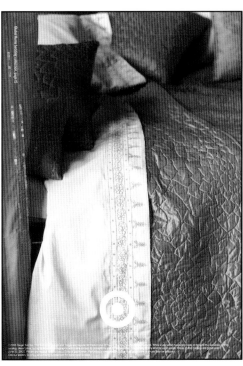

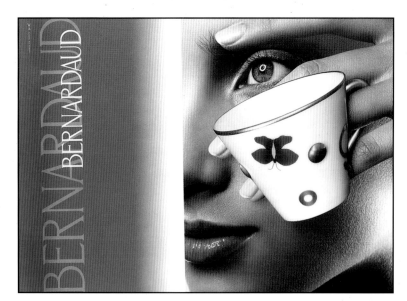

Bernardaud

Porcelain manufacturer

MEDIA: catalog
DIMENSIONS: 11³/₄" x 8¹/₄"
PAGES: 46
WEBSITE: www.bernardaud.fr

An icon of the grand tradition of excellence based in Limoges, France, Bernardaud embodies one of the most innovative spirits among French luxury houses today. A trendsetter in design, its porcelain collections are characterized by delicate colors and original forms, capturing the essence of their time... Traditional or contemporary, the Bernardaud collections elegantly modernize the art of entertaining.

Frivole

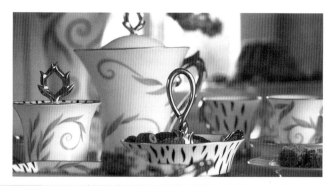

The Frivole collection combines daring originality with soft feminity to create a sophisticated design for the table. Its baroque personality is expressed through its graceful lines and rich finishing touches. A color palette of plum and aniseed green recalls fashionable design trends for today. The Frivole collection perfectly integrates into either a contemporary or traditional interior.

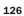

Naxos

Perfection of scale, the purity of white, the refinement of porcelain cast into fluid forms: Naxos exemplifies a resolutely contemporary aesthetic. Inspired by the coffered ceilings of Renaissance castles, its geometric motif emphasizes the sense of depth and quality of the material. Pleasingly understated in design, the Naxos collection adapts itself with elegance and simplicity to each daily moment and in any interior setting. Moving beyond its primary usage, each piece in the collection may be whimsically interpreted, the relish dish as a desk valet, the sugar bowl as a decorative covered box...

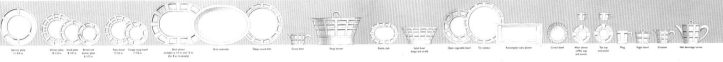

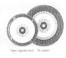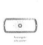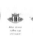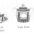

Grand Versailles

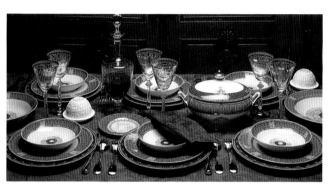

The Grand Versailles service exemplifies French classicism from the 17th and 18th centuries, which Voltaire called "Le Grand Goût." The service creates a luxurious setting with an appearance that is both sumptuous and royal. A highly decorated pattern, the collection is characterized by the richness of its details and its spectacular trompe l'oeil effects. More than 20 colors taken from silk tapestries, embroideries, trimmings, and brocades found at the Versailles château will transport you and your guests to a festive table fit for a king.

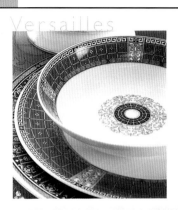

After an introductory spread showing fine porcelain in the making, Bernardaud showcases each pattern with sumptuous table shots and a diagram running the width of the spread. This diagram includes detailed drawings of each piece in the set, clearly labeled and seen in relation to its tablemates. A spread near the end of the catalog gives suggestions as to when to use the various pieces of a collection—a coupe soup bowl versus a rim soup bowl, for instance.

Entertaining ideas

Creating your own table setting is as simple as following your instincts and composing your dinnerware service according to your personal lifestyle. With a little experimentation, you will find that each piece may extend beyond its traditional usage. Just as you might change a few ingredients to spice up a classic recipe, varying the uses of your dinnerware can turn your table into a personal fashion statement. Here are a few hints that you can try as you start to develop your unique entertaining style.

Service plates — The service plate, also called a charger plate, is used to set the overall tone of your table setting and serves to highlight the presentation of the meal. By using these plates to frame each course, your table remains elegantly set from start to finish. You may also use service plates as serving pieces for hors d'oeuvre or appetizer courses.

Salad plates — Consider using a salad plate as an accent to your place setting to meld with your table setting with personal flair. Salad plates are smaller than dinner plates and larger than dessert plates, making them versatile enough to serve as appetizer plates, dessert plates, or luncheon plates.

Bread and butter plates — Bread and butter plates or side plates have been designed with a specific purpose in mind, however you may also use them to serve a small assortment of canapés or petits fours at your next tea party.

Coupe soup bowls — The coupe soup bowl is a noteworthy addition to your dinnerware service. It may be used to enhance a soup course, a green salad, a gazpacho, or even a dessert, such as chocolate cake with crème anglaise sauce or a warm fruit gratin. For a casual pasta dinner, the coupe soup bowl is just the right choice.

Rim soup bowls — The rim soup bowl may be used in a similar way as the coupe soup bowl although its traditional uses imply that it is usually reserved for more formal occasions.

Flat round dishes and oval platters — Versatile with color, these two serving pieces may be used interchangeably or in tandem at any occasion. The flat round dish is best suited to appetizer or cold meat courses, while the oval platter is best used for meat roasts, grilled fish or poultry.

Deep round dishes — For larger servings of main courses, cooked in a sauce, such as stew, stuffed cabbages or bouillabaisse, the deep round dish is the perfect serving piece.

Gravy boats — Traditionally used for serving hot sauces, the gravy boat is equally adept at holding chilled sauces or salad dressings and even maple syrup or caramel sauce.

Soup tureens — The traditionally preferred way to serve soup, it offers both the beauty of a graceful shape and the practicality of a lid to keep its contents warm. At home in both a casual or formal setting, the soup tureen may also be used to serve couscous, beef stews or chili.

Salad bowls — Naturally this bowl has been conceived to serve salad, however it is also perfectly suitable for pasta salad or risotto. In addition, you may use it for serving desserts, such as fruit salad or chocolate mousse.

Open vegetable bowls — The open vegetable bowl is the ideal choice for fresh fruit salads, side dishes of vegetables or grains.

Tart platters — The tart platter is an elegant way to serve small dessert tarts, pastries or quiches at a formal brunch. You may also use it for pancakes, French toast or at a cocktail party for cheese and crackers.

Rectangular cake platters — The perfect way to display a home made cake, this serving platter may also be used for meat loafs, cold terrines, finger sandwiches, cheese and crackers, or other snacks for a luncheon or over an impromptu glass of wine.

Relish dishes — Designed for serving butter and other condiments, the relish dish may also be used to hold snacks such as nuts, olives or chocolates on a buffet. You might also consider placing them at each place setting at a formal dinner party to hold an assortment of mini appetizers.

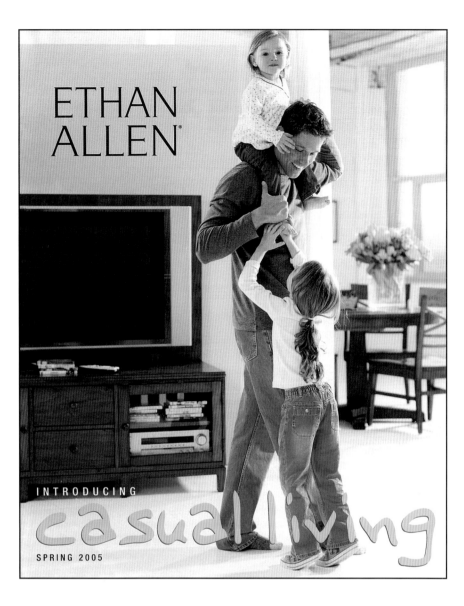

Ethan Allen

As illustrated by the cover shot and explained in the letter on the first page, this catalog "shines the spotlight" on Ethan Allen's casual styles. First up is the new Tango collection. After a page introducing four aspects of the collection (opposite, top), each is given its own page. Lifestyle photos, although small, add lots of warmth and set a casual mood.

Home furnishings and furniture

MEDIA: catalog
DIMENSIONS: 8⅞" x 11"
PAGES: 48
WEBSITE: www.ethanallen.com

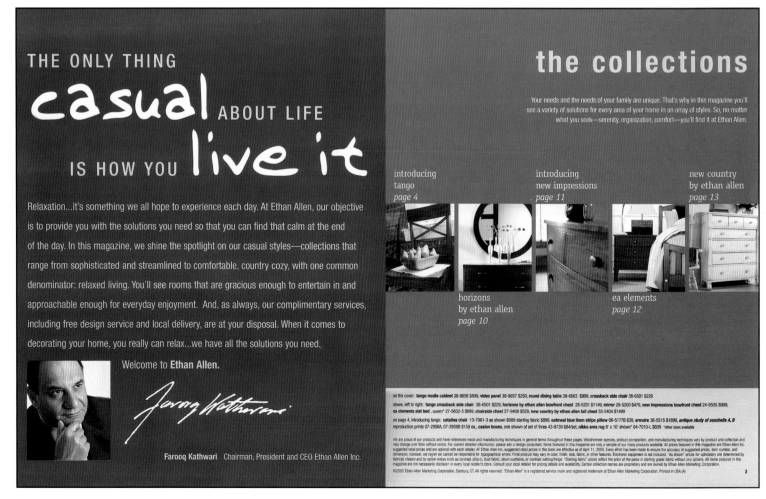

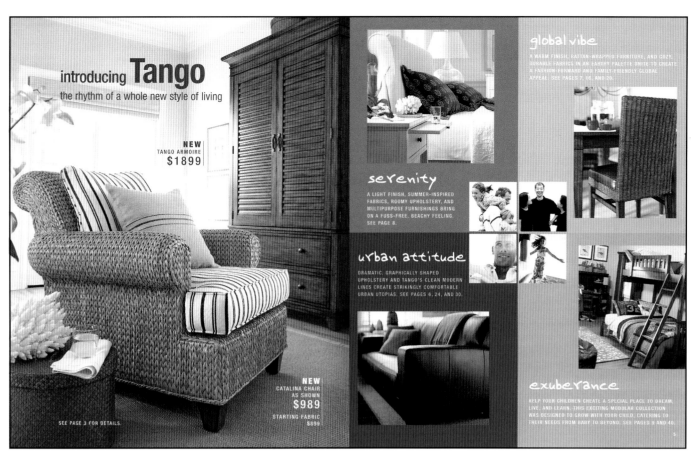

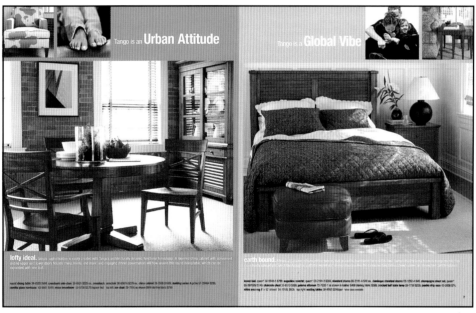

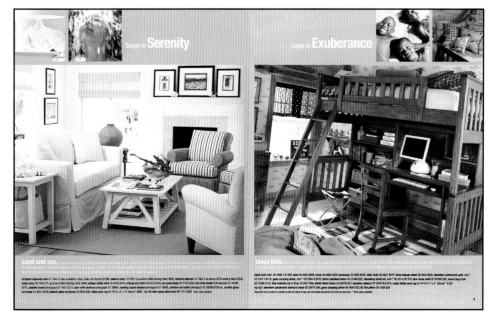

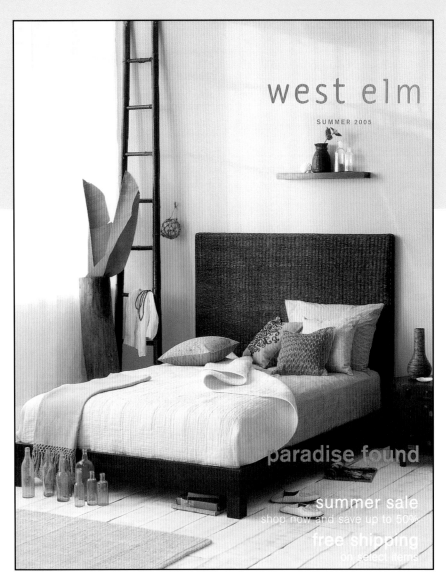

West Elm

A carefully controlled color palette gives the front section of this catalog an eye-pleasing cohesiveness. The complementary color pair of blue and orange predominates and, as any student of color theory knows, complementary colors, when placed side-by-side, reinforce one another— each adding pop to its partner. (Note to the non-color-theorists: complementary colors appear opposite from each other on the color wheel.)

Home funishings and furniture
MEDIA: catalog
DIMENSIONS: 8 3/8" x 10 1/2"
PAGES: 84
WEBSITE: www.westelm.com

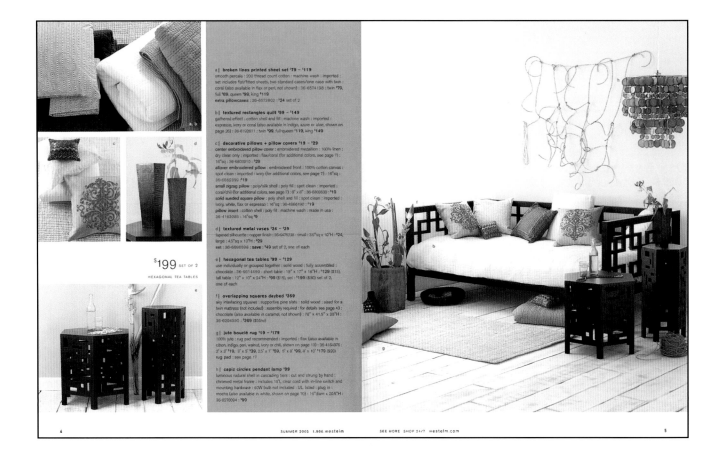

a | **contrast stitch overlay pillow** $24
silk shell : poly fill : imported : spot clean : aloe/white, espresso/flax, turq/chartreuse, coral/chili, indigo/cerulean, white/aloe or ivory/flax : 14"sq : 36-6548705 : $24

b | **center embroidered pillow cover** $29
embroidered medallion : 100% linen : dry clean only : imported : flax/espresso, white/azure, flax/coral or kiwi/cerulean : 16"sq : 36-6603910 : $29

c | **center beaded medallion pillow cover** $19
hand beaded : poly/silk shell : spot clean : imported : tobacco or olive (also available in violet, shown on page 24) : 16"sq : 34-6702906 : $19

d | **allover embroidered pillow cover** $19
embroidered front : 100% cotton canvas : spot clean : imported : light turq, coral, aloe or ivory : 16"sq : 36-6562360 : $19

e | **block print sequin pillow cover** $29
light catching sequins : poly/silk shell : spot clean : imported : coral/espresso, aloe/olive, ivory/espresso or turq/sapphire : 16"sq : 34-6691075 : $29

f | **mirror pillow cover** $24
poly blend shell : spot clean : imported : aloe, azure, chili, espresso, white, indigo or fuchsia : 8" x 16" : 36-6308424 : $24

g | **small zigzag pillow** $19
poly/silk shell : poly fill : spot clean : imported : cilantro/cerulean or coral/chili (also available in lilac/cloud, shown on page 70) : 6" x 8" : 36-6603530 : $19

h | **single tuft cushion** $29
silk dupioni shell and poly fill : can also be used as a floor cushion : spot clean : imported : kiwi, turq, chili, lilac or latte (also available in cloud, shown on page 71) : 22.5"sq : 36-6568588 : $29

i | **pillow inserts** $7 – $9
cotton shell : poly fill : machine wash : made in usa : 36-4163085 :
11" x 16" : $7, 12"sq : $7, 12" x 16" : $8, 16"sq : $9

upholstered cutout chair · molded woven chair + ottoman · simple wood chair · upholstered bucket armchair · wood slit chair

free shipping
sit back, relax and save

$169
CURVED CHAIR

curved chair

a | **upholstered cutout chair** $199.99 free shipping
slim profile : wood construction : foam padding : chromed steel legs : spot clean : mix of usa/imported fabrics : simple assembly : solid textured cotton or organic squared print : solid in indigo or flax (also available in sky, shown on page 83) : print in flax : 26" x 25" x 30"H : 36-6236244 : $299 sale price $199.99 ($30)

b | **molded woven chair + ottoman** $149 – $249 free shipping
comfortable contoured shape : hidden black iron frame for support : covered in woven fiber
chair : 24.75" x 24.25" x 29.25"H : 36-6562243 : $249 ($25)
ottoman : 25" x 20" x 18"H : 36-6568927 : $149 ($25)

c | **simple wood chair** $299.99 free shipping
slim lines : poly foam cushions : wood construction : simple assembly : chocolate : sky linen (also available in espresso or flax linen) : chair : 33" x 32" x 29"H : 36-6674756 : $399 sale price $299.99 ($30xd)
additional cushion covers : 36-6572549 : $129 sale price $79.99
simple wood sofa : see page 58

d | **upholstered bucket armchair** $249.99 free shipping
upholstered frame with metal legs : spot clean : imported : flax suede-texture or spot : 34" x 29" x 29"H : 36-6561875 : $399 sale price $249.99 ($30)

e | **wood slit chair** $199.99 free shipping
comfortable curves : padded seat : upholstered in imported natural cotton twill : wood construction : spot clean : simple assembly : chocolate : 24.5" x 19.5" x 31.5"H : 36-6202600 : $299 sale price $199.99 ($25)

f | **curved chair** $119.99 – $169 free shipping
upholstered vinyl seat : chrome plated legs : simple assembly : white or aloe : 29.5" x 25.3" x 27.9"H : 36-6696127 : $169 sale price $119.99 ($15)

free shipping on select items through july 31, 2005

Flor

A company devoted entirely to modular rugs and floor coverings (everything comes in mix and match square tiles), takes it customers step by step through the process of planning, ordering and installing modular flooring. The graphics on the first page (below) reinforce the copy. Of the four easy steps outlined number four is of particular interest to the "green" customer: Flor promises to pick up, and recycle, any of its products the customer no longer wants.

Home furnishings

MEDIA: catalog
DIMENSIONS: 8³/₄" x 10¹/₂"
PAGES: 56
WEBSITE: www.florcatalog.com

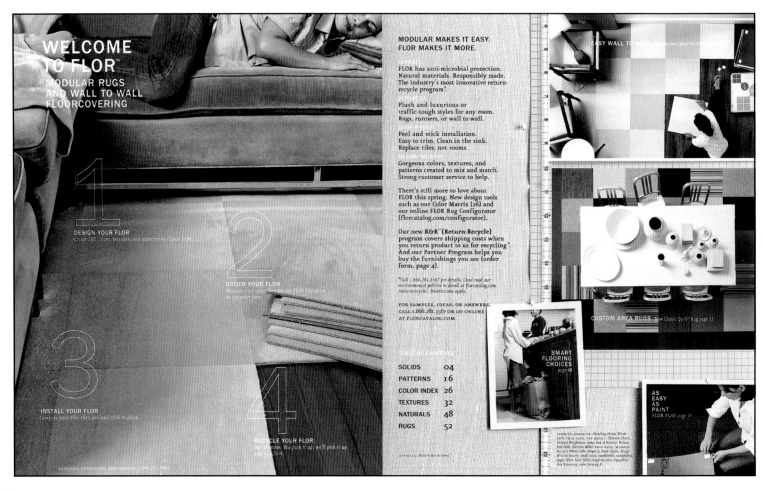

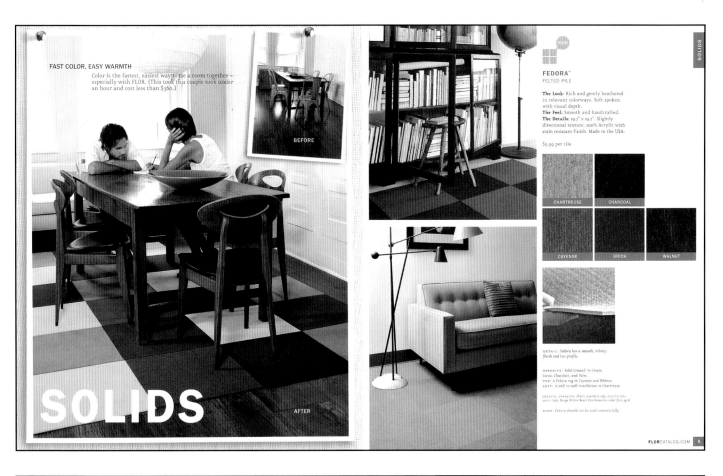

FAST COLOR, EASY WARMTH

Color is the fastest, easiest way to tie a room together ~ especially with FLOR. (This took this couple took under an hour and cost less than $360.)

SOLIDS

BEFORE

AFTER

FEDORA™
FELTED PILE

The Look: Rich and gently heathered in relevant colorways. Soft spoken with visual depth.
The Feel: Smooth and handcrafted.
The Details: 19.7" x 19.7". Slightly directional texture. 100% Acrylic with stain resistant finish. Made in the USA.

$9.99 per tile.

CHARTREUSE | CHARCOAL

CAYENNE | BRICK | WALNUT

DETAIL: *Fedora has a smooth, velvety finish and low profile.*

OPPOSITE: *Solid Ground™ in Cream, Cocoa, Chocolate, and Palm.*
TOP: *A Fedora rug in Cayenne and Walnut.*
LEFT: *A wall to wall installation in Chartreuse.*

CREDITS, OPPOSITE: *Chairs, Guéridon, sofa, Lost City Arts. LEFT: Sofa, Design Within Reach (See Resources, order form pg 4)*

NOTE: *Fedora should not be used commercially.*

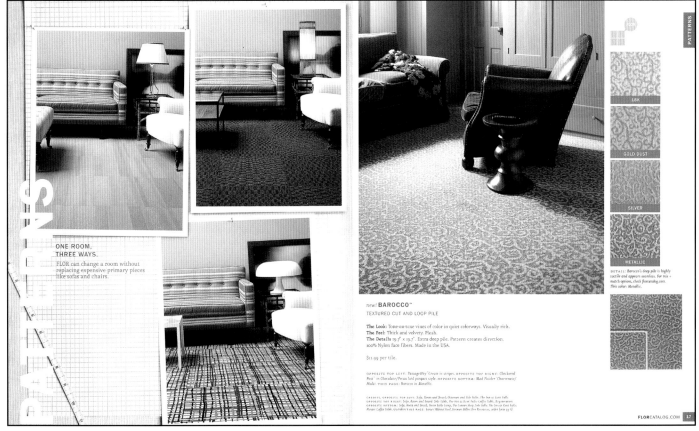

PATTERNS

ONE ROOM, THREE WAYS.

FLOR can change a room without replacing expensive primary pieces like sofas and chairs.

new! **BAROCCO™**
TEXTURED CUT AND LOOP PILE

The Look: Tone-on-tone vines of color in quiet colorways. Visually rich.
The Feel: Thick and velvety. Plush.
The Details 19.7" x 19.7". Extra deep pile. Pattern creates direction. 100% Nylon face fibers. Made in the USA.

$11.99 per tile.

18K

GOLD DUST

SILVER

METALLIC

DETAIL: *Barocco's deep pile is highly tactile and appears seamless. For mix + match options, check florcatalog.com. This color: Metallic.*

OPPOSITE TOP LEFT: *PassageWay™ Cream in stripes.* OPPOSITE TOP RIGHT: *Checkered Past™ in Chocolate/Pecan laid parquet style.* OPPOSITE BOTTOM: *Mad Plaider Chartreuse/Mula.* THIS PAGE: *Barocco in Metallic.*

CREDITS, OPPOSITE TOP LEFT: *Sofa, Room and Board, Ottoman and Side Table, The Inn at Kent Falls. OPPOSITE TOP RIGHT: Sofa, Room and Board. Side Table, The Inn at Kent Falls. Coffee Table, Regeneration. OPPOSITE BOTTOM: Sofa, Room and Board, Atom Table Lamp, The Conran Shop, Side Table, The Inn at Kent Falls. Mosaic Coffee Table, Guéridon. THIS PAGE: Lucas Walnut Stool, Herman Miller (See Resources, order form pg 4)*

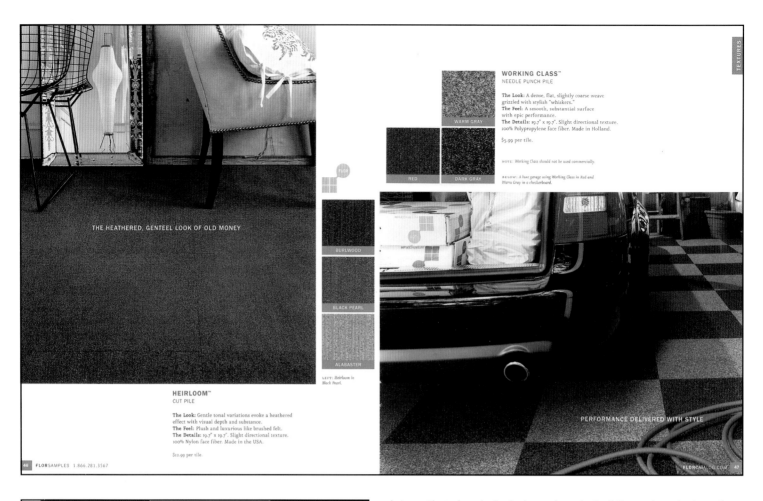

WORKING CLASS™
NEEDLE PUNCH PILE

The Look: A dense, flat, slightly coarse weave grizzled with stylish "whiskers."
The Feel: A smooth, substantial surface with epic performance.
The Details: 19.7" x 19.7". Slight directional texture. 100% Polypropylene face fiber. Made in Holland.

$5.99 per tile.

NOTE: Working Class should not be used commercially.

BELOW: A luxe garage using Working Class in Red and Warm Gray in a checkerboard.

WARM GRAY

RED DARK GRAY

THE HEATHERED, GENTEEL LOOK OF OLD MONEY

FLOR

BURLWOOD

BLACK PEARL

ALABASTER

LEFT: Heirloom in Black Pearl.

HEIRLOOM™
CUT PILE

The Look: Gentle tonal variations evoke a heathered effect with visual depth and substance.
The Feel: Plush and luxurious like brushed felt.
The Details: 19.7" x 19.7". Slight directional texture. 100% Nylon face fiber. Made in the USA.

$12.99 per tile.

PERFORMANCE DELIVERED WITH STYLE

46 FLORSAMPLES 1.866.281.3567

FLORCATALOG.COM 47

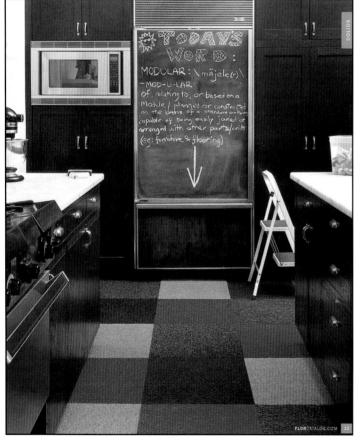

Interesting visuals include a nice shot of the exhaust pipe of a car (promoting flooring for the garage and including a peek of Flor product boxes), and a kitchen chalkboard that steps out of character, so to speak, and talks directly to the viewer via a definition of the word modular. Also included is a page showing the company's website.

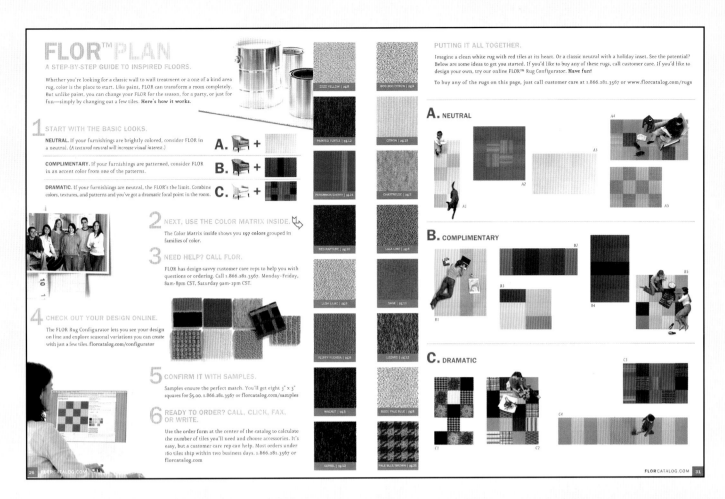

The center spread is a gatefold. Closed, it presents clear information on how to order; opened, its wide expanse is utilized to show the complete collection of tiling.

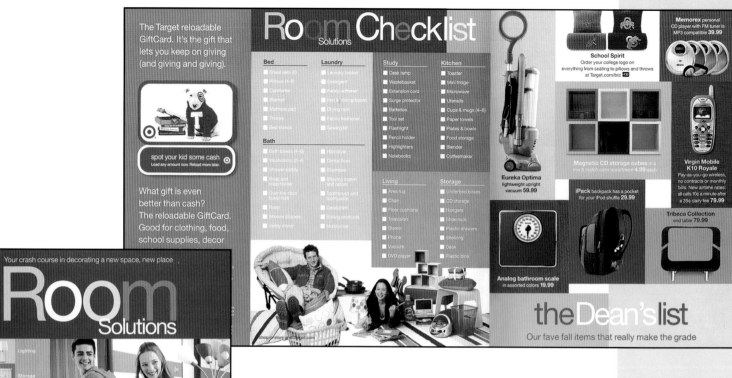

Target

Target offers a "crash course in decorating a new space" to the college bound. The first spread (above) includes a handy-dandy checklist. Many spreads are headed with pseudo course titles—"Spatial Planning 101" even has a "before" picture. "Wetland Survival Studies" is an especially fun way to sell bath and shower necessities.

Mass merchandiser

MEDIA: catalog
DIMENSIONS: 6¹/₂" x 9¹/₈"
PAGES: 52
WEBSITE: www.target.com

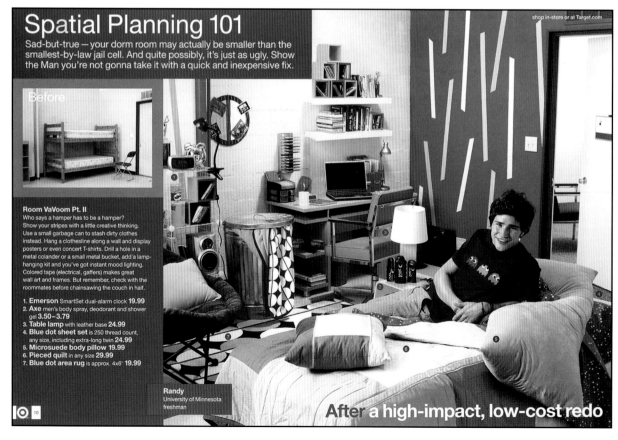

Department Chair

The room may be small, but it's also ugly. Fix that with stylish seating that was made for small spaces. These are all designed with serious relaxing (and yeah, some studying) in mind.

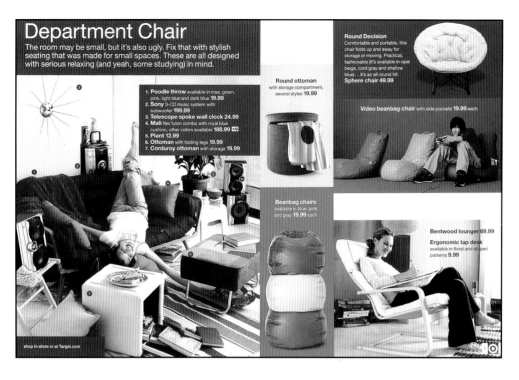

1. **Poodle throw** available in rose, green, pink, light blue and dark blue **19.99**
2. **Sony** 3-CD music system with subwoofer **199.99**
3. **Telescope spoke wall clock** **24.99**
4. **Mali** flex futon combo with royal blue cushion, other colors available **188.99**
5. **Plant** **12.99**
6. **Ottoman** with folding legs **19.99**
7. **Corduroy ottoman** with storage **19.99**

Round ottoman with storage compartment, several styles **19.99**

Round Decision
Comfortable and portable, this chair folds up and away for storage or moving. Practical, fashionable (it's available in opal beige, cord gray and shallow blue)...it's an all-round hit.
Sphere chair **49.99**

Video beanbag chair with side pockets **19.99** each

Beanbag chairs available in blue, pink and gray **19.99** each

Bentwood lounger **69.99**

Ergonomic lap desk available in floral and striped patterns **9.99**

shop in-store or at Target.com

The Psychology of Sleep

One thing is for sure, you certainly won't be majoring in sleep. On average college students get less shut-eye than new parents. (Yikes!) Make up for it with bedding you've been dreaming about.

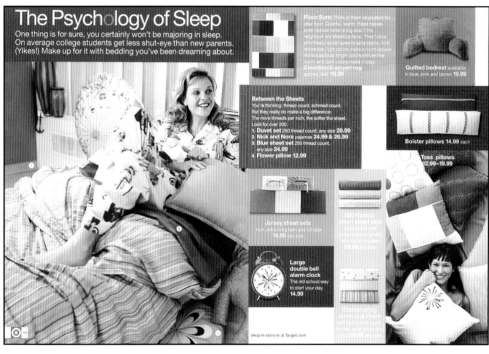

Floor Sure: Think of them as posters for your floor. Colorful, warm, these babies even reduce noise (a big deal if the neighbors are Metallica fans). They'll also effortlessly cover questionable stains. And remember, light colors make a room appear more spacious, bright colors enliven the room, and dark colors make it cozy.
Colorblock woven rug approx. 4x8 **19.99**

Quilted bedrest available in blue, pink and brown **19.99**

Between the Sheets
You're thinking: thread count, schmed count. But they really do make a big difference. The more threads per inch, the softer the sheet. Look for over 200.
1. **Duvet set** 250 thread count, any size **29.99**
2. **Nick and Nora** pajamas **24.99 & 26.99**
3. **Blue sheet set** 250 thread count, any size **24.99**
4. **Flower pillow** **12.99**

Bolster pillows **14.99** each

Toss pillows **12.99–19.99**

Jersey sheet sets twin, extra-long twin and full size **14.99** any size

Large double bell alarm clock The old school way to start your day. **14.99**

shop in-store or at Target.com

Wetland Survival Studies

Now that you're sharing this morning ritual with a whole floor (or at least a roommate or two) a stocked shower caddy is a must. Your life in a little plastic basket? Yes, it really has come to that.

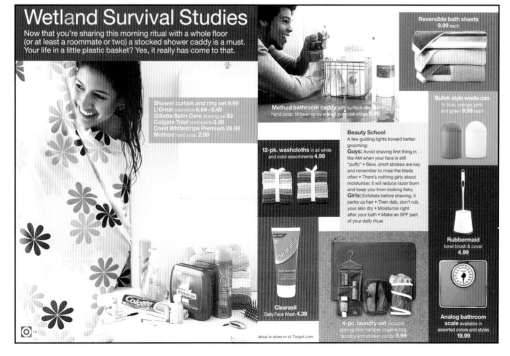

Reversible bath sheets **9.99** each

Shower curtain and ring set **9.99**
L'Oreal cosmetics **6.64–8.49**
Gillette Satin Care shaving gel **$2**
Colgate Total toothpaste **2.99**
Crest Whitestrips Premium **29.99**
Method hand soap **2.99**

Method bathroom caddy with surface disinfectant, hand soap, shower spray and all-purpose wipes **9.99**

Bullet-style waste can in blue, orange, pink and green **9.99** each

12-pk. washcloths in all white and color assortments **4.99**

Beauty School
A few guiding lights toward better grooming:
Guys: Avoid shaving first thing in the AM when your face is still "puffy" • Slow, short strokes are key and remember to rinse the blade often • There's nothing girly about moisturizer, it will reduce razor burn and keep you from looking flaky.
Girls: Exfoliate before shaving, it perks up hair • Then dab, don't rub, your skin dry • Moisturize right after your bath • Make an SPF part of your daily ritual

Rubbermaid bowl brush & cover **4.99**

Clearasil Daily Face Wash **4.39**

4-pc. laundry set includes pop-up mesh hamper, lingerie bag, laundry and shower caddy **9.99**

Analog bathroom scale available in assorted colors and styles **19.99**

shop in-store or at Target.com

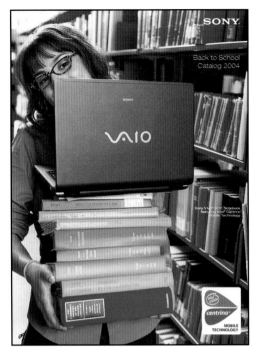

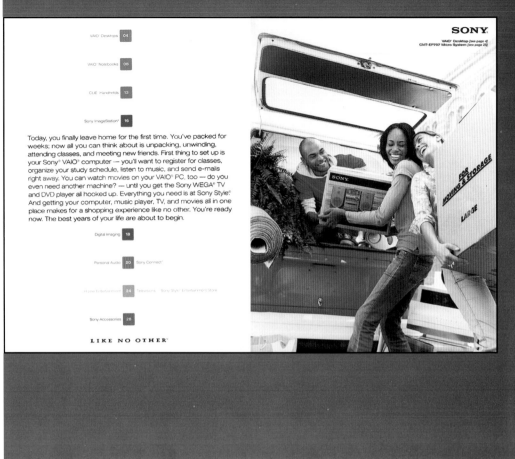

Sony

Home electronics

MEDIA: catalog
DIMENSIONS: 7 $^7/_8$" x 10 $^1/_2$"
PAGES: 32
WEBSITE: www.sonystyle.com/reg

Sony assumes, perhaps correctly, that no college kid can live without a room full of electronic gadgetry, and where there's a need…. The middle spread (below) is a feel-good-about-the-company montage.

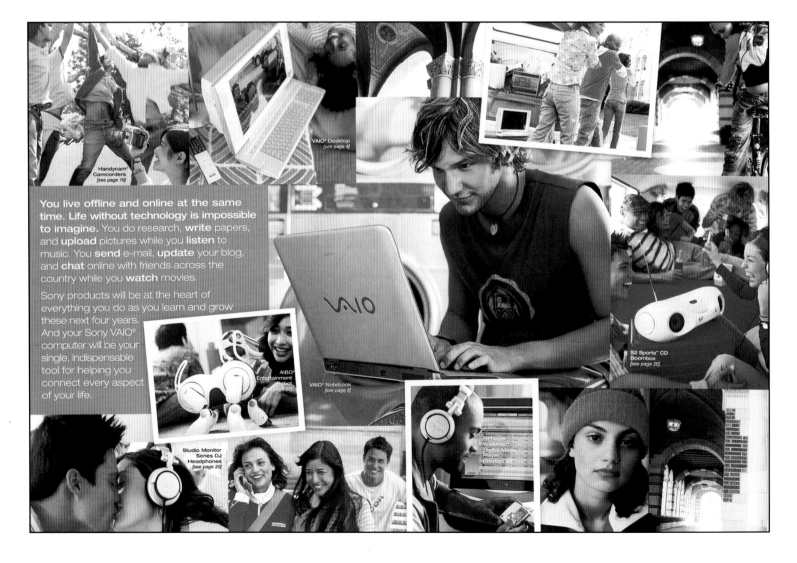

Friends and good times? Sure. Images of study and hard work never sold anything.

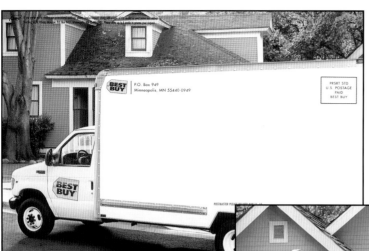

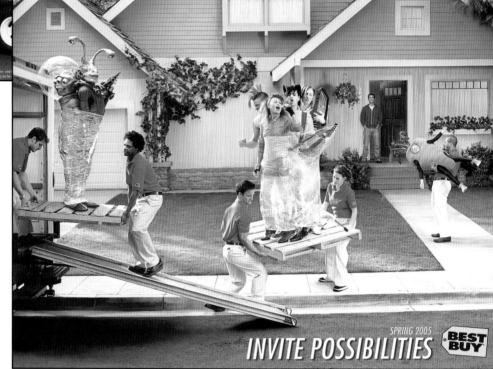

Best Buy

Home Electronics

MEDIA: catalog
DIMENSIONS: 10³/₈" x 8"
PAGES: 64
WEBSITE: www.bestbuy.com

Visualization is the key to this catalog from Best Buy. On the cover "Possibilities" are unloaded from the Best Buy delivery truck (seen in full on the back cover), only here, substituted for the electronic items themselves, are the wrapped entertainment (or entertainers) the electronic gear makes possible. The company's computer support services are brought to life via a "Geek Squad" (below).

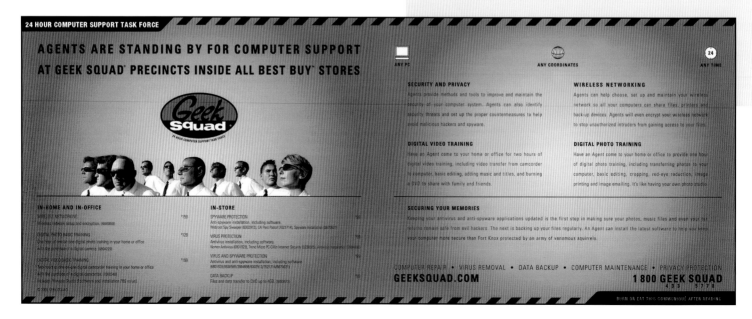

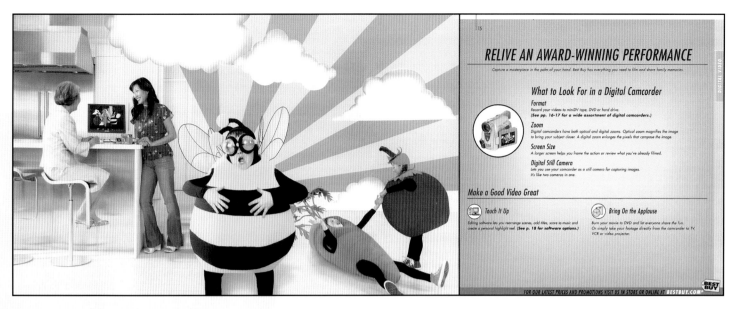

On the introductory spread for each product category, a surreal vignette allows that product's uses to be visualized. Digital recorders are for kids and grandmas; home computers are for planning trips; and home theater systems are for laser-gun-wielding space aliens.

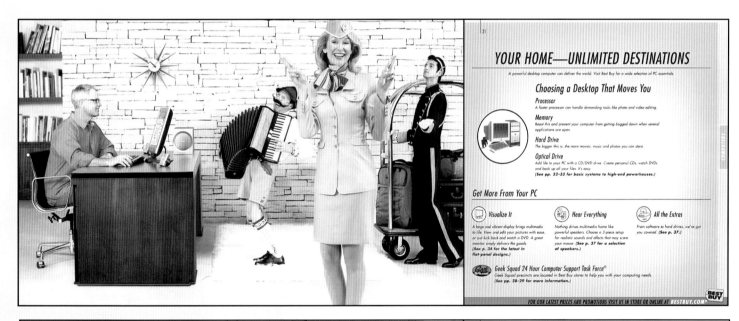

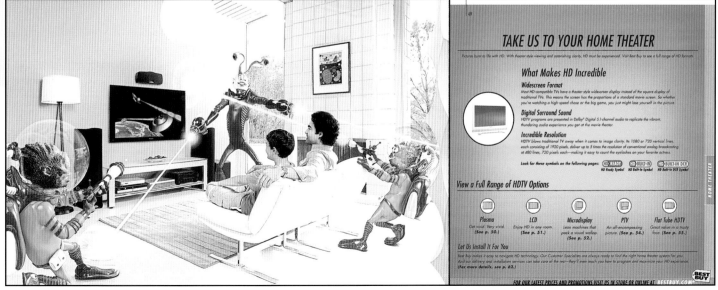

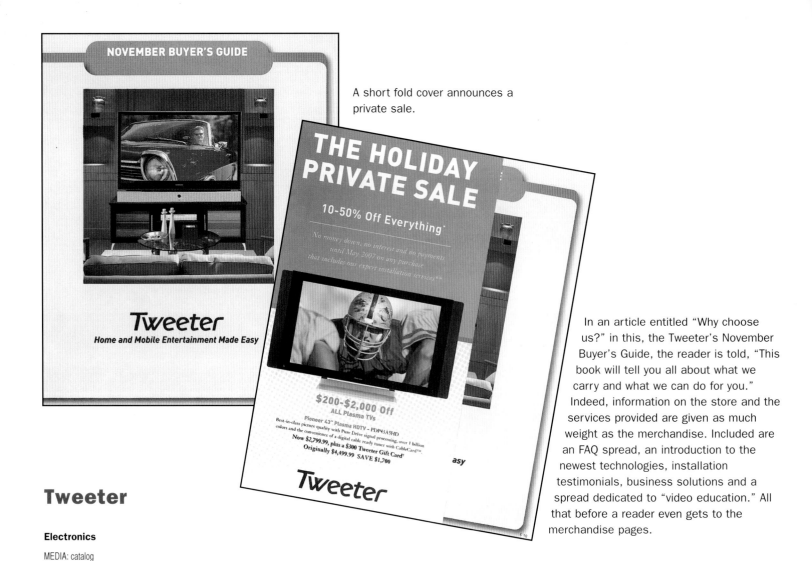

A short fold cover announces a private sale.

In an article entitled "Why choose us?" in this, the Tweeter's November Buyer's Guide, the reader is told, "This book will tell you all about what we carry and what we can do for you." Indeed, information on the store and the services provided are given as much weight as the merchandise. Included are an FAQ spread, an introduction to the newest technologies, installation testimonials, business solutions and a spread dedicated to "video education." All that before a reader even gets to the merchandise pages.

Tweeter

Electronics

MEDIA: catalog
DIMENSIONS: 8³/₄" x 10¹/₂"
PAGES: 94
WEBSITE: www.tweeter.com

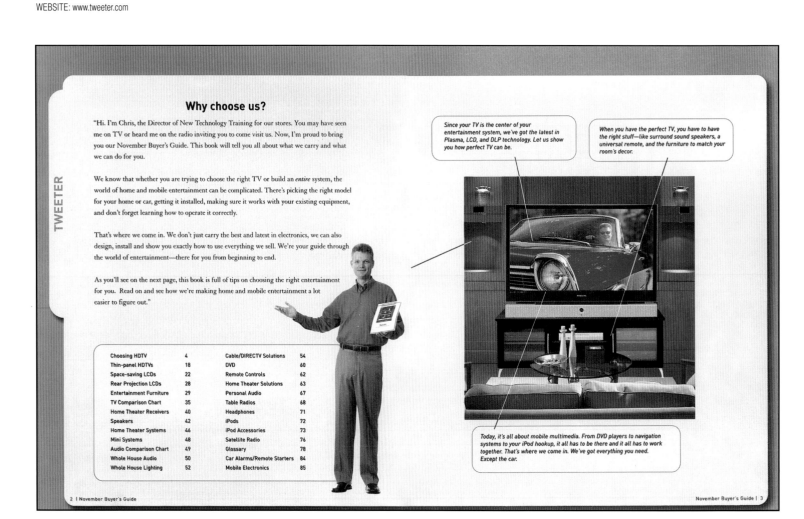

Why choose us?

"Hi, I'm Chris, the Director of New Technology Training for our stores. You may have seen me on TV or heard me on the radio inviting you to come visit us. Now, I'm proud to bring you our November Buyer's Guide. This book will tell you all about what we carry and what we can do for you.

We know that whether you are trying to choose the right TV or build an *entire* system, the world of home and mobile entertainment can be complicated. There's picking the right model for your home or car, getting it installed, making sure it works with your existing equipment, and don't forget learning how to operate it correctly.

That's where we come in. We don't just carry the best and latest in electronics, we can also design, install and show you exactly how to use everything we sell. We're your guide through the world of entertainment—there for you from beginning to end.

As you'll see on the next page, this book is full of tips on choosing the right entertainment for you. Read on and see how we're making home and mobile entertainment a lot easier to figure out."

Since your TV is the center of your entertainment system, we've got the latest in Plasma, LCD, and DLP technology. Let us show you how perfect TV can be.

When you have the perfect TV, you have to have the right stuff—like surround sound speakers, a universal remote, and the furniture to match your room's decor.

Today, it's all about mobile multimedia. From DVD players to navigation systems to your iPod hookup, it all has to be there and it all has to work together. That's where we come in. We've got everything you need. Except the car.

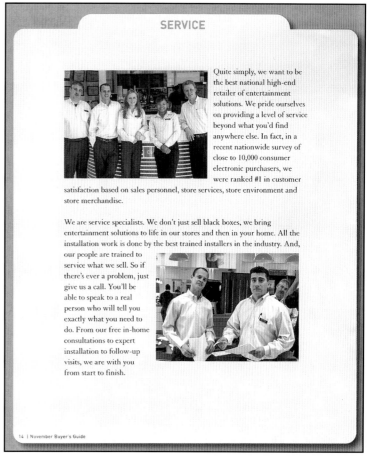

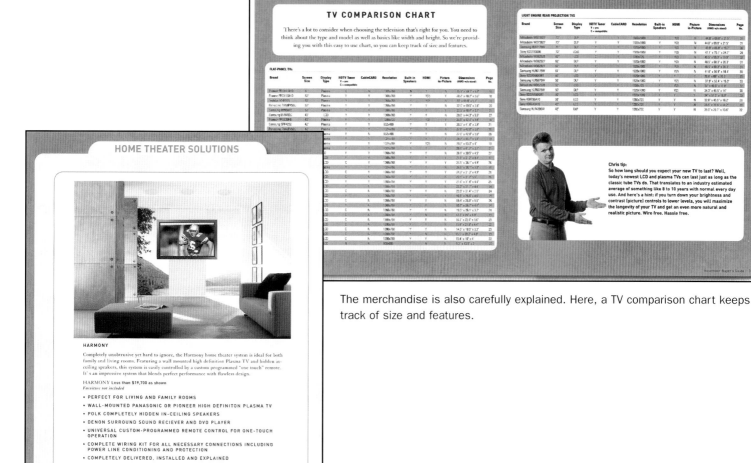

The merchandise is also carefully explained. Here, a TV comparison chart keeps track of size and features.

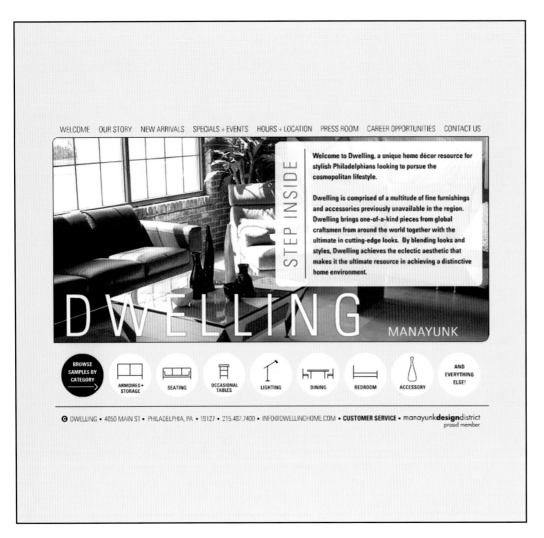

Dwelling

Home furnishings and furniture

MEDIA: website/magazine ads
WEBSITE: www.dwellinghome.com

An attractive, consistent design is carried through every page of the Dwelling site. Icons with simple line drawings allow browsers to view different categories of merchandise. No page is overlooked—even the "our story" and "hours + location" pages are as carefully considered as the home page and the merchandise pages. The icons and the background color act as a common denominator throughout the site.

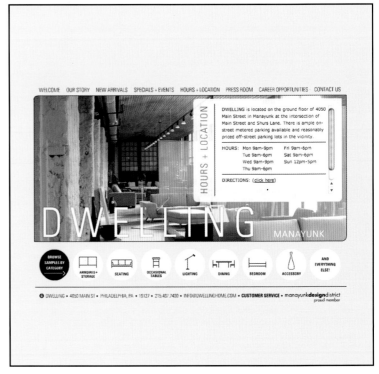

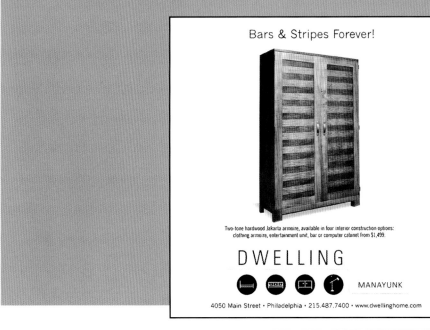

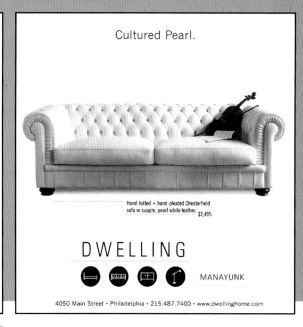

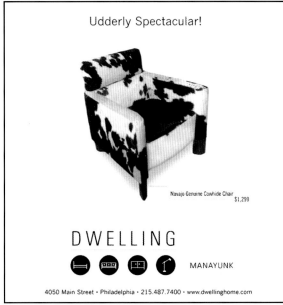

Icons found on small-space magazine
ads echo the design of the website.

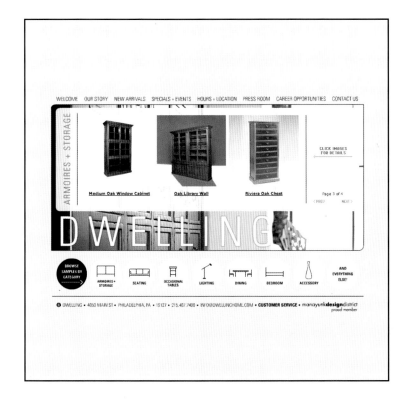

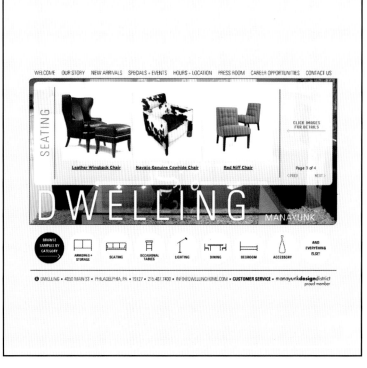

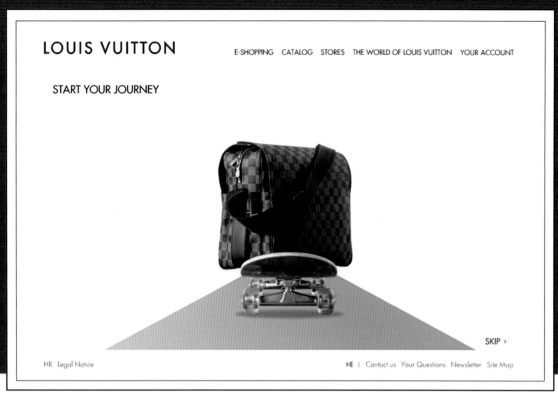

LOUIS VUITTON

E-SHOPPING CATALOG STORES THE WORLD OF LOUIS VUITTON YOUR ACCOUNT

START YOUR JOURNEY

SKIP ›

HR Legal Notice ◀| | Contact us Your Questions Newsletter Site Map

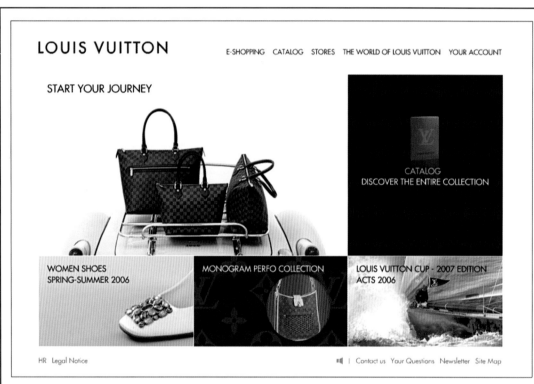

LOUIS VUITTON

E-SHOPPING CATALOG STORES THE WORLD OF LOUIS VUITTON YOUR ACCOUNT

START YOUR JOURNEY

CATALOG
DISCOVER THE ENTIRE COLLECTION

WOMEN SHOES
SPRING-SUMMER 2006

MONOGRAM PERFO COLLECTION

LOUIS VUITTON CUP - 2007 EDITION
ACTS 2006

HR Legal Notice ◀| | Contact us Your Questions Newsletter Site Map

Louis Vuitton

Louis Vuitton's website playfully opens with a handbag riding a skateboard. The home page invites viewers to explore the site with changing images of Vuitton merchandise on different modes of transportation—all under the headline, "start you journey." (Shown below are close-ups of the various modes of transportation.)

Leather goods and accessories

MEDIA: webstie

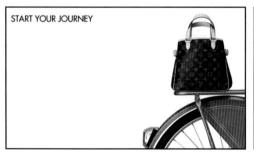

START YOUR JOURNEY

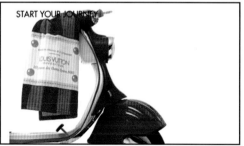

START YOUR JOURNEY

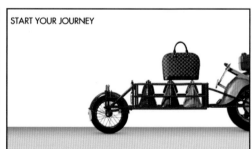

START YOUR JOURNEY

146

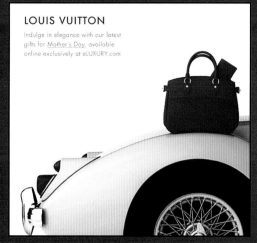

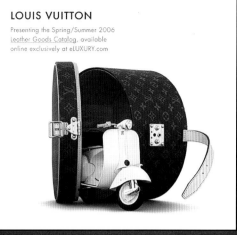

The transportation-inspired imagery was also utilized for e-broadcasts.

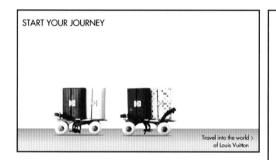

An image of wallets riding an old-fashioned pair of roller skates leads viewers to the product pages (right). Selecting a small circle brings the product it contains into view in the large circle.

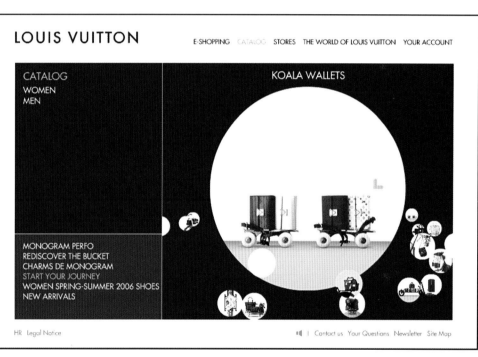

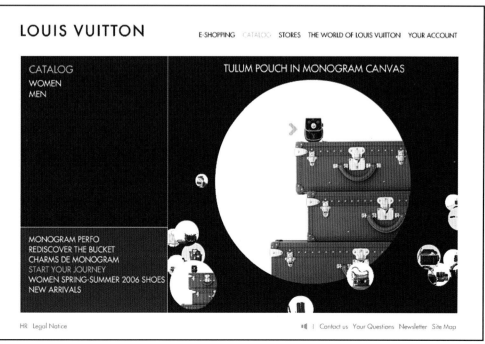

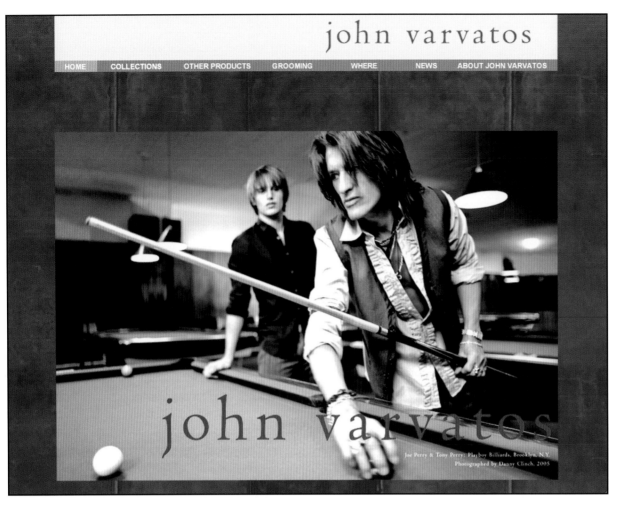

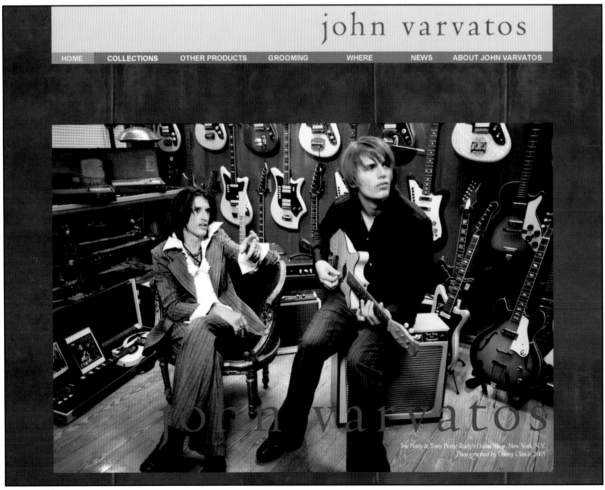

John Varatos

Designer fashion
MEDIA: website
WEBSITE: www.johnvarvatos.com

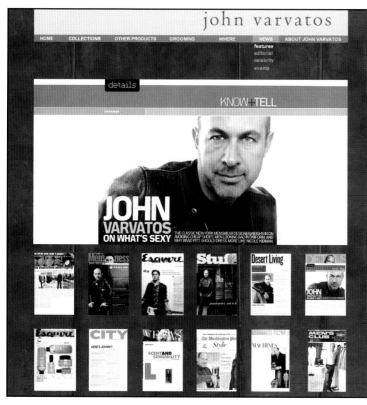

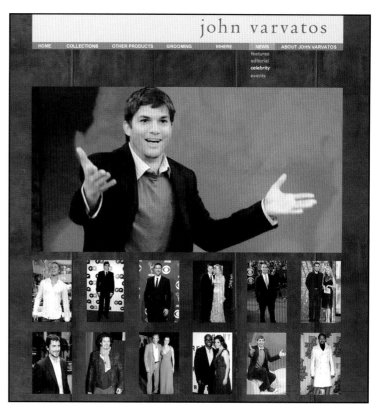

It's certainly not news that celebrity and fashion have become inseparable partners in the art of self promotion and, as John Varvatos demonstrates here, the Internet has added yet another outlet for exposure. The home page (opposite) morphs back and forth between two images from the fall print campaign featuring Aerosmith rocker Joe Perry and his son Tony. Other pages from the site neatly display examples of Varvatos in the press and on the backs of assorted celebs.

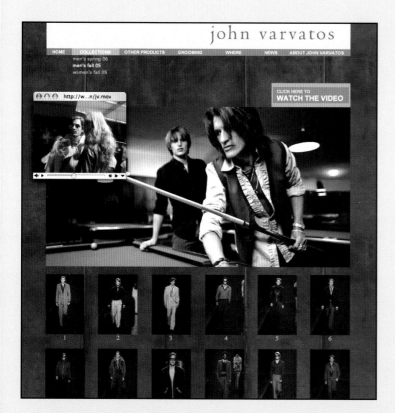

No one is forgetting about the merchandise—it is viewable both via still photography and a video.

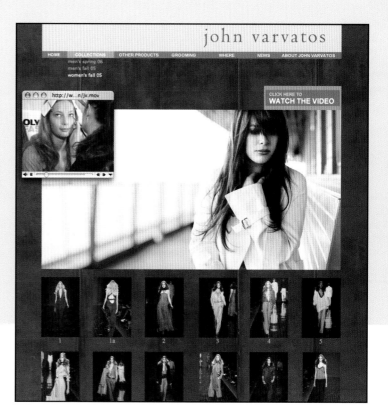

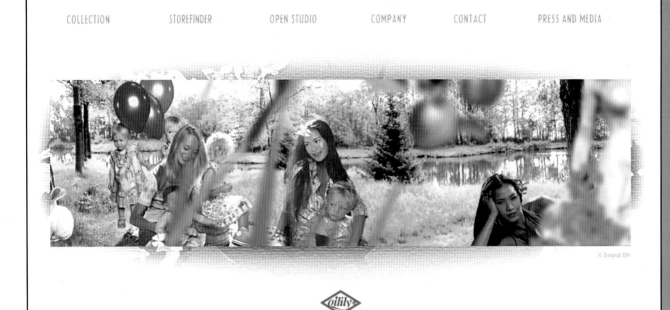

COLLECTION STOREFINDER OPEN STUDIO COMPANY CONTACT PRESS AND MEDIA

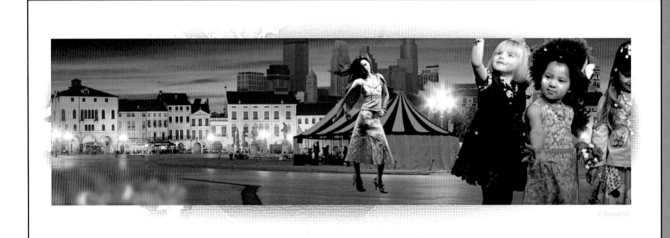

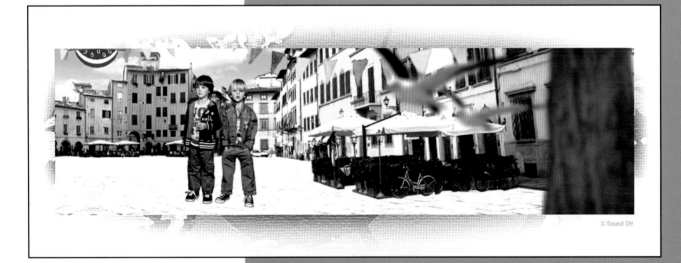

Oilily

Women's and children's apparel

MEDIA: website
WEBSITE: www.oililyUSA.com

The Oilily homepages features a delightful, movable mural. The image can be panned from side to side using the cursor. The scene changes from a sun-filled meadow to a colorful town and the figures appear and disappear along the way.

Another section of the site called "open studio" opens onto a bare-looking studio space. As the viewer watches a piece of furniture "falls" into the scene and opens up. Running the cursor over its compartments allows selections to be made. When a selection is made another piece of furniture "falls" into the middle of the empty storage space. For example, after "biography" is selected a cabinet falls into place, its doors swing open and out pops a photo as illustrations "grow" from a pedestal. This assemblage allows another selection to be made.

Open Studio of Rianne Makkink & Jurgen Bey

Open Studio of Rianne Makkink & Jurgen Bey

Biography

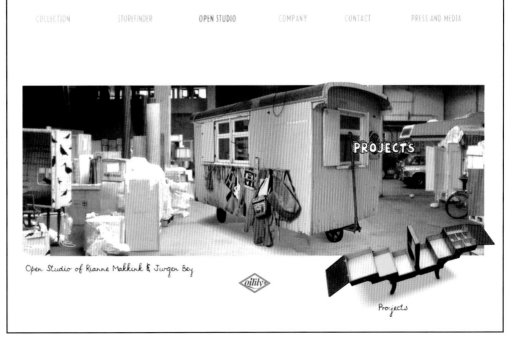

Open Studio of Rianne Makkink & Jurgen Bey

Projects

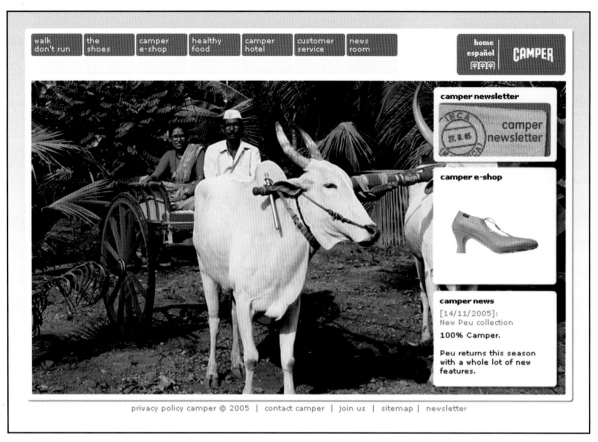

Everything Camper does is out of the ordinary, including its website. One section of which (first page, below) pairs shoes with indigenous peoples and the art they create. A very handsome water buffalo graces the home page (above).

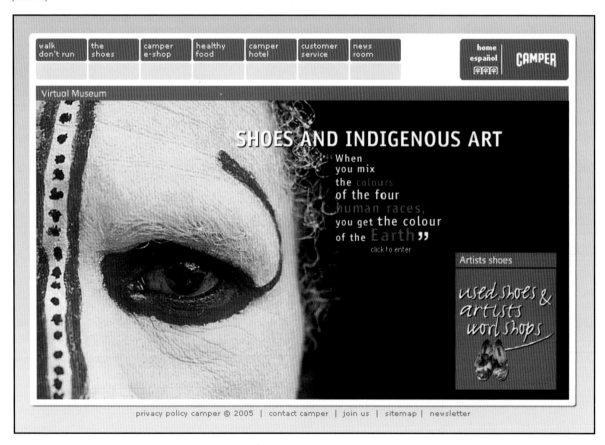

Camper

Shoe manufacturer

MEDIA: website
WEBSITE: www.camper.com

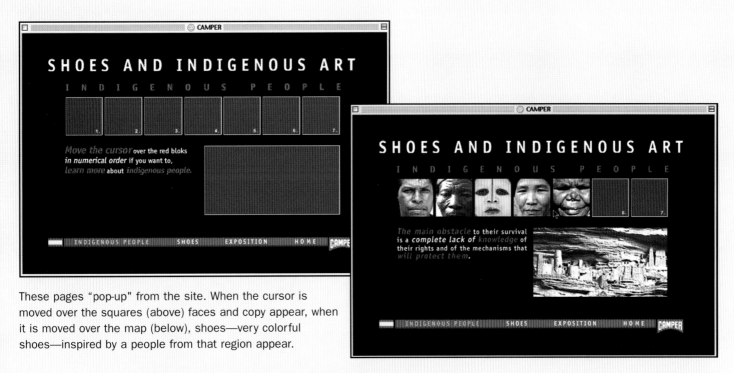

These pages "pop-up" from the site. When the cursor is moved over the squares (above) faces and copy appear, when it is moved over the map (below), shoes—very colorful shoes—inspired by a people from that region appear.

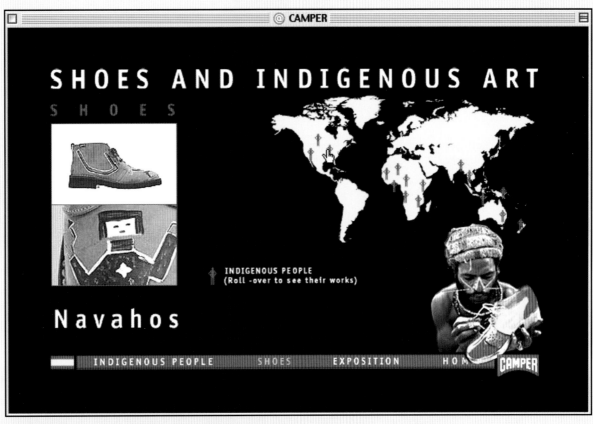

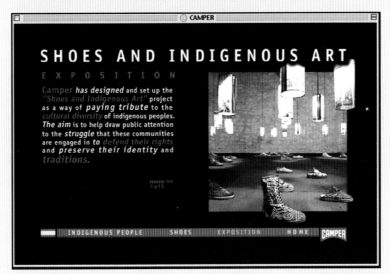

Camper has set up an exposition entitled "Shoes and Indigenous Art." A great way to combat the sameness of mass culture

Polo Jeans Co. Ralph Lauren

Sportswear

MEDIA: Magazine ads, website
WEBSITE: www.polojeans.com

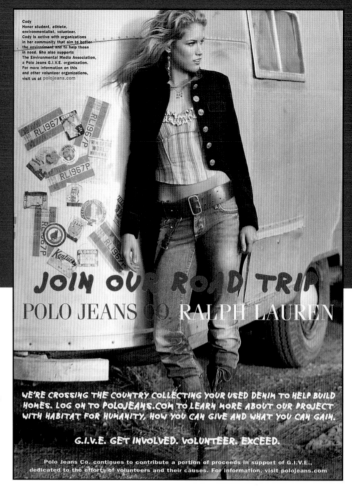

Gone are the days when teens and young adults could perceive themselves as involved in world affairs by merely reading an article about an atrocity or a social ill in their favorite, cool magazine. Involvement now means active involvement, it means time. Polo Jeans Co. utilizes magazine ads and its website to help readers in their pursuit of the purpose driven life. After inviting readers to donate used denim for the benefit of Habitat for Humanity, an ad (right), directs them to the website (below), to learn more.

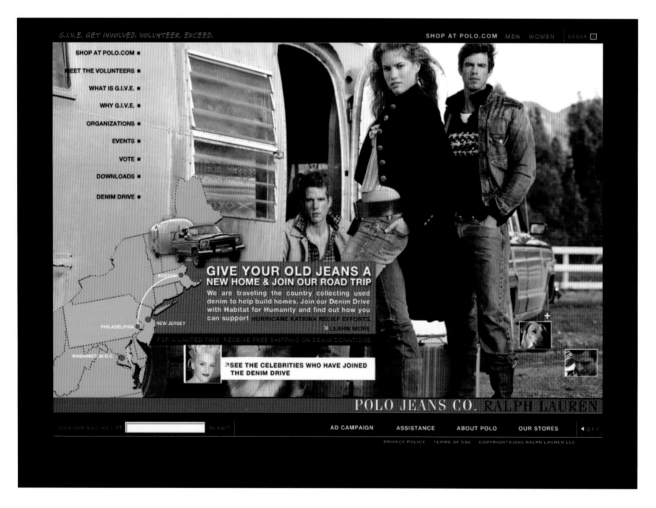

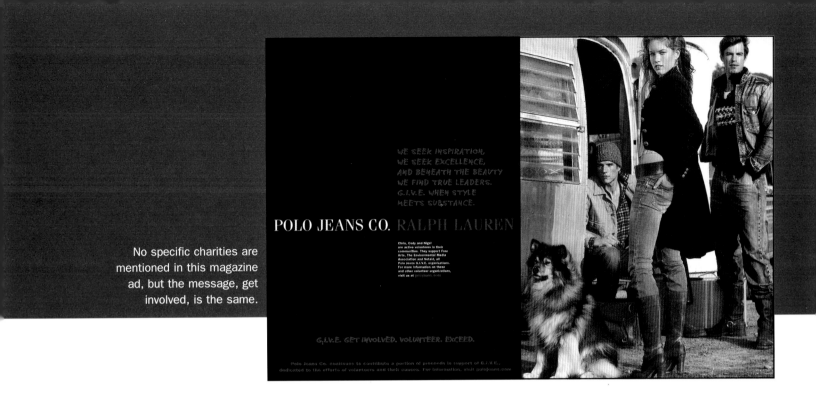

No specific charities are mentioned in this magazine ad, but the message, get involved, is the same.

The website presents a unique top ten list: the top ten reasons to volunteer. It also includes a list of charitable organizations the company is involved and, for good measure, throws in a few celebrities.

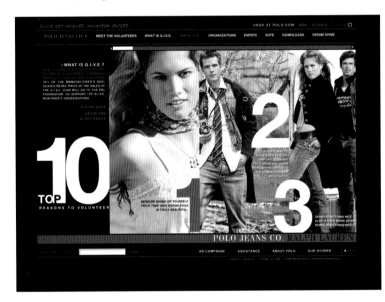

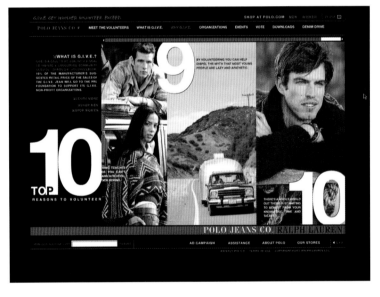

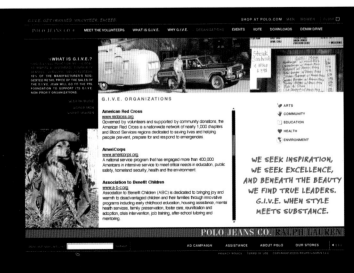

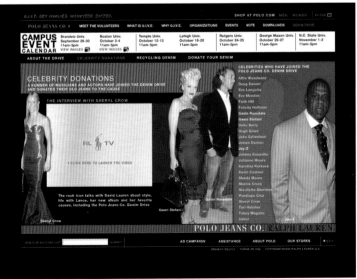

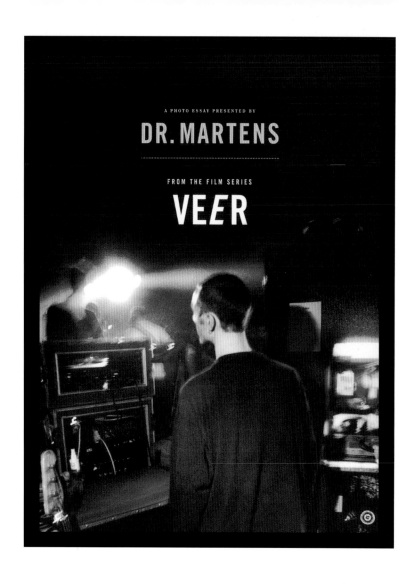

Dr. Martens

This magazine insert from Dr. Martens does double duty—it very effectively reinforces the company image of rugged individualism, and it invites consumers to visit the website. In the insert, six people—individualists all—are introduced, each is the subject of a short film that is viewable on the website. The company also took the film series on a tour of college campuses.

Footwear manufacturer

MEDIA: magazine insert, website
WEBSITE: www.drmartens.com

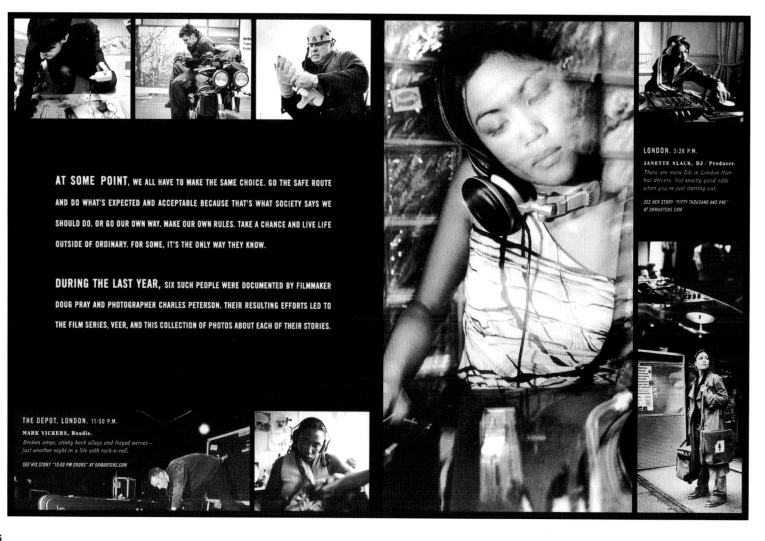

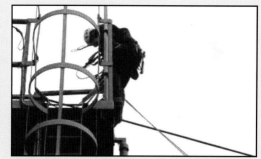

Screen shots from the short film telling the story of John Williams, a fearless inspector of tall structures.

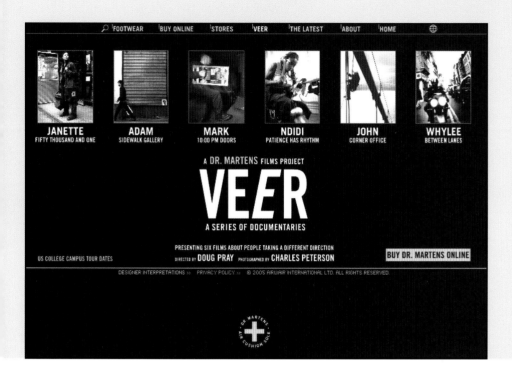

A DR. MARTENS FILMS PROJECT

VEER

A SERIES OF DOCUMENTARIES

PRESENTING SIX FILMS ABOUT PEOPLE TAKING A DIFFERENT DIRECTION
DIRECTED BY **DOUG PRAY** PHOTOGRAPHED BY **CHARLES PETERSON**

US COLLEGE CAMPUS TOUR DATES

BUY DR. MARTENS ONLINE

DESIGNER INTERPRETATIONS >> PRIVACY POLICY >> © 2005 AIRWAIR INTERNATIONAL LTD. ALL RIGHTS RESERVED.

JANETTE FIFTY THOUSAND AND ONE
ADAM SIDEWALK GALLERY
MARK 10:00 PM DOORS
NDIDI PATIENCE HAS RHYTHM
JOHN CORNER OFFICE
WHYLEE BETWEEN LANES

FOOTWEAR BUY ONLINE STORES VEER THE LATEST ABOUT HOME

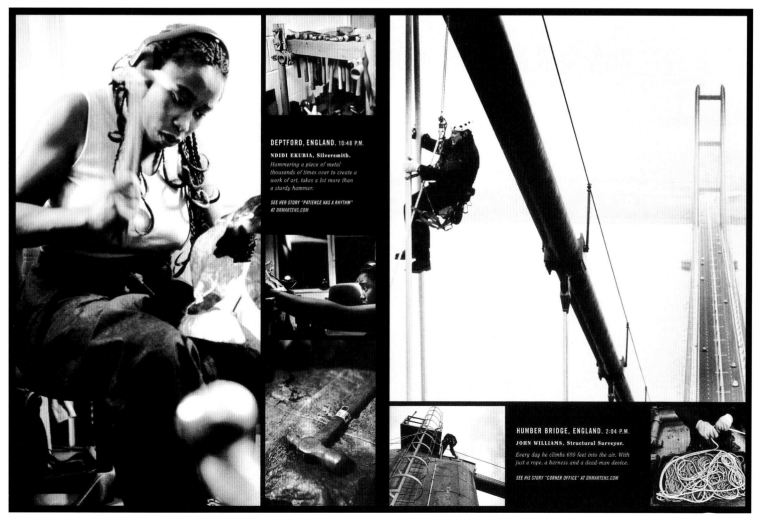

DEPTFORD, ENGLAND. 10:48 P.M.

NDIDI EKUBIA, Silversmith.

Hammering a piece of metal thousands of times over to create a work of art, takes a lot more than a sturdy hammer.

SEE HER STORY "PATIENCE HAS A RHYTHM"
AT DRMARTENS.COM

HUMBER BRIDGE, ENGLAND. 2:04 P.M.

JOHN WILLIAMS, Structural Surveyor.

Every day he climbs 600 feet into the air. With just a rope, a harness and a dead-man device.

SEE HIS STORY "CORNER OFFICE" AT DRMARTENS.COM

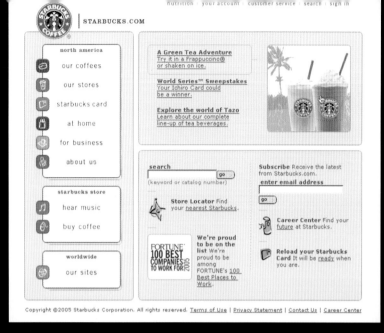

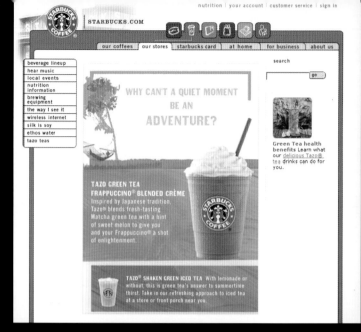

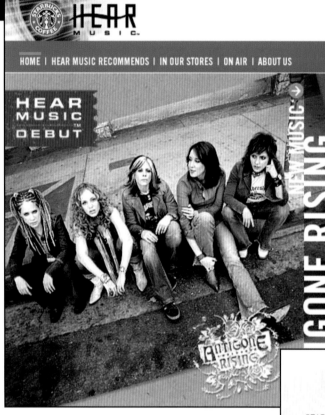

Starbucks enriches the browsing experience with the help of its partners, such as Tazo and Hear Music. For the armchair traveler, a host of Starbucks' international sites are readily viewable (below, New Zealand). All serve to keep the stickiness factor high.

Starbucks

Food specialty

MEDIA: website
WEBSITE: www.starbucks.com

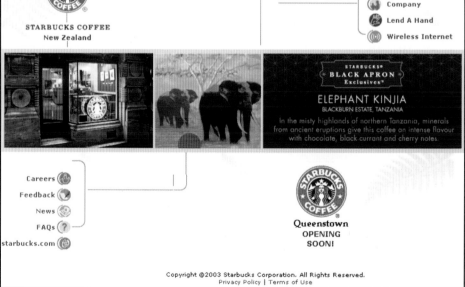

From Starbucks' home page, browsers are invited to "Explore the world of Tazo," a link to the Tazo site (a brand of tea available at Starbucks and elsewhere). This site is a dream for any dedicated tea drinker—rich, earthy colors, sumptuous photography and plenty of information about tea. And, the steam seen rising from a cup of tea (below), looks—and moves—just like the real thing.

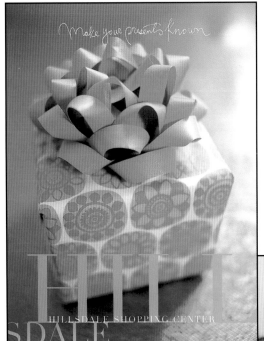

Hillsdale Shopping Center

Green, in all of its wonderfull varieties and hues, graces Hillsdale Shopping Center's holiday catalog. Some rich reds are splashed around for contrast, while script lettering and touchable textures complete the package.

Shopping Center

MEDIA: catalog
DIMENSIONS: 8½" x 11"
PAGES: 24
MARKETING DIRECTOR: Christine Kupczak
CREATIVE DIRECTOR, DESIGNER: Andrew Mandolene
WEBSITE: www.hillsdale.com

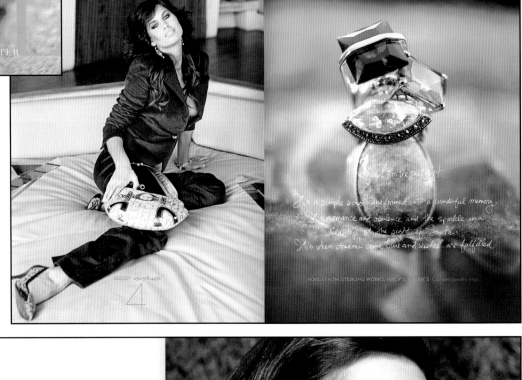

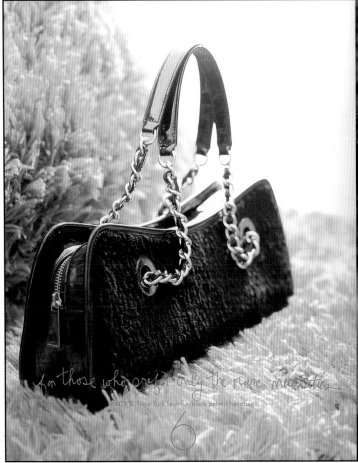

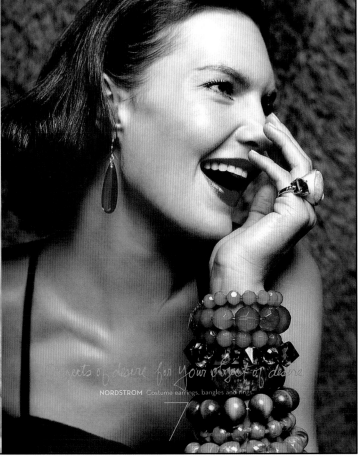

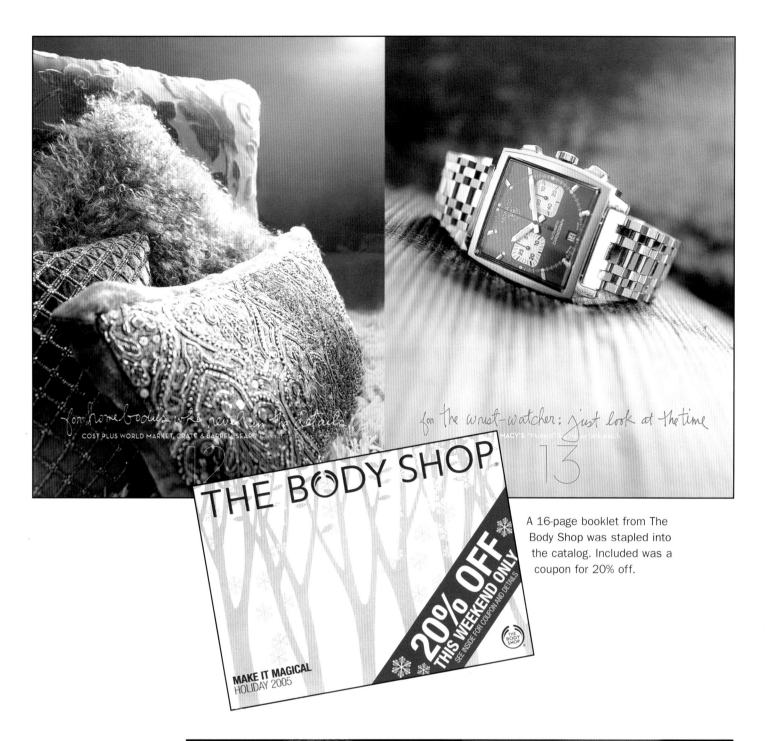

for homebodies who revel in the details
COST PLUS WORLD MARKET, CRATE & BARREL, SEARS

for the wrist-watcher: just look at the time
MACY'S "Monaco" Stainless link watch

THE BODY SHOP

20% OFF THIS WEEKEND ONLY
SEE INSIDE FOR COUPON AND DETAILS

MAKE IT MAGICAL
HOLIDAY 2005

A 16-page booklet from The Body Shop was stapled into the catalog. Included was a coupon for 20% off.

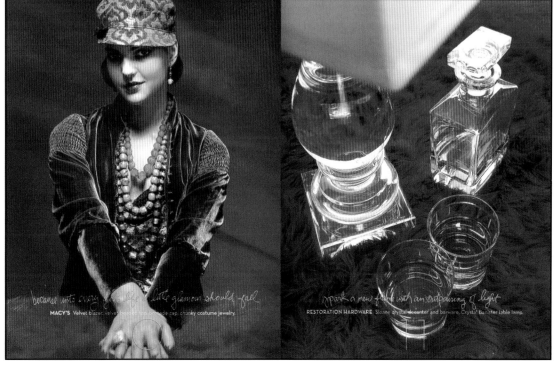

because into every girl's life a little glamour should fall
MACY'S Velvet blazer, velvet beaded brocade cap, chunky costume jewelry.

spark a new feel with an outpouring of light
RESTORATION HARDWARE Sloane crystal decanter and barware, Crystal banister table lamp.

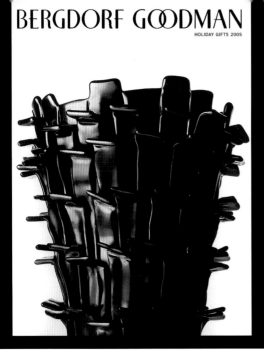
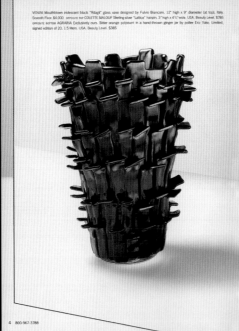
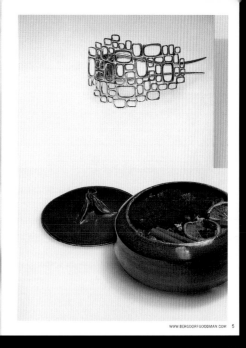

Bergdorf Goodman

The curiosity draws consumers into Bergdorf Goodman's holiday catalog. What exactly is that interesting item on the cover? (It turns out to be a vase.) Once inside the viewer comes upon page after page of enticing gift ideas wonderfully photographed—no background clutter detracts from the merchandise.

Specialty Store

MEDIA: catalog
DIMENSIONS: 6 1/2" x 9"
PAGES: 64
WEBSITE: www.bergdorfgoodman.com

SELF
REFLECTION

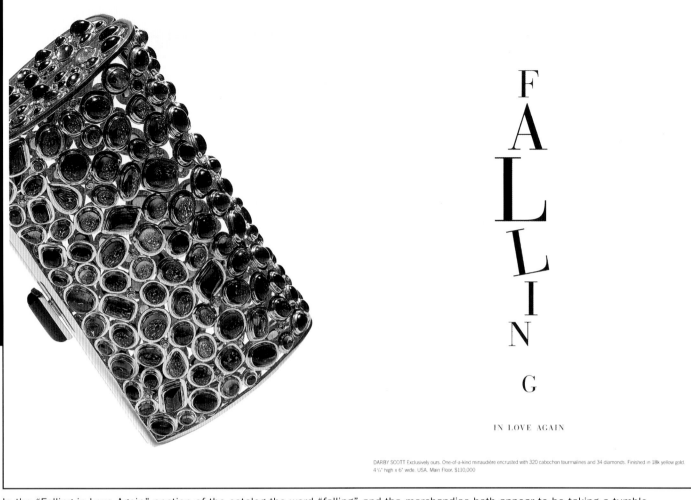

F
A
L
L
I
N
G

IN LOVE AGAIN

DARBY SCOTT Exclusively ours. One-of-a-kind minaudière encrusted with 320 cabochon tourmalines and 34 diamonds. Finished in 18k yellow gold. 4¼" high x 6" wide. USA. Main Floor. $110,000

In the "Falling in Love Again" section of the catalog the word "falling" and the merchandise both appear to be taking a tumble.

OPPOSITE LEFT IPPOLITA Hoop earrings in 18k yellow gold with diamonds. Small hoops, 1" diameter; Medium hoops, 1½" diameter; Large hoops, 2¼" diameter. USA. Main Floor. Small, $1,275. Medium, $2,025. Large, $2,760. OPPOSITE RIGHT JIMMY CHOO Natural rabbit fur and glass bead "Cosmo" evening bag with gold leather strap. 4¾" high x 10½" wide. Imported. Main Floor. $1,200. JAR PARFUMS Exclusively ours. "Bolt of Lightning" extrait de parfum in a hand-etched glass bottle. 1oz. France. Beauty Level. $765

Nordstrom

Specialty store

MEDIA: catalog
DIMENSIONS: 7³/₄" x 10¹/₂"
PAGES: 100
WEBSITE: www.nordstrom.com

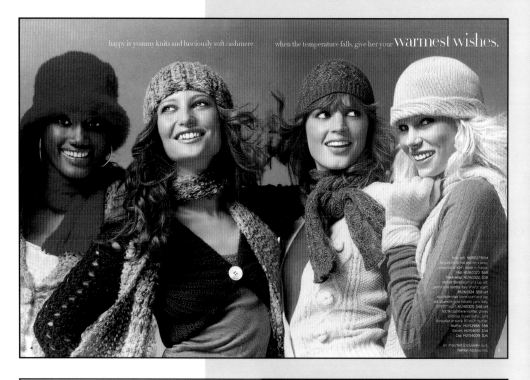

happy is yummy knits and lusciously soft cashmere. when the temperature falls, give her your *warmest wishes.*

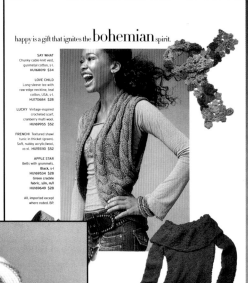

happy is a gift that ignites the **bohemian** spirit.

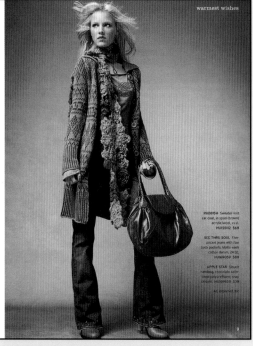

warmest wishes

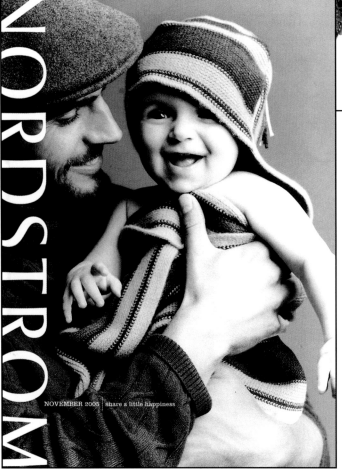

NOVEMBER 2005 | share a little happiness

Nordstrom took what in other hands might have been a Father's Day image and created a memorable cover for this holiday catalog—complete with instructions to "share a little happiness." Inside, many spreads revolve around headlines that begin with the words "Happy is…" Included are gift suggestions for everyone in the family—man, woman, teenager and child.

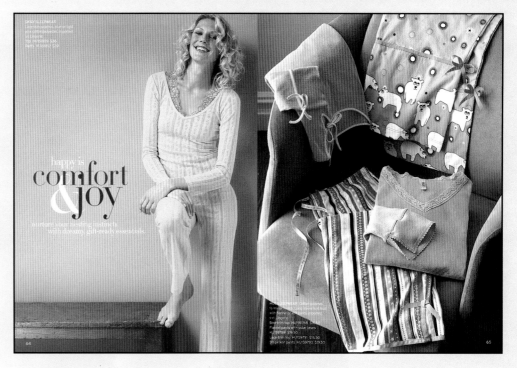

DKNY SLEEPWEAR. Cotton essentials.
to mix-and-match. Long sleeve knit top
with flannel or stripe knit bottoms.
S-XL. Lingerie.
Top. HU95805 $36.
Pants. HU30902 $39.

happy is
comfort
& joy

nurture your nesting instinct
with dreamy gift-ready essentials.

HUE SLEEPWEAR. Cotton essentials
to mix-and-match. Long sleeve knit top
with flannel or stripe bottoms.
S-XL. Lingerie.
Bow trim top. HU99768 $19.50.
Flannel pants with polar bears.
HU99788 $19.50.
Lace trim top. HU99793 $16.50.
Stripe knit pants. HU99793 $19.50.

64 · 65

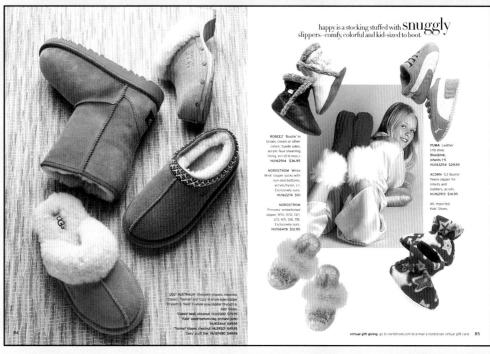

happy is a stocking stuffed with **snuggly**
slippers—comfy, colorful and kid-sized to boot.

ROBEEZ 'Bootie' in
brown, cream or other
colors. Suede soles,
acrylic faux shearling
lining. xs-l (0-6 mos.).
HU162914 $36.95.

NORDSTROM 'White
Mink' slipper socks with
non-skid bottoms,
acrylic/nylon. S-L.
Exclusively ours.
HU162274 $10.

NORDSTROM
'Princess' embellished
slipper, 9/10, 11/12, 13/1,
2/3, 4/5, 5/6, 7/8.
Exclusively ours.
HU156478 $12.95.

PUMA Leather
crib shoe.
Blue/pink,
infants 1-5.
HU143254 $29.95.

ACORN 'EZ Bootie'
fleece slipper for
infants and
toddlers, acrylic.
HU162913 $14.95.

All, imported.
Kids' Shoes.

UGG AUSTRALIA Sheepskin slippers, imported.
'Classic', 'Tasman' and 'Cozy' in whole sizes toddler
8/youth 6. 'Kalie' in whole sizes toddler 8/youth 6.
Kids' Shoes.
'Classic' boot, chestnut. HU03300 $79.95.
'Kalie' wood bottom clog, orchard (pink).
HU153444 $49.95.
'Tasman' slipper, chestnut. HU39301 $49.95.
'Cozy' scuff, tan. HU157480 $49.95.

84 · **virtual gift giving.** go to nordstrom.com to e-mail a nordstrom virtual gift card. 85

a gift of cashmere.

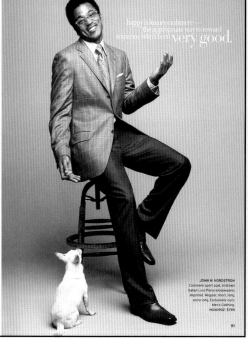

happy is luxury cashmere—
the appropriate way to reward
someone who's been **very good.**

JJ BRITCHES Cashmere trousers
with double reverse pleats, in
tobacco, blue ink, light grey, dark
grey or black, Italy, waists 32-36,
38, 40, 42 (sizes vary by store).
Men's Clothing. HU70980 $395.

Feed
Me

JOHN W. NORDSTROM
Cashmere sport coat, in brown
Italian Loro Piana windowpane,
imported. Regular, short, long,
extra long. Exclusively ours.
Men's Clothing.
HU161902 $795.

90 · **virtual gift giving.** go to nordstrom.com to e-mail a nordstrom virtual gift card. 91

A Holiday Story

—

BANANA REPUBLIC

WRITTEN ESPECIALLY FOR BANANA REPUBLIC CARDMEMBERS

Banana Republic

Sportswear retailer

MEDIA: catalog
DIMENSIONS: 8¾" x 6½"
PAGES: 50
WEBSITE: www.bananarepublic.com

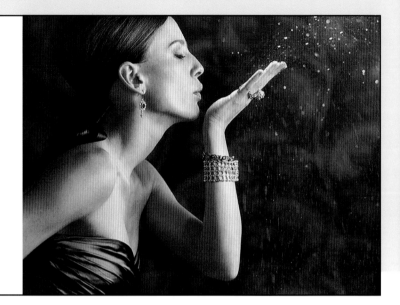

R. S. V. P.

NEW YORK CITY. The Holiday Season. A package marked "Rush Delivery" arrives at Annie and Mack's doorstep just in the nick of time. You see, Annie and Mack were in terrible trouble. Terrible! They had accepted every invitation to every holiday party they were invited to—and three of them were occurring that very same night.

By chance, Mack had seen a late-night TV advertisement for something named E-Z Transportation Granules. When he heard that E-Z Granules promised to help people "be in two places at once—possibly three!—or your money back," Mack called immediately.

The directions for E-Z were surprisingly simple: "Pour contents into hand. Close eyes. Blow granules in desired direction. Travel."

2

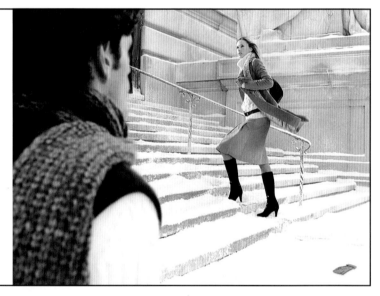

LOST MITTEN

THERE'S ONLY ONE PROBLEM WITH FATE. It's frustrating. Like the day Fate handed Will Elliott his destiny on the front steps of the National Museum. Yes, right in Will's path, not ten feet from him, was Emily Baker, his needle in the proverbial haystack.

And what did he do? Follow her? Accidentally bump into her? Introduce himself? Nope. He saw his chance—and he totally blew it.

18

24

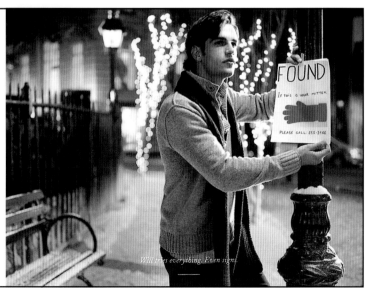

Will tries everything. Even signs.

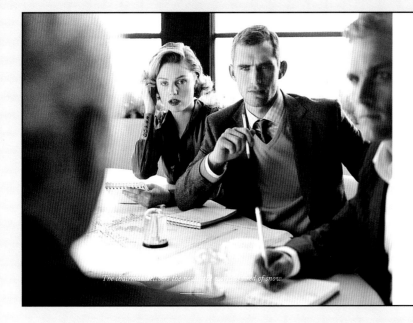

EVERYONE SAT DUMBFOUNDED, uncertain of what to do. Everyone, that is, except Noah. The minute the meeting ended, Noah set out to help the world fall in love with snow again. And in practically no time, he had his first invention: Flavored Snow!

The flavors were endless. Vanilla Bean, Coconut, Minty-Mint—even Chicken, which was actually rather delicious though it might not sound so. (Sadly, the idea was nixed in focus groups due to weak consumer response.) Undeterred, Noah devised inventions too many to list, but here are a few anyway: Gravity-Defying Snow, Scented Snow, and Warm Snow, which turned out more like rain, and that, of course, has even more enemies than snow itself.

Late one night, a coworker saw Noah asleep at his desk. She stopped to study him, since she'd secretly liked him from her first day at Snow, Inc. Then, at that very moment, the power went out, turning the factory pitch-black. When it noisily stammered back on, Noah woke up and, much to her embarrassment, saw her standing not two feet away. But how fortunate it was, for it made Noah realize that the main power room held the solution all along. All he had to do— how clear it was now!—was break in and pull the snow switch. Because once the magic of snow was experienced somewhere in the world, requests would pour in and Snow, Inc. would be saved.

The story is now told. Some will gather from it that hard work pays off. Others will assert that falling asleep at your desk can lead to falling in love with the prettiest girl in the South Pole. Whatever may be concluded, one thing is certain. Snow is like love. It must always be. ✳

The chairman delivers the news—to an audience scared of snow.

13

Portions of the story "Snow, Inc." as seen in a magazine ad (left) and in the catalog (above).

Banana Republic told "A Holiday Story" (actually four stories) throughout its seasonal media mix. In the retailer's holiday catalog (opposite) the stories are told over multiple pages with beautifully-set text and photos that illustrate the plot. Interspersed are off-figure merchandise shots. A magazine campaign continued the stories as did a limited-time website.

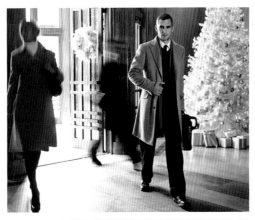

SNOW, INC.

LITTLE IS SAID OR KNOWN about the South Pole, but it is there that Snow, Inc.® quietly toils, supplying the entire world with snow. Now the hero of our story —for every story must have one— is young Noah Dasho, who not only single-handedly rescued Snow, Inc., but pretty much the entire holiday season as well…*continued at holidaystory.com*

BANANA REPUBLIC

Collatoral, such as this postcard, also carried the "story" images. Here the return of the "Lost Mitten."

ENJOY 20% OFF
your next Luxe card purchase of $150 or more with this card through December 24th. Plus, get free shipping when you redeem this offer online.

BANANA REPUBLIC
Offer excludes handbags

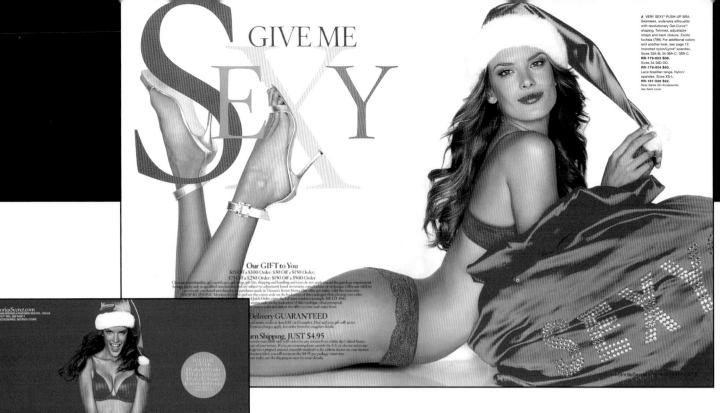

Victoria's Secret

"Sexy" or "very sexy" are the choices on offer in the holiday catalog from Victoria's Secret. Here, Christmas red is reinvented as hot pink and paired with black and silver. Santa and *her* sack never looked quite like this before.

Specialty Store

MEDIA: catalog/magazine ad
DIMENSIONS: 8 3/8" x 10 3/4"
PAGES: 188
WEBSITE: www.victoriassecret.com

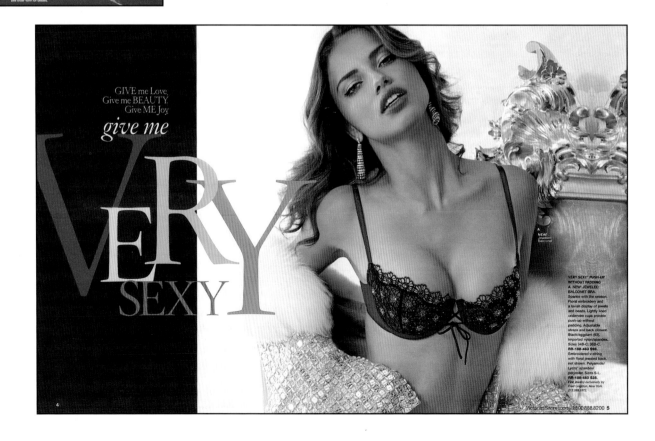

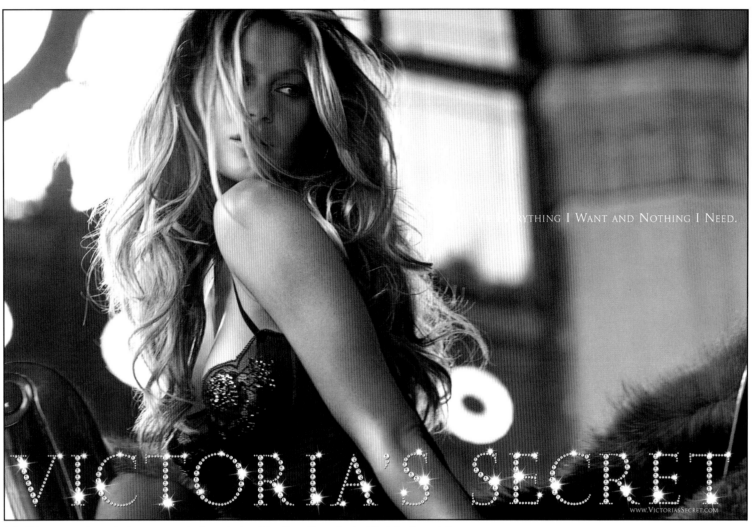

...RYTHING I WANT AND NOTHING I NEED.

VICTORIA'S SECRET

WWW.VICTORIASSECRET.COM

A holiday magazine ad shows more hair and shoulder than lingerie, but it gets its point across.

Hollywood & Highland Center

Shopping center

MEDIA: direct mail
DIMENSIONS: 4¹⁄₂" x 6¹⁄₂"
12 card mailed within clear cellophane envelope
WEBSITE: www.hollywoodandhighland.com

A packet of brightly-colored cards from the multi-use center Hollywood & Highland expanded on the theme "Live Large."

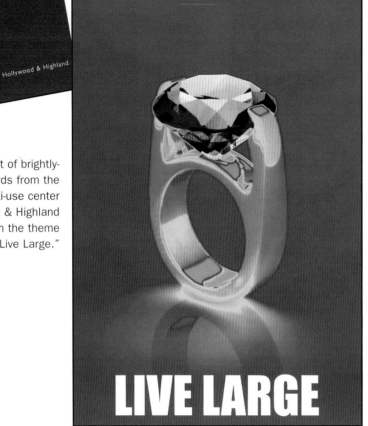

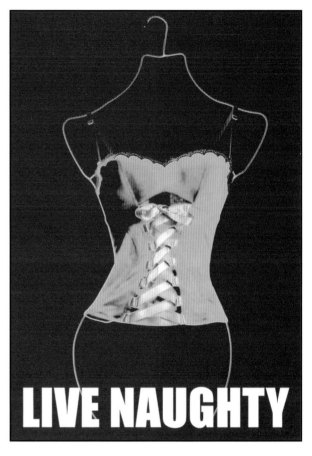

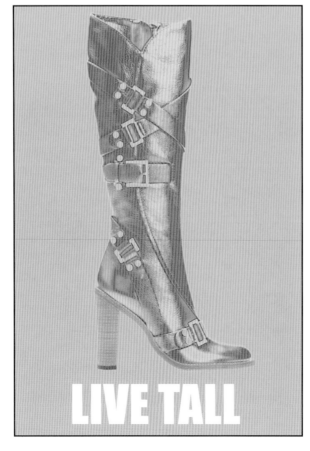

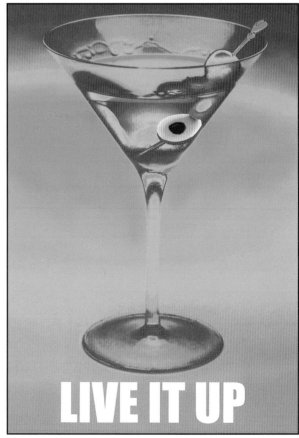

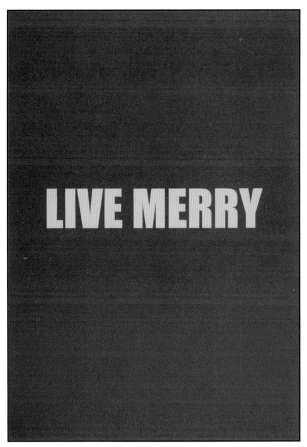

"Live Merry" (this was a holiday mailing) was the first card customers saw. The reverse side of each card contained specific information on stores and other center attractions.

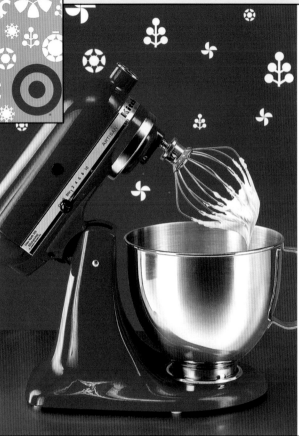

Target

Mass merchandiser

MEDIA: catalog
DIMENSIONS: 7¼" x 10½"
PAGES: 56
WEBSITE: www.target.com

On the cover the target logo is echoed in the various holiday motifs.

THE HOLIDAY-GATHERING SEASON 🍲 IS NEAR. TIME TO SHIFT INTO HOSTING GEAR. THERE ARE MENUS TO PLAN. TABLES TO SET. LOTS OF LITTLE ⚫ SUPPLIES TO GET. AN EARLY START IS THE KEY TO SUCCESS, AND TO ACTUALLY ENJOYING THE PARTY WITH YOUR GUESTS. SO 🥄🍴 GET WHAT YOU NEED 🔪 TO MAKE YOUR HOME LOOK 🍷 FINE. IT'S YOUR TIME TO SHINE.

opposite page | KitchenAid 5-qt. 325-watt Artisan stand mixer. Also in white. 249.99 | Also at Target.com.

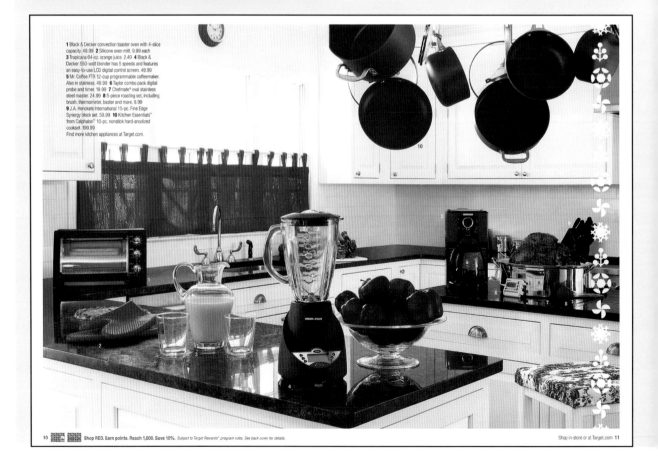

1 Black & Decker convection toaster oven with 4-slice capacity. 49.99 2 Silicone oven mitt. 9.99 each 3 Tropicana 64-oz. orange juice. 2.49 4 Black & Decker 550-watt blender has 5 speeds and features an easy-to-use LCD digital control screen. 49.99 5 Mr. Coffee FTX 12-cup programmable coffeemaker. Also in stainless. 49.99 6 Taylor combo pack digital probe and timer. 19.99 7 Chefmate® oval stainless steel roaster. 24.99 8 5-piece roasting set, including brush, thermometer, baster and more. 9.99 9 J.A. Henckels International 15-pc. Fine Edge Synergy block set. 59.99 10 Kitchen Essentials™ from Calphalon™ 10-pc. nonstick hard-anodized cookset. 199.99 Find more kitchen appliances at Target.com.

10 Shop RED. Earn points. Reach 1,000. Save 10%. *Subject to Target Rewards® program rules. See back cover for details.

Shop in-store or at Target.com 11

Target divides its holiday catalog into red sections and green sections. Within each, design elements, type and merchandise shots—both large and small—are all carefully color controlled. Accents of contrasting color (note the orange juice on a "red" spread) add interest.

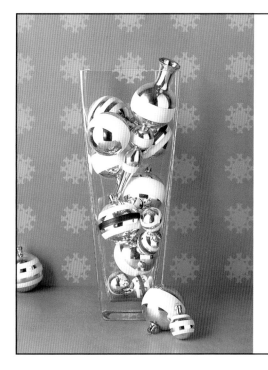

WE ★ INTERRUPT THIS MOMENT OF BLISSFUL PAGE FLIPPING TO SHIFT YOUR ATTENTION TO DECORATING. DAZZLING IS THE LOOK YOU'RE GOING FOR HERE. AND YOU'RE DANGEROUSLY CLOSE TO BEING DONE. YOU HAVE YOUR TABLE, TREE, EVEN YOUR TODDLER SPARKLING AND GLEAMING. AND NOT A MOMENT TOO SOON. YOUR DOOR BELL IS RINGING.

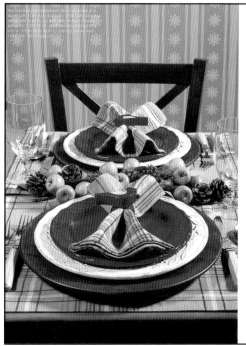

SIMPLY SHABBY, HOLIDAY PRETTY.

Visit our stores
and website
for last minute
holiday savings

For Christmas Delivery
Order by 10am (PST) December 22.
See back cover for details.

Sur La Table

What's red and white with lots of cheery gift ideas? Sur La Table's holiday catalog. The opening spreads group merchandise around themes, mostly to do with entertaining—and making merry with a little liquid fun. The color combination of red and white, along with the beautifully photographed products and clear, attractive layouts, prove irresistible.

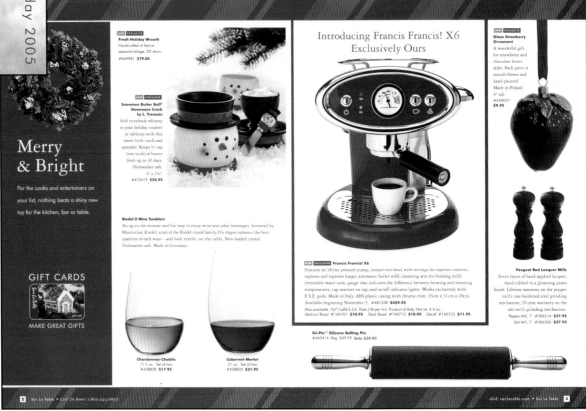

Kitchen and housewares

MEDIA: catalog
DIMENSIONS: 7½" x 10½"
PAGES: 104
WEBSITE: www.surlatable.com

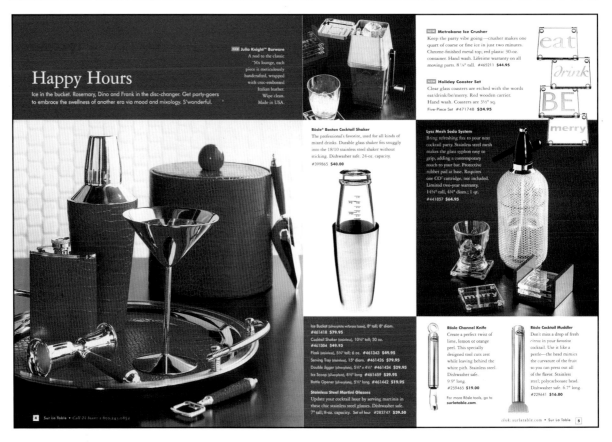

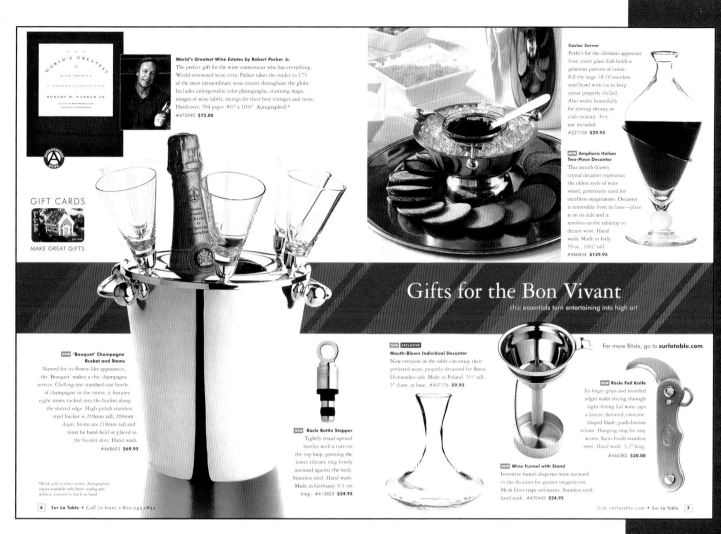

World's Greatest Wine Estates by Robert Parker Jr.
The perfect gift for the wine connoisseur who has everything. World-renowned wine critic Parker takes the reader to 175 of the most extraordinary wine estates throughout the globe. Includes unforgettable color photographs, stunning maps, images of wine labels, ratings for their best vintages and more. Hardcover; 704 pages. 8½" x 10¾". Autographed.*
#475590 **$75.00**

GIFT CARDS

MAKE GREAT GIFTS

Caviar Server
Perfect for the ultimate appetizer. 6-oz. inner glass dish holds a generous portion of caviar. Fill the large 18/10 stainless steel bowl with ice to keep caviar properly chilled. Also works beautifully for serving shrimp or crab cocktail. Tray not included.
#227108 **$29.95**

NEW Amphora Italian Two-Piece Decanter
This mouth-blown crystal decanter represents the oldest style of wine vessel, generously sized for excellent oxygenation. Decanter is removable from its base—place it on its side and it revolves on the tabletop to decant wine. Hand wash. Made in Italy. 59 oz., 10½" tall.
#468454 **$129.95**

Gifts for the Bon Vivant
chic essentials turn entertaining into high art

NEW 'Bouquet' Champagne Bucket and Stems
Named for its flower-like appearance, the 'Bouquet' makes a chic champagne service. Chilling one standard-size bottle of champagne in the center, it features eight stems tucked into the bucket along the slotted edge. High-polish stainless steel bucket is 210mm tall, 200mm diam. Stems are 218mm tall and must be hand-held or placed in the bucket slots. Hand wash
#468603 **$69.95**

*Book sold in select stores. Autographed copies available only from catalog and website; limited to stock on hand.

NEW EXCLUSIVE Mouth-Blown Individual Decanter
Now everyone at the table can enjoy their preferred wine, properly decanted for flavor. Dishwasher safe. Made in Poland. 5½" tall, 5" diam. at base. #457176 **$9.95**

NEW Rösle Bottle Stopper
Tightly reseal opened bottles with a turn on the top loop, pressing the lower silicone ring firmly outward against the neck. Stainless steel. Hand wash. Made in Germany. 9.3 cm long. #413823 **$24.95**

For more Rösle, go to **surlatable.com**.

NEW Rösle Foil Knife
Its finger grips and rounded edges make slicing through tight-fitting foil wine caps a breeze. Serrated, crescent-shaped blade; push-button release. Hanging ring for easy access. Satin-finish stainless steel. Hand wash. 3.2" long.
#466383 **$20.00**

NEW Wine Funnel with Stand
Inventive funnel disperses wine outward in the decanter for greater oxygenation. Mesh filter traps sediments. Stainless steel; hand wash. #470443 **$24.95**

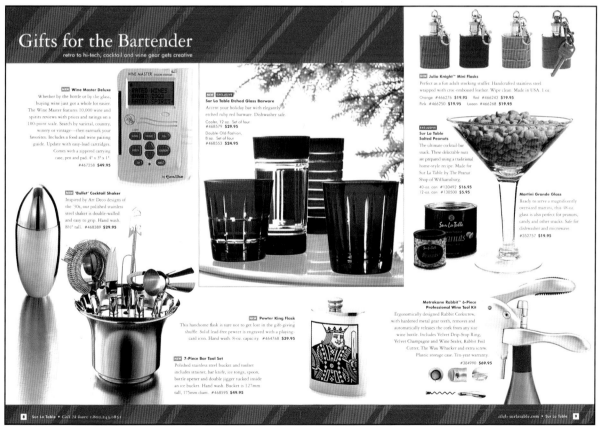

Gifts for the Bartender
retro to hi-tech, cocktail and wine gear gets creative

NEW Wine Master Deluxe
Whether by the bottle or by the glass, buying wine just got a whole lot easier. The Wine Master features 10,000 wine and spirits reviews with prices and ratings on a 100-point scale. Search by varietal, country, winery or vintage—then earmark your favorites. Includes a food and wine pairing guide. Update with easy-load cartridges. Comes with a zippered carrying case, pen and pad. 4" x 3" x 1".
#467258 **$49.95**

NEW 'Bullet' Cocktail Shaker
Inspired by Art Deco designs of the '30s, our polished stainless steel shaker is double-walled and easy to grip. Hand wash. 8½" tall. #468389 **$29.95**

NEW 7-Piece Bar Tool Set
Polished stainless steel bucket and toolset includes strainer, bar knife, ice tongs, spoon, bottle opener and double jigger tucked inside an ice bucket. Hand wash. Bucket is 127mm tall, 175mm diam. #468595 **$49.95**

NEW EXCLUSIVE Sur La Table Etched Glass Barware
Accent your holiday bar with elegantly etched ruby red barware. Dishwasher safe.
Cooler, 12 oz. Set of four #468579 **$29.95**
Double Old-Fashion, 8 oz. Set of four #468553 **$24.95**

NEW Julia Knight™ Mini Flasks
Perfect as a fun adult stocking stuffer. Handcrafted stainless steel wrapped with chic-embossed leather. Wipe clean. Made in USA. 1 oz.
Orange #466276 **$19.95** Red #466243 **$19.95**
Pink #466250 **$19.95** Green #466268 **$19.95**

EXCLUSIVE Sur La Table Salted Peanuts
The ultimate cocktail-bar snack. These delectable nuts are prepared using a traditional home-style recipe. Made for Sur La Table by The Peanut Shop of Williamsburg.
40-oz. can #130492 **$16.95**
12-oz. can #130500 **$5.95**

Martini Grande Glass
Ready to serve a magnificently oversized martini, this 58-oz. glass is also perfect for peanuts, candy and other snacks. Safe for dishwasher and microwave.
#352757 **$19.95**

NEW Pewter King Flask
This handsome flask is sure not to get lost in the gift-giving shuffle. Solid lead-free pewter is engraved with a playing-card icon. Hand wash. 8-oz. capacity. #464768 **$39.95**

Metrokane Rabbit™ 6-Piece Professional Wine Tool Kit
Ergonomically designed Rabbit Corkscrew, with hardened metal gear teeth, removes and automatically releases the cork from any size wine bottle. Includes Velvet Drip-Stop Ring, Velvet Champagne and Wine Sealer, Rabbit Foil Cutter, The Wax Whacker and extra screw. Plastic storage case. Ten-year warranty.
#384990 **$69.95**